Joseph Beuys

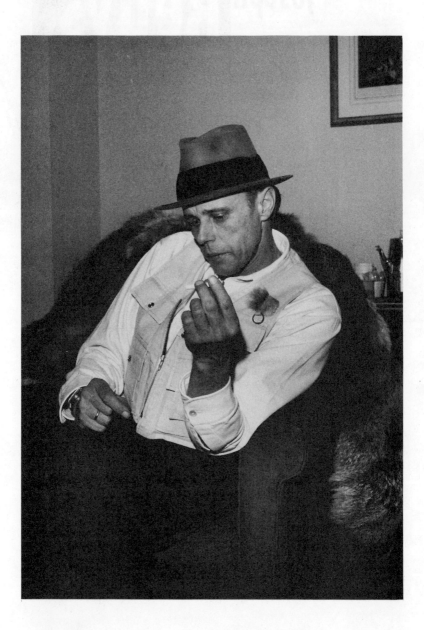

Joseph Beuys

HEINER STACHELHAUS

Translated by David Britt

Abbeville Press Publishers
New York London Paris

This book is printed on acid-free recycled paper.

Editors: Laura Lindgren and Nancy Grubb
Designer: Scott W Santoro/WORKSIGHT
Production editor: Philip Reynolds
Production manager: Dana Cole
Chronology by Daniel Starr and Heiner Stachelhaus
Selected bibliography by Daniel Starr with Philip Reynolds
Typesetting: Emily Tenzer/WORKSIGHT

Cover: the Action *Drama Steel Table*. See page 141.
Frontispiece: Joseph Beuys, New York, 1974.

First U.S. edition

Library of Congress Cataloging-in-Publication Data

Stachelhaus, Heiner.
 [Joseph Beuys. English]
 Joseph Beuys/Heiner Stachelhaus; translated by David Britt.
 p. cm.
 Includes bibliographical references.
 Includes index
 ISBN 1-55859-107-9
 1. Beuys, Joseph. 2. Artists—Germany (West)—Biography.
I. Title.
N6888.B463S7413 1991
709' .2—dc20 90-49991
 [B] CIP

Contents

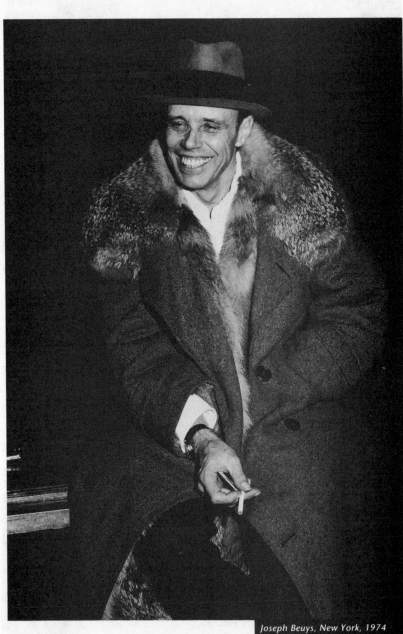

Joseph Beuys, New York, 1974

Preface

I first came to know Joseph Beuys in 1966. He was giving a lecture on Fluxus and Happenings at the Grillo-Gymnasium in Gelsenkirchen and afterward held a discussion with the students. After that I met with him frequently, and we had a succession of invariably interesting and—for me—enlightening conversations, often at his home on Drakeplatz, in the Oberkassel district of Düsseldorf. Had it not been for that ongoing dialogue, this book could never have been conceived.

It is hardly possible to keep up with the torrent of literature on Beuys. He has stirred public opinion as no other artist since World War II has, and the verdicts on him range from charlatan to genius. The purpose of this book is to make the life and work of Joseph Beuys as accessible to the reader as possible. This means that, with a few exceptions, I have steered clear of interpretation and analysis, whether my own or those of others. Beuys's impact becomes apparent primarily through his own thoughts and actions. A comprehensive presentation and evaluation of the artist's work would require study in still greater detail.

I have organized this biography according to the principal phases of his life and work to help bring clarity to this difficult material. In addition to my study of the relevant literature, my preparation of this book was facilitated by my own written notes of conversations with Beuys and much valuable information provided by others personally acquainted with him. Crucial to the realization of this book was the support and encouragement of Eva

Beuys, who in the course of several extensive conversations helped me to understand Beuys better than before. I am deeply grateful to her and to her two children, Wenzel and Jessyka. Special thanks are also due to the brothers Hans and Franz Joseph van der Grinten, Beuys's friends and early collectors; to Erwin Heerich, who remained a loyal and understanding colleague, both as an academy professor and as an artist; and to the naturalist Heinz Sielmann, who deepened Beuys's love of nature and fostered his scientific bent. All have made me aware of new aspects of Beuys's life and of his work as an artist.

Origins

Date of birth: May 12, 1921. Birthplace: Krefeld—not Kleve, as Joseph Beuys himself declared in his "Life Course/Work Course," which he compiled in 1964 in the form of a list of exhibitions. The reason that Beuys first saw the light of day in Krefeld is simple: the family doctor did not want Beuys's mother, Johanna Beuys (née Hülsermann), to give birth at home, because he feared complications. So he sent her to have her baby at the obstetric clinic in Krefeld.

But Beuys was, of course, a man of Kleve. He went to high school in Kleve, and after the war it was there he had his first studio. Artistic talents are not to be found in his family, on either his father's or his mother's side. His ancestors were from Holland. Beuys's father, Joseph Jacob Beuys, who came from Geldern, in North Rhine–Westphalia, was a businessman. In Rindern, a small village near Kleve, he worked as general manager of a dairy cooperative until it folded in 1930 during the Depression. In the same year Beuys senior, whose father had been a miller, started a flour and fodder business in Rindern in partnership with his brother. As a result, the family had to move from Kleve to Rindern. During World War II Beuys's father was employed by the municipal government. He died in 1958.

Joseph Beuys never made any secret of the fact that he did not have a particularly close relationship with his parents. In the strongly Catholic, petit bourgeois environment in which he grew up—and from which he made early attempts to

escape—there was little room for tenderness. His father has been described as strict and proper. His mother, who came from Wesel, was reserved and remained in the background of family affairs. She died in 1974. Still, she did pass on to her son the scientific interests of the Hülsermann family. And for all her reserve, she closely and critically followed his development and his artistic career. Once, she expressed her disappointment that he was not a famous sculptor by the 1950s.

Both parents spoke the Lower Rhine dialect of Low German—as did Beuys, who loved down-to-earth talk. In Rindern and in Kleve, even long after he had become famous, Beuys was known to his friends and neighbors as "dat Jüppken": our Joey. At the age of twelve Jüppken planted a weeping willow in front of his parents' house at Rindern. He was a wild child who would rather climb up the downspout and go in through the skylight than use the front door, and in high school he used to demonstrate his acrobatic skill by racing down the stairs on his bicycle. Beuys the high-school student was always up to whimsical pranks. But strangely enough, it never brought him any harm. The teachers, and even the principal, of the old Hindenburg secondary school in Kleve (now the Freiherr-vom-Stein-Gymnasium) were protective of him.

His English teacher, Dr. Heinrich Schönzeler, was particularly fond of him, and Beuys reciprocated, in his own way. Schönzeler, who had lost both legs in World War I and wore artificial ones, went to school every morning on a motorized tricycle. Beuys and a few of his classmates took care to meet him at a particular street corner and accompany him to school on their bicycles. Beuys was the noisiest and most cheerful of this early morning reception party and the natural leader of the escort.

In Schönzeler's apartment, in 1946, Beuys first met the brothers Hans and Franz Joseph van der Grinten, then still students at the Hindenburg secondary school. None of them foresaw how close and fruitful Joseph Beuys's connection with these two farm boys from Kranenburg was to be.

Beuys did not exactly speed through high school with flying colors. A restless spirit, he ran away with a traveling circus one year before graduation. He was set to work as a roustabout, putting up posters and looking after animals, and his parents were in despair until he was finally tracked down in the Upper Rhine valley, where the circus was performing, and hauled

back home. His father decided to take him out of school at once. He wanted to send him straightaway to apprentice in the margarine factory in Kleve, founded in 1888, whose principal product was known as "Schwan im Blauband"—after the swan in the crest of the counts of Kleve. But young Beuys got off cheaply, benefiting once more from the goodwill of his teachers at the Hindenburg secondary school. He was put back one grade and graduated in 1940. It is one of fate's little ironies that margarine was later to play, in a very different way, such a significant role in Beuys's life.

The Lower Rhine, with its flat, expansive landscape, its history, its myths and legends, left its mark on Beuys, as did the little town of Kleve, which at present has a population of about 45,000. Kleve has held a municipal charter since 1242; from 1056 it was the seat of the counts, and from 1417 the dukes, of Kleve. The ancestry of the counts of Kleve can be traced to Lohengrin, the knight of the swan, who according to German medieval legend was the son of Parzifal, knight of the Holy Grail. Beuys's special liking for swans is evident in his early drawings— and in this context it should be mentioned that he was also receptive to the operas of Richard Wagner.

Under Count Johann Moritz von Nassau, who governed Kleve from 1647 through 1670, this decayed capital was transformed into a garden city unique to seventeenth-century Europe. Nassau's reputation as a botanist and a garden expert was great, and he acted as consultant to Louis XIV, the "Sun King." Nassau had symbolic landmarks placed at avenue intersections, and in 1653 the monument known as the Iron Man was erected at the end of Nassauer Allee on the corner of Gocher Landstrasse.

As a grade-school student Beuys waited at the Iron Man for the streetcar to take him to school in the inner city. The monument consisted of a long-barreled iron cannon, which was crowned by a cupid in armor and surrounded by four iron mortars or "bomb kettles," once used to fire powder charges at short range. Beuys, like many others who waited at that stop, often used to sit on those mortar barrels. (In 1976, having become a world-famous artist, he restaged this childhood memory in the German Pavilion of the Venice Biennale in a sensational artistic tour de force.)

Of great significance to the young Beuys was the story of Anacharsis Cloots, born Baron von Cloots at Schloss

Gnadenthal, near Kleve, in 1755. As a child Beuys often played at the Cloots palace. He was fascinated by this extraordinary individual and at one time so strongly identified with him that he called himself "Joseph Anacharsis Clootsbeuys." In 1776 Cloots appeared in Paris, where he assumed the name of Jean-Baptiste du Val-de-Grâce. During the French Revolution he was on the side of the Jacobins. He addressed the National Convention as "Orator of the Human Race"; campaigned against the Girondists; presented to the National Assembly, "in the name of all peoples," a letter of thanks for the abolition of tyranny; called for the secularization of the churches; and declared the ideals of the Revolution to be universal human ideals, thereby committing the crime of antinational agitation. In 1794 Cloots was arrested as a foreign agent and accused of betraying the Revolution. On March 24 of that year, on Robespierre's orders, he was guillotined. Before the blade fell, Anacharsis Cloots, citizen of the world, who had always subscribed to the religion of Reason, is said to have bowed thrice to the mob of onlookers, once to the left, once to the right, and once to the center, thus expressing in his own way the ideals of the French Revolution: liberty, equality, fraternity.

The landscape of the Lower Rhine powerfully influenced Beuys. His boyhood adventures in the countryside lived on in his memory down to the smallest detail, and he always enjoyed recounting them. Tongue in cheek, he claimed that his memory stretched back to the tender age of eighteen months, when he remembered lying on his back and delighting in the clouds and the blue sky. Beuys also recalled that during his adolescent years he went around pretending to be a shepherd, with an imaginary flock and a genuine shepherd's crook—which he later transformed into *Eurasian Staff* in one of his Actions.

He learned about plants, grasses, trees, herbs, mushrooms. He jotted down his observations in notebooks and kept a botanical collection in his parents' house. There he even maintained a small zoo and laboratory and was always hunting for mice, rats, flies, and spiders for it. He also caught fish and frogs. As a sideline, he took cello and piano lessons and played cello in the school orchestra. With his playmates he built tents and subterranean labyrinths in which he laid out his treasures. Beuys traced certain images that later appeared in such work as *Genghis Khan* or *Stag Leader* back to his intense childhood experiences.

Three years before graduation, Beuys met the Kleve sculptor Achille Moortgat, who had been influenced by such artists as Constantin Meunier and Georges Minne. He often visited Moortgat in his studio. But more important, and indeed decisive for Beuys's own sculpture, was his first encounter with the work of the German Expressionist sculptor Wilhelm Lehmbruck. Beuys discovered reproductions of sculpture by Lehmbruck in a catalog that he managed to rescue in 1938 from one of the book burnings ordered by the Nazis in the school yard of the high school in Kleve. He also plucked from the heap a book by Thomas Mann and the *Systema naturae* of the Swedish botanist Carolus Linnaeus.

Beuys openly defied his strict Catholic family by joining the Hitler Youth. Later he admitted that as an adolescent he had taken this chance to sow his wild oats: by which he presumably meant that for a time the temptations of that period had in many respects suited his restless temperament. Beuys excluded this phase of his development from his biographical record. But one thing remains clear: the discovery of Lehmbruck had moved him deeply. He had spiritualized the experience, and many years later he brought it to light like a precious treasure. Upon receiving the Wilhelm Lehmbruck Prize of the city of Duisburg on January 12, 1986—eleven days before his death—he acknowledged his great inspirer. As a young student who was gifted in science and working toward academic training in that field, Beuys instinctively knew when he saw the illustrations of work by Lehmbruck that this experience of form would never let him go. At sixty-four, a dying man and world celebrity, he found moving words to commemorate his "teacher" Lehmbruck.

13

In that speech Beuys was no doubt incorporating memories of further encounters with the work and biography of Lehmbruck. He spoke of a little book, found somewhere by chance, in which he had discovered a sculpture by Lehmbruck. A revelation came to him: "Sculpture—there's something to be done with sculpture. 'Everything is sculpture,' the picture more or less told me. And in the picture I saw a torch, I saw a flame, and I heard: 'Protect the flame!'" Later, he said, his encounter with Lehmbruck had inspired him to tackle sculpture himself, and he had embarked on his studies in sculpture in Düsseldorf. He wondered whether any other sculptor—Hans Arp or Pablo Picasso or Alberto Giacometti or "some kind of Rodin"—would have been

capable of "causing me to make this decision." His answer: "No, because the extraordinary work of Wilhelm Lehmbruck crosses a threshold in the concept of sculpture."

Beuys had a deep understanding of Lehmbruck, as his Duisburg speech confirmed in every single sentence. "He brings the tradition of experiencing space through the human body—the human frame—to a culmination that transcends even Rodin." Beuys's own "law of the universe"—the principle that sculpture is all—was not unfamiliar to Lehmbruck, to whom sculpture stood for inner experience. "This means," Beuys explained, "that his sculptures are not to be grasped visually. They can be grasped only through an intuition that opens up completely different organs of perception; above all, hearing—hearing, thinking, willing. And this means that there are categories present in his sculpture that had never been present before."

Later, when Beuys had begun to think of creating sculpture of not only physical but also psychic material, he had been positively driven to the idea of "Social Sculpture." He considered it a message from Lehmbruck when one day, in a dusty bookcase, he had found Rudolf Steiner's much-suppressed *Appeal to the German People and the Civilized World,* of 1919, a call for the social organism to be rebuilt on a completely new foundation. Beuys remarked in Duisburg: "After the experiences of the war, in which Lehmbruck had suffered so grievously, one man stood up and saw that the causes of the war lay in the impotence of spiritual life." Steiner's appeal, Beuys said, was aimed at creating an organization that would "effectively found a new social organism." Among the founding committee members he saw the name of Wilhelm Lehmbruck, with a cross after it. Beuys surmised that Lehmbruck, before his death in 1919, had offered "in the last hour of his life, this will, this flame that he wanted to pass on when he had already passed through the gates of the death of his own sculpture. . . . In the passing of the torch I found a movement that is still necessary today, a movement of which many people ought to be aware, and a fundamental idea for the renewal of the social whole that leads to 'Social Sculpture.'"

In his tribute to Lehmbruck, Beuys expressed his conviction that Lehmbruck's sculpture stands for the extension of the concept of space to include the concepts of time and warmth.

14

In this sense Lehmbruck passed on the flame: "I have seen that flame," said Beuys. He thus aligned himself with the cause for which Lehmbruck had lived and died, and with the message to every human being that Lehmbruck had expressed in a poem: "Protect the flame; for if the flame is not protected, before one knows it, the wind will soon quench the light it has kindled. Then break, thou piteous heart, silent with pain." And Beuys concluded his testamental speech, "I would not like to deprive Wilhelm Lehmbruck's work of its tragedy."

It is surprising that the seventeen-year-old Beuys, when he first saw those catalog reproductions of Lehmbruck's sculptures in 1938, was already able to grasp intuitively the specific sculptural issues involved, to realize what sculpture could truly be. There are notable similarities between the careers of Lehmbruck and Beuys. Lehmbruck, born in 1881, the eighth child of a miner's family in the Meiderich section of Duisburg, showed early signs of artistic talent, just as Beuys had, and like him, he earned a living for a time from occasional commissioned works. Lehmbruck studied at the Düsseldorf Academy (1901–6). There he was a master student of Carl Janssen, known especially for his historical monuments. Forty-six years later Beuys began his studies at the same Academy and became a master student of Ewald Mataré. Lehmbruck's teacher Janssen, like Beuys's teacher Mataré, put the greatest emphasis on craftsmanship and technical perfection. At the outset of his studies Lehmbruck was strongly impressed by the work of Constantin Meunier, which was engaged with the industrial environment and which Beuys in turn encountered during his visits to Moortgat's studio in Kleve.

Lehmbruck had strikingly portrayed social problems in such early sculptures as *Miner, Labor Monument, Firedamp,* and *Beggar Couple.* Beuys well understood the tightrope that Lehmbruck walked between the classical tradition, which culminated in Rodin and which Beuys himself had been trained in, and the new Cubist-inspired tendency toward reduction of volume and liberation from the pedestal. In his "Thanks to Lehmbruck" speech, Beuys pointed to this new kind of sculpture. Certainly he knew Lehmbruck's credo that every work of art must carry with it a trace of the first days of creation: "the smell of earth, one might say—something animal."

15

It was almost inevitable that Beuys would identify himself with the earlier artist. That the burdens of life led both to deep depression—around the age of thirty-five in both cases—is another of their strange existential parallels. Lehmbruck asked in a poem in 1918: "Have you, who deal so much death, have you no death for me?"

From that moment of discovery in 1938, Lehmbruck remained in Beuys's mind a great and—as it transpired—permanent source of inspiration; but Beuys had many other tangible preoccupations. For one thing, he painted. Even at fifteen, the schoolboy showed surprising talent. Of the series of watercolor landscapes that he painted in 1936 only one, *Landscape at Rindern,* has survived. A number of these watercolors hung in the staircase of the Hindenburg secondary school in Kleve, which was destroyed on October 7, 1944. What became of the others is unknown.

Beuys did a great deal of reading in the years before he graduated from high school: Johann Wolfgang Goethe, Friedrich Schiller, the Romantics in general, Friedrich Hölderlin, Novalis, and the Scandinavian writers—Knut Hamsun most of all. Among painters, Beuys regarded Edvard Munch particularly highly. His favorite composers were Erik Satie and Richard Strauss. In philosophy his main interest was Sören Kierkegaard and the insight that existence is the synthesis of the temporal and the eternal, and that man is the absolute.

There is a certain consistency in the literary and artistic influences on the young Beuys. Novalis turned toward mysticism after the death of his fifteen-year-old fiancée, Sophie von Kühn, and he equated man's transcendence of death with the resurrection of Christ. The Belgian Symbolist writer Maurice Maeterlinck, author of *The Life of the Bee* (1901), developed a mystical pantheism. The Norwegian novelist Knut Hamsun (author of *Hunger, Mysteries, Pan,* and *Growth of the Soil*) was concerned with Norse mythology and its simple folk. From Paracelsus—whom Beuys especially admired, along with Goethe and Leonardo da Vinci—Beuys learned about a speculative cosmology and anthropology that led him, in 1941, into a lifelong involvement with the teachings of Rudolf Steiner.

Thus, even in high school Beuys was deeply interested in existential and anthroposophical questions. He had a powerful sense of the dark side of life, the mysteries of the cosmos, and

he was well prepared to bring his knowledge of physics, chemistry, and botany into harmony with the mythical. This interplay of myth, inner life, and natural science is the foundation of his concept of Social Sculpture, which Beuys was later to posit as the goal of his "expanded concept of art."

The War

Graduation and the arrival of his draft notice occurred almost simultaneously, in 1940. Beuys had already made a rather halfhearted decision to study medicine, specializing in pediatrics. Now he was obliged to go into the military. He volunteered for the Luftwaffe and was assigned to the air communications school in Posen (now Poznań). His instructor there was a corporal four years older than himself, Heinz Sielmann. A friendship that was to be particularly important for Beuys at a very difficult stage in his life soon sprang up between the two.

Sielmann came from Rheydt, fifty miles from Kleve; he had been a student of biology and zoology, and right after graduating from high school he had shot his first film, "Baltic Lagoon and Meadow Birds." (After his release from a British POW camp, Sielmann became a production adviser for school films on biology in Hamburg. He went on to achieve international fame with his entertaining and absorbing television series, "Expeditions to the Animal Kingdom," which made the complex processes of nature comprehensible to countless viewers.) Beuys of course benefited from Sielmann's profound scientific knowledge, and Sielmann soon realized that Beuys too possessed considerable understanding of the subject. So, whenever their duties permitted, they went on hikes together and analyzed their observations. Beuys, as Sielmann remembers, had adopted a dog, a half-starved spitz, and nursed it back to health, illegally, in the barracks. The dog, which Beuys called Lumpi, went along on all their walks.

Beuys was fortunate to have been assigned to an instructor who shared his love of animals and of nature, and who did his utmost to encourage the recruit's thirst for knowledge. Sielmann recognized Beuys as an individualist who was not about to obey the rules blindly and who, as Sielmann put it, "didn't move his ass" when an officer came in and a report had to be made. However, such acts of insubordination clearly did not impair their friendship. On the contrary: Sielmann kept Beuys out of trouble by making him what was known as a *Putzer*. This was an orderly, a soldier who acted as a kind of servant to a superior and, in a sense, his confidant as well. Just as the tiny pilot fish keeps a big shark free from parasites, so the soldier-servant had to perform such tasks as shining his superior's boots and keeping his room clean. Not that Sielmann exploited Beuys: he had him carry messages from time to time, but mainly he enjoyed his notable culinary skills. And so it was that on occasion, thanks to Beuys's particular—and later much praised—talent as an amateur cook and spice expert, there were some fantastic meals in Sielmann's room in the Posen barracks.

At that time Sielmann considered his friend to be "utterly normal." He discerned no sign whatever of artistic genius. According to Sielmann, Beuys was a good radio operator, highly alert, quick on the uptake, even-tempered, a good comrade. Sielmann often took him along to audit zoology, botany, and geography lectures at the Reich University of Posen, where he himself had studied for four semesters.

Beuys once described the war years as "a learning experience." That is typical of him. He never complained, even though he was severely wounded. Just as he had taken participation in the Hitler Youth in stride, so he accepted soldiering and the war itself as a fate that had to be borne. If you lost your life, that was too bad; if you survived, you were in luck. Of course Beuys wanted to survive. And it was because he repeatedly came very close to death that he was later able to incorporate it into his work.

In Posen, however, all of that still lay in the future. Beuys studied radio communications under Sielmann and made contact with a group of philosophically minded soldiers who gathered around Hermann Ulrich Asemissen, one year older than Beuys and in charge of the Posen barracks armory. In Asemissen's tiny garret they conducted long and intense philosophical discussions.

19

And so they were not bored in their leisure hours, felt no pressing need to go out, and could avoid having to confront the local population as members of the occupying force. Under the date of 1940 in his "Life Course/Work Course," Beuys mentions the name of Eduard Spranger, without explanation. This is a reference to the Posen philosophy group, which at the time was engaged primarily in a study of Spranger's *Psychology of Youth*. Beuys was obviously fascinated by Spranger's "psychology of the sense-oriented life" and by his theory of education, with its emphasis on the harmonious development of all human powers.

It was thanks to Sielmann and to Asemissen (who was later to become professor of philosophical anthropology and aesthetics at Kassel University and principal of the art college there) that Beuys could describe the war period as a learning experience. Whenever he was asked about the war, he replied that, for him, that time had not been wasted.

About the rest of his military career Beuys said very little. Having completed his training as a radio operator in Posen, he was sent in 1941 first to Erfurt, then to Königgrätz (now Hradec Kralové in Czechoslovakia), to train as a dive bomber pilot. The exact sequence of events will never be known, for whether passively or willfully, Beuys endorsed contradictory versions of the story. Thus, in the catalog of the exhibition of drawings, watercolors, oil paintings, and sculptural paintings from the van der Grinten collection (Städtisches Museum, Haus Koekkoek, Kleve, 1961), he noted that "the designation 'dive bomber aircrew' [was] accurate, as I worked my way through every department of that branch of service; radio operator is wrong." Perhaps he simply meant to say that he was not only a radio operator but also a pilot and gunner, since he was undeniably a radio operator, thanks to the efforts of Heinz Sielmann.

The war at this point had not affected Beuys much. One incident makes this clear. In May 1941 he was granted a few days' furlough. He traveled from Erfurt to Weimar, where he visited the Nietzsche Archive. There, behind Schloss Belvedere, he drew an abstract form in watercolor and pencil on top of a text he had previously written on a double-perforated printed form. The text reads as follows:

Nordic Spring
O Spring
Thy thousand powers stream into me

when I walk through the wood
how tree after tree here catches the early light
through the filigree treetops falls the red
shimmer on the green leaves.
There flows the stream. There is a silvery ring
as tiny waves sweetly splash
over the colored pebbles. Already the nine-year moss
spreads over the high protruding rocks.
And close beside the brook the vigorous
pushing and reaching of the plants. Everything
reaches toward the glorious early windows of sunlight
above me. Here it turns red, and there
opal blue. And now it quivers shimmering
in the grass between the stones.
Ostara [Spring] traverses the shadows. A
vast tension mounts between
Fauna and Flora. Man feels
that plants and animals are his kin.
This endless force, this Dionysian birthright
and overflow, is shaped by man through his
mental view of the truth of nature
into an ideal image
and into a pure work of art
cells and biological heredity. The three spread plantlike
and teem without limit from ever-new sources from an
unconquerable biological
creative power is that what the Greeks in the 6th
[century] called
Dionysian. Man can do what he will through his
genius and his fanatical will the Dionysian into
the Apollonian Apollo with Dionysos
Nordic mythology.

21

This effusive poem to nature indicates that the twenty-year-old Beuys was indeed a long way from the reality of the war, despite the extremely heavy losses suffered by the Ju 87 dive bombers or "Stukas." It was their specialty to attack targets such as bridges, ships, or tanks in a steep power dive from a considerable height. The bombs were released at about 2,000 feet, just before the pilot pulled up from the dive. The technique of diving down to the target naturally placed the Stukas in great danger of being hit by enemy antiaircraft fire. This happened to Beuys several times, but in most cases the crew got back to base without major difficulties. Only once did Beuys have to make an emergency landing.

The event that was to have the most lasting effect on Joseph Beuys was his crash in the Crimea during the winter of 1943. After an attack on a Russian antiaircraft position, Beuys's

Stuka was hit as it pulled out of the dive. Beuys and his second crewman were just able to get the machine back behind German lines. Then the altimeter suddenly failed, a blizzard came down, and the plane went out of control and crashed. Beuys was hurled out of the cockpit on impact and pinned under the tail. He lost consciousness. The other man was killed.

It was a miracle that Beuys survived; and he owed his survival to a group of nomadic Tartars who discovered the wrecked Stuka and its badly injured pilot in deep snow. They took him into one of their tents, devotedly tended the mostly unconscious man for eight days, salved his massive injuries with animal fat, and wrapped him in felt to warm him and help him conserve body heat. They fed him milk, curds, and cheese.

Beuys had suffered a double fracture at the base of his skull; he had shrapnel all over, only a portion of which could later be removed. He had broken his ribs, legs, and arms. His hair was singed to the roots, his nose smashed. Without the care of the Tartars, Beuys would have died. All this touched him deeply. When his health was more or less restored, his rescuers asked him to stay with them. This idea, he remembered later, was not unattractive. That brief life with the Tartars evoked images that he never forgot, and they reappeared, metamorphosed, in many of his Actions. Felt and fat became his basic sculptural materials.

After a while Beuys was discovered by a German search party and taken to a military hospital. He made such a full recovery that he was reassigned to frontline duty. Did the authorities intend this as a punishment? Already insubordinate as a trainee in Posen, Beuys had remained less than totally obedient. Twice he was demoted for disobeying orders—from sergeant, his highest rank, to private. He would probably have been more severely punished had it not been for the exceptional bravery that won him the Iron Cross, Second Class and then First Class.

Once discharged from the hospital, he was sent from the Crimea to northern Holland. Later, in Oldenburg, northern Germany, he was a member of the last reserve, the Erdmann Ghost Division, a paratrooper unit recruited from all branches of the service. Beuys was wounded in combat four more times, the last shortly before the war ended in 1945, and his spleen had to be removed. To his collection of medals for bravery he added the Golden Badge for the Wounded, the equivalent of the Purple Heart.

By the time he reached a British prisoner-of-war camp in Cuxhaven, he was a physical wreck.

A year or so later Beuys was finally able to return home. His mind was already made up: he was going to study art. As far back as Posen, auditing science classes at the Reich University, it had been clear to him that he was not cut out for specialization. The idea of becoming, say, an expert on the amoeba, was utterly repugnant to him. And just as he had no desire to confine himself to a narrow scientific specialty, he clearly saw that it would be his task as an artist to expand the boundaries of art.

Beuys made his preparations systematically. During his training as a radio operator and as a pilot he had spent any spare time he could get combing second-hand bookstores for art books and scientific treatises. Hitler's reign, the war, the wounds: he left all that behind him, apparently without a second thought, with one exception. His encounter with the Tartars was to emerge as a key experience.

Nor did his postwar captivity particularly affect Beuys. He later recalled that he and his fellow prisoners suffered dreadfully from hunger. So he went around the camp looking for edible plants—something he knew a lot about—and conjured up for his companions the most varied vegetable dishes.

Beuys's World War II experiences, even his serious injuries, did not overtly inspire his art. Virtually no wartime works by him exist. All that remains is a pencil sketch here and there: a Russian nurse (1943), an airplane landing, the Sevastopol lighthouse (1946). The experiences of pain and closeness to death, of nomads, steppes, and Tartars, were to be transmuted in a different and extraordinary way. When the van der Grinten brothers asked him in 1961 about his wartime movements and his most vital impressions, Beuys gave the following answer, which was printed in the catalog of the exhibition held that year in Kleve:

Vital impressions:
The Slav lands
Poland
Czechoslovakia (Prague)
(Moravia) Russia
(Southern Russia)
Vital impressions: the Black Sea
the Sea of Azov
the Rotten Sea

The Russian Steppe (Kuban)—home of the Tartars
Tartars wanted to take me into their family
The Nogai steppes
The Crimea
Places: Perekop, Kerch, Feodosia
Simferopol, Bakchisarai
Yailo mountains
The Colchis of the Greeks!
(Golden Fleece)
Odessa, Sevastopol.
Romania (Danube Delta)—Hungary (steppes)
Croatia (Sava) / Vienna (Huns and Turks before Vienna!)
Southern Italy: Apulia.
Western theater of war: as paratrooper in northern
Holland—Oldenburg to North Sea coast.

By the time he wrote this, Joseph Beuys was
already well on the way to his expanded concept of art, and to all
the sensations and scandals of his life.

Studies

Early in 1947 Joseph Beuys entered the State Academy of Art in Düsseldorf. It would be wrong to say that he was a fully developed artist at the start, but he was far ahead of his fellow students and differed from them in both style and ideas. Beuys's shrewd, reticent friend, Erwin Heerich, who first met Beuys in 1946, can attest to this.

A year younger than Beuys and a native of Kassel, Heerich had served in the navy during the war. He studied under Ewald Mataré at the Düsseldorf Academy from 1945 to 1950 and shared a master studio with Beuys in the severely bomb-damaged Academy building. In the van der Grinten brothers' house at Kranenburg, in 1964, Heerich held his first exhibition of the cardboard sculptures that soon gained him a reputation as a leading exponent of the concrete-constructivist, rational, and systematic tendency in contemporary European art. At the same time he began a distinguished teaching career—first as a temporary assistant to Mataré, then, after 1961, as director of the spatial-sculptural training course in Düsseldorf, and from 1969 as a professor at the Düsseldorf Academy, from which he retired in 1987. Over the years Heerich observed Beuys closely at the Academy, first as a fellow student in Mataré's class, then as a fellow professor. During the difficult and turbulent period when Beuys was teaching at the Academy, Heerich was sympathetic to his extreme stand on education and—without ever succumbing to his spell—repeatedly defied faculty opinion by defending him, both in private and in public.

26

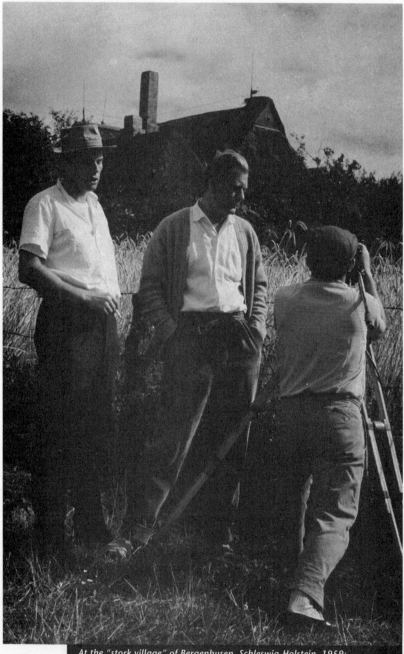

At the "stork village" of Bergenhusen, Schleswig-Holstein, 1959:
left to right, Joseph Beuys, Heinz Sielmann, cameraman Georg Schimanski.

But that was still far in the future. War and captivity had left their mark on Beuys, and his health had been permanently damaged, but he took it all in stride and set to work to develop and apply the ideas that mattered most to him. Tough and determined, Beuys followed through with the decision he had made, while still a soldier, to abandon his study of science for art. Immediately after his release from the POW camp, he contacted the Kleve sculptor and tutor Walter Brüx, whose studio he worked in to prepare himself for the Düsseldorf Academy. At the same time he made the acquaintance of the painter Hanns Lamers, also in Kleve, who was to remain a close, lifelong friend. Brüx, who modeled an impressive portrait of his student as early as 1946, and Lamers both recognized Beuys's exceptional artistic talent and encouraged his desire to be a sculptor. They invited him to join in the revival of the Kleve artists' society, Profile, with which Beuys was to exhibit fairly regularly for the next eight years.

In 1947, before he had begun his studies at the Academy, Beuys again met up with his former radio instructor, Heinz Sielmann, who was shooting his first feature-length documentary film, *Song of the Wild,* in the Ems wetlands. As Sielmann remembers: "All of a sudden, there stood Jupp." Beuys, in a stroke of luck, found that Sielmann and his assistant cameraman Georg Schimanski, could use his help. He toted the camera, built blinds, and expertly lured wild creatures by mimicking their cries. They stayed in the local mayor's house, smoked as excessively as they had in Posen—three to four packs a day each—and talked about everything under the sun. Sielmann had the feeling that he was seeing a changed Beuys. The crash in the Crimea must have had some mental effect on him; he never remembered his friend as being so hypersensitive. Through Sielmann, Beuys met the celebrated Austrian ethologist Konrad Lorenz. From 1951 to 1954 Lorenz worked in a moated castle at Buldern (Westphalia), as director of research in behavioral physiology for the Max Planck Institute of Marine Biology. Sielmann filmed there a number of times, and now and again Beuys visited him. After this, Sielmann and Beuys met only sporadically: Sielmann once paid a visit to Mataré's class, and he also recalls that in 1959 Beuys was in Bergenhusen (Schleswig-Holstein), where he was filming and where Beuys once again acted as his able assistant. Sielmann confirms that, despite assertions to the contrary, Beuys did not take

part in his great Congo expedition of 1957. Years later they met up in Düsseldorf on the occasion of the premiere of Sielmann's film *Galápagos*, and Beuys, now a famous artist, invited the popular filmmaker back for a duck dinner that he had cooked himself. Sielmann well remembered from Posen days that his one-time orderly was a talented cook. Beuys's high regard for Sielmann is evident in his several published references to him, both in his "Life Course/Work Course" and in the catalogs for the exhibitions organized by the van der Grinten brothers, in 1961 at Haus Koekkoek in Kleve and in 1963 at Kranenburg.

After his admission to the Düsseldorf Academy in 1947, Beuys was assigned to the class of the sculptor Joseph Enseling, who taught there from 1938 to 1952. Open-minded and curious, Beuys accepted this random placement, though he soon realized that Enseling—a student of Auguste Rodin's—was an academician through and through, an artist concerned with pure representation, with capturing nature and laying bare its phenomena. Not just for Beuys but for all those who had been through the war and experienced its terror, suffering, and death, all this belonged to a different world, the old world.

28

Beuys was all the more attracted to the class of Ewald Mataré, one of those Academy instructors who had been condemned by the Nazis as "degenerate." Maaré was a sharp, uncompromising artist who never let his students get away with anything. Beuys was impressed at their first meeting. On seeing his portfolio of drawings and a number of three-dimensional works from Enseling's class, Maaré growled that Beuys was no sculptor but certainly could be a painter. That was in 1949. One year later Maaré noted in his journal that his student Beuys would "one day be a very good sculptor. . . . He has a distinct sense of rhythm and admirable endurance—both indispensable prerequisites."

Born in Aachen in 1887, Maaré studied between 1907 and 1912 at the College of Visual Arts in Berlin, under Lovis Corinth and as a master student with Arthur Kampf. He produced his first wood sculptures and woodcuts in 1920, and these soon became the focal point of his work. He stayed in Berlin until 1932, when he was appointed to a teaching post at the Düsseldorf Academy, from which he was driven out one year later by the Nazi authorities. Maaré settled at Büderich, near Düsseldorf, and survived mostly on church commissions. His sculpture *The Hero Lies in*

State, a huge black basalt war memorial, was ceremonially installed in Kleve by the Nazis in 1934. Because it contradicted the Party's new official artistic doctrine of naturalism the work was removed four years later. But it survived: in 1977 it was unearthed, severely damaged, during a building excavation, and after careful restoration it was set up again on the Kleiner Markt in Kleve, in front of the city's Gothic church.

In October 1945 Mataré was reinstated as professor and appointed acting director at the Düsseldorf Academy. He planned a fundamental reform of art education. Intensive discussions with Georg Meistermann, who had been Mataré's student at the Academy in 1932–33 and who was to be professor of painting there from 1955 to 1960, reinforced Mataré in his decision to work out a new syllabus for a twelve-semester course. The basic idea was that students should start their training earlier, at the age of fourteen. There were to be forty hours of teaching every week. In the first four semesters the emphasis was to be on drawing; in the next four, the future sculptors, painters, and printmakers were to receive their practical training. In the final four semesters the focus was to be on independent work supervised by the master, with additional collective projects from time to time. Other mandatory subjects were to be German, philosophy, biology, and religion, as well as modeling, spatial theory, and comparative art appreciation.

Mataré's fundamental idea was to create classroom communities that would remain together for the whole of their studies. This also led him to demand new, fresh teachers such as the old Academy system could not provide. It soon became clear that he was not going to get his reform plans past the authorities. As a result, even before the official reopening of the Academy on January 31, 1946, he resigned as acting director and concentrated instead on his own sculpture class.

Mataré's teaching program, inspired by the medieval masons' lodges, held a special fascination for his students. Even though Beuys found the confines of any group uncongenial, and remained an outsider in Mataré's class, he submitted to the master's authority without reservation when it came to learning the sculptor's craft. Beuys was one of Mataré's keenest students. His sensitivity to materials, for which he was later to be so much praised, was already fully developed. He had no difficulty modeling a clay pot without a wheel or carving a spoon or a spade

directly out of wood. There can be no doubt that Mataré was well aware of his student's exceptional gifts and that this was the source of latent tension between them.

As far as drawing was concerned, both in form and in content, even from the first Beuys was on another planet. He did not compose at all, in the traditional sense; he de-composed. He developed his drawing out of a fragmentary complex of lines, infused it with new energies, new elements of myth and of ritual, and thus found fresh attributes in human beings and animals. These works did not result from his studies in Mataré's sculpture class, yet they were what mattered most. Already Beuys was giving artistic form to the intellectual and experimental concerns that had developed and grown since high school, to the problems and discoveries that arose from his intense preoccupation with science—botany, zoology, and geology—as well as with philosophy, anthroposophy, and history. It was while studying with Mataré that Beuys was really able to unleash the encyclopedic knowledge he had accumulated so far, which formed the basis for the expansion of his materials and for the deepening of his insight.

30

As an artist and a teacher, Mataré was sensitive enough to know that the impulse behind Beuys's drawing and sculpture was entirely different from his own. And yet there was common ground between the two men, above all in their endeavors to discover something of the essential nature of animals. Mataré expertly achieved this by reducing sculptural masses to their intrinsic forms; Beuys surely profited from this. But the two differed markedly even in the animals they favored. Mataré most preferred the cow, and then the calf, the cat, and the rooster; Beuys preferred the stag, the elk, the sheep, the hare, the swan, and the bee. The crucial point here is that Mataré, for all his modernity, maintained a sculptural convention that Beuys consistently violated: Beuys's animals, especially in reliefs and sculptures in the round, are set in new relationships that are often difficult or even impossible to visualize.

Nevertheless, Beuys's studies with Mataré were important. Mataré taught his students that art was certainly related to emotion, but that emotion must be kept under measured control. Mataré was a strict teacher who maintained discipline in his classroom and tolerated no tardiness or unexcused absences. He

entered into discussion only when it was germane to the matter at hand. Then he spoke with candor and often with asperity.

Under these circumstances it is not surprising that those who knew both Mataré and Beuys have spoken of a love-hate relationship between them. Mataré made more allowances for Beuys than for any of his other students, but then no other student gave him such a hard time. The two men were very alike in their ideas and in their actions; each was obsessed with his own mission as an artist. Beuys himself later became a contentious and authoritarian teacher at the Academy, and he too laid great emphasis on craftsmanship. As a professor, Beuys too advocated a different and freer Academy, though he left his predecessor's ideas of a traditional masons' lodge spectacularly far behind him.

Both Mataré and Beuys were to show a poignant reluctance to leave the Düsseldorf Academy. Mataré had to be more or less forced into retirement in 1957 at the age of seventy. The Düsseldorf state authorities could no longer put off his long-overdue retirement. Still, he maintained a room at the Academy until his death eight years later. As for Beuys, after his summary dismissal in 1972, he fought for reinstatement and finally succeeded when the federal labor court established that he could retain the title of professor and a room at the Academy.

Mataré was quick to recognize Beuys's exceptional skill in applied arts, and since he received an increasing number of public commissions in the postwar years, he was glad to have the aid of his students on certain projects. Those most involved were Heerich, who kept in close touch with Mataré after the end of his studies, and Beuys, who was enlisted to help with the last stages of work on Mataré's Pentecost Door at the south portal of Cologne Cathedral. That was in the summer of 1948. Mataré worked on the four doors—the Bishop's, Pope's, Pentecost, and Creation Doors—from 1947 to 1954. Beuys assembled the mosaic for the panel *Cologne Burning,* from which a bronze cast was made. On July 27, 1948, Mataré noted in his journal:

> I am now under great pressure to complete the two doors by August 15. Some of the mosaics are finished, and good, but it was hard to get the tesserae, they never arrived from Berlin (because of the political situation), and then it turned out that at

31

Meerbusch there was a pool in the grounds of a mansion, all bombed out and deserted, and there were mosaic tesserae by the score and in all colors, but set in concrete, so that they had to be laboriously chipped away. My student Beuys made splendid efforts, and was exceptionally skilled and serviceable in setting the mosaic areas.

On August 8, 1948, Mataré wrote: "My student Beuys, and G., have been a great help to me. Both have been setting mosaic for the first time in their lives, but very painstakingly, and I myself have learned a great deal about stone setting in general."

Beuys assisted Mataré on a number of subsequent occasions, including the memorial to Heinrich and Maria Nauen in 1951. The Rhineland Expressionist Heinrich Nauen had been a friend of Mataré's, and from 1921 until his dismissal by the Nazis in 1938 he had taught painting at the Düsseldorf Academy. Mataré's Nauen tombstone, a trapezoidal slab of Solnhofen limestone, shows a horseman with a bird perched on his lance; the horse's reins are held by an angel swooping down from a cloud. The relief was carved by Joseph Beuys. This stone-carving assignment was followed in 1952 by work on the west window of Aachen Cathedral, for which Mataré had designed cast-iron tracery. For the transition from his model to the actual window twenty-five feet high and seven feet wide, Mataré was able to rely completely on Beuys's skill.

During his time with Mataré, and later, Beuys had to struggle to make ends meet. Many who saw his work recognized him as an outstanding sculptor, but commissions were few and far between. He made a tall cross for the tomb of the owner of a Düsseldorf department store, but it was rejected by the family. The only works to be completed and installed were a formally precise monument in sandstone for Fritz Niehaus, in the Büderich cemetery (1951), and ten years later a van der Grinten monument with two cross-figures, a symbol that preoccupied Beuys at the time. Beuys also designed the oak entrance door of the Büderich war memorial, which bears the names of the fallen; inside the Romanesque church tower hangs a crucifix that he made in 1958. This ten-foot oak crucifix is suspended in front of the wall—an impressive monument, austere and powerfully evocative.

Rooted in the Catholicism of the Lower Rhine, Beuys was still fairly closely involved with Christian symbolism

32

between 1947 and 1960, even though it was apparent that he was working toward a metamorphosis. In the realm of applied religious art, he designed candelabra; baptismal fonts; a holy-water stoup with a relief of Saint Veronica's veil; a series of crosses representing redemption, sacrifice, and resurrection; a processional cross; a *Peg Cross;* a *Hand Cross;* a *Solar Cross;* and, again and again, the Pietà. In all these works, it is apparent that Beuys was striving to cast off the shackles of tradition and to raise his subject to a new level. As early as 1949 Beuys made *Christ in a Box:* the figure, made of putty, is stuck to the inside of a Glocke von Bremen cigar box. Then he made the *Peg Cross,* combined with a *Throwing Cross,* which is fitted with a real stopwatch in the upper left-hand corner. The first design for this dates from 1952. In 1961 Beuys equipped another *Throwing Cross* with a hare's skull and a kneecap. The drawings from this period make evident the growth of Beuys's artistic expressive resources in all his subject areas.

Beuys was the outstanding personality in Mataré's class, and his fellow students acknowledged as much. His only difficulties were with Mataré. Although from the very start Beuys resisted any stylistic limitations, he respected his teacher and always recognized the decisive influence that Mataré had exerted on him. But he could be cutting and sarcastic even about Mataré. Franz Joseph van der Grinten believes that Beuys had a deep understanding of Mataré's work—rather too deep for Mataré's liking—and that there was a certain conscious spitefulness in Mataré's relationship with his student as a result. For example, Mataré exerted his influence (without success) to prevent his former master student from getting the 1958 commission for the Büderich war memorial. And again in 1958, when Beuys had a chance of being appointed a professor at the Düsseldorf Academy, old Mataré stood in his way—this time successfully. Beuys was not appointed. Mataré convinced a majority in the Senate of the Academy that Beuys, though an extraordinarily talented artist, would fail as an Academy teacher because he would overwhelm his students rather than help them to find themselves. In view of later events at the Düsseldorf Academy and Beuys's central part in them, it is hard to deny that Mataré had a point. Nor is it surprising that the two had become profoundly estranged by the time Beuys concluded his studies in 1951, although they went on playing the occasional game of boccie in Mataré's garden at Büderich.

33

Beuys took advantage of the privilege granted to all master students of using a so-called master studio, which consisted of a room that he shared with Erwin Heerich in the attic of the highly dilapidated Academy building. Whenever Beuys was there, Heerich vividly remembers, there was always a hissing and bubbling in his corner of the room. He had set up a lab, just as he had done in his parents' house as a boy, and experimented with all kinds of chemicals, examined plants and animals, and made analyses using microscopes, magnifiers, forceps, needles, dishes, and tubes. In short, Beuys was assembling the equipment and materials with which he would deepen his knowledge of scientific and especially biological relationships, of microcosmic events, and of bodily functions. To Heerich, the whole thing smacked of alchemy, but he understood why this scientific groundwork was necessary to Beuys. Recognizing the hopelessness of a scientifically oriented world view, Beuys was starting out to discover art as the principle of life.

Was Joseph Beuys a second Leonardo? Such comparisons are worse than rash. Nevertheless, that great Renaissance universalist was at the center of Beuys's attention. Instead of painting a new Mona Lisa, Beuys set out to create his Social Sculpture. He would follow in Leonardo's footsteps by seeking a synthesis of art and science: no easy matter, nowadays, with disciplines drifting further and further apart and with specialists much in demand. From the moment Beuys moved into his master studio, he was filled with an unrest that had both positive and negative consequences. On the one hand, he was able to work and read a great deal; on the other, he was desperately short of cash and received virtually no public recognition.

Even the tiniest exhibition was an achievement. Beuys showed with the Profile group in Kleve about once a year. In 1951 he showed some work at the van der Grintens' house at Kranenburg and in 1952 at art museums in Wuppertal and Nijmegen. In the latter year, thanks to a recommendation from the Cologne sculptor Gerhard Marcks, who was already widely known, he won a prize for a Pietà at the *Steel and Iron* exhibition organized by the Düsseldorf ironworks association. Also in 1952 Beuys designed an unconventional fountain for the steel company Edelstahlwerke Krefeld, which was first shown at the Stedelijk Museum in Amsterdam and then set up in the courtyard of the Kaiser Wilhelm Museum in Krefeld.

True to his character, Beuys found time to expand his mental horizons, following the example of his idol Leonardo, in spite of the restlessness that churned in him, the financial worries that tormented him, and the artistic ambition that drove him. Later, when Beuys traveled the world, talking, preaching, proclaiming, recruiting, teaching, it was a constant source of surprise and fascination to see how comprehensively well informed a man he was, how profound and original his thinking, how astute his analyses. He could talk on any subject, and anyone who ever watched him speak realized that his speech was an artistic activity in itself. Language for him was a kind of sculpture. Like Anacharsis Cloots, the revolutionary from Kleve he so admired, Beuys was an Orator of the Human Race.

His formal studies over, Beuys turned once more to Goethe, whose universal mind—like Leonardo's—had deeply impressed him. Goethe was another who, as a scientist and a researcher, was able to see through things, to get to their roots, and to give a new kind of artistic form to his discoveries. It is no coincidence that Leonardo and Goethe were central figures in Beuys's world. It is logical, too—in those years of unrest, during which a humanistic theory of sculpture was taking shape in Beuys's mind—that his involvement with the anthroposophy of Rudolf Steiner attained critical significance.

Steiner was born in 1861 at Kraljević on Mur Island (then part of Austria, now Yugoslavia). There his father was working as a telegraphist for the Austrian Southern Railroad. At the Vienna Institute of Technology, Steiner studied mathematics, biology, physics, and chemistry. As minor subjects he chose German literature, philosophy, and history. In addition, as a student Steiner found time for a comprehensive study of Goethe—with the result that at twenty-one he was entrusted with editing Goethe's scientific writings for the series Kürschner's National Literature. In 1890 Steiner moved to Weimar, where he joined the staff of the Goethe and Schiller Archives, earned a doctorate of philosophy from the University of Rostock, and published *The Philosophy of Freedom* (1894) and *Goethe's World View* (1897). Also in 1897 he went to Berlin, where he and Otto Erich Hartleben edited two magazines, *Magazin für Literatur* and *Dramatische Blätter*. Between 1899 and 1904 he taught in Berlin at a workers' education institute. He lectured on Nietzsche; he delivered a speech to seven thousand com-

35

positors and printers in a Berlin circus on the occasion of Johannes Gutenberg's quincentennial and another to mark the inauguration of the Foundation for Working-Class Women and Girls. In 1902 he joined the Theosophical Society, whose expansion he promoted as secretary of its German branch.

From 1905 onward, Steiner intensified his already vigorous activity as a lecturer. In Germany and numerous centers elsewhere, he delivered major series of lectures on the gospels, on theosophy and the Apocalypse, on the Second Coming of Christ, and on occult physiology. In 1912 he founded the Anthroposophical Society and in 1913 laid the foundation of the Goetheanum at Dornach in Switzerland. In 1918 he formulated the central idea of his anthroposophical view of society, the "Threefold Commonwealth," which was to become the basis of Beuys's expanded concept of art.

Shortly before his death, in his Duisburg tribute to Lehmbruck, Beuys told of the accident that had placed in his hands Steiner's 1919 *Appeal to the German People and the Civilized World*— an appeal that was signed not only by Lehmbruck but also by a number of well-known professors, theologians, industrialists, museum directors, politicians, and the writers Hermann Hesse and Wilhelm von Scholz. Steiner was a pacifist, not a chauvinist. And naturally he was a figure of controversy. He believed in the "mission of individual national souls"; in other words, he believed that each nation had its own specific mission. His *Appeal to the German People* was concerned with the release of the spiritual forces that World War I had submerged.

When Beuys came across this little volume years later, he read in it the following words:

> Half a century after setting up its imperial edifice, the German nation was confident that it would endure forever. In August 1914 it believed that the catastrophic war, then beginning, would prove that edifice to be indestructible. Today that edifice lies in ruins. After such an experience it is time to take thought. For this experience has revealed that the thinking of half a century, and in particular the ideas dominant in the war years, were a tragic error.
>
> What are the causes of this fatal error? This question must cause reflection in the souls of those

who make up the German nation. Whether the strength for such reflection can be mustered today is the issue upon which the survival of the German nation hangs. Its future hangs on its ability to ask itself, in all seriousness, one question: how did I go wrong? If the nation faces this question today, then the awareness will dawn that half a century ago it founded an empire but neglected to set that empire a task arising from the essence of German national identity .

Steiner added to this theory his call for a Threefold Commonwealth, the establishment of three separate systems within the state: cultural, political, and economic. This was his way to avert chaos: "Either people will make up their minds to adapt their thinking to the demands of reality, or else they will have learnt nothing from misfortune and will make it infinitely worse by piling new misfortunes upon it."

As World War I drew to a close, the social question was central to Steiner's teaching. He foresaw Germany's defeat and felt it was his task to prepare for the troubles of the postwar period, which were certain to shake society to its foundations, by devising a rational program. This led, in 1918, to the foundation of a Threefold Commonwealth movement in Germany. Beuys was later to take up this idea.

Steiner's first priority was to break the all-encompassing power of the state. Society could become healthy only if state, economy, and culture were separated. The traditional state—and this was the nucleus of Steiner's doctrine—had overstepped its boundaries; the new state was to be limited to the task of protecting its citizens from internal and external dangers. This was the function of the law, the police, and the army. No more, no less. The principle was equality before the state for all people. Furthermore, the state could not operate as a business enterprise, because economic activity was too complex and its boundaries too undefined. All those powers engaged in the economic process—manufacturers, distributors, and consumers—should work together in councils for the speedy and peaceable solution of problems, to oppose social injustice, and to uphold the principle of fraternity. Finally, there was to be no more state authority in matters of the mind and spirit. Art, science, religion, and education must be rooted in the principle of liberty.

Equality before the state and before the law, fraternity in commerce, and liberty of the spirit: Steiner was consciously reviving the ideals of the French Revolution. Beuys must have been reminded once more of the legendary Anacharsis Cloots, who had laid down his life in the fight for liberty, equality, and fraternity. At the same time, in terms of cultural history, Beuys was looking forward: he would incorporate the Threefold Commonwealth in his own sculptural theory.

Politicians, entrepreneurs, and labor unionists were united in their opposition to Steiner's concepts. After setting up the first of the Waldorf Schools in Stuttgart in 1919 (at first the company school for the children of employees at the Waldorf cigarette factory), Steiner gave lectures on light, heat, astronomy, mathematics, medicine; ran seminars for theologians and educators; conducted courses on acoustic and therapeutic eurythmy; spoke on economics, law, and agriculture; wrote books and essays; founded the Christian Community in 1922, the General Anthroposophical Society in 1923, and in 1924 the Free University for Mental Science, whose program certainly lay behind the foundation by Beuys and Heinrich Böll of the Free International University for Creativity and Interdisciplinary Research in Düsseldorf in February 1974.

Leonardo, Goethe, Steiner—as disparate as they were in spiritual and artistic approach, and in their significance and influence, all three played key roles in Beuys's understanding of art and life, of time and existence, of heaven and hell, of earth and cosmos. Artistically, he came a long way during those restless 1950s, especially with his often poignant, frail-looking drawings and with a number of sculptures that, like everything Beuys ever made, are infused with intense personal experience and consequently difficult or even impossible to interpret. Still, his main preoccupation was with the quest for his own identity.

Many were involved in this process of clarification, which came to a head in the period following Beuys's studies with Mataré. Fritz Rolf Rothenburg, who died in the Sachsenhausen concentration camp in 1943, had first recommended Steiner and anthroposophy to Beuys in 1941. Initially, however, Steiner's teachings on his world view left Beuys fairly nonplussed. It was not until he was studying at the Academy that he discovered for himself the profundity and breadth of Steiner's thought. Steiner's insight that

in each of us lie dormant faculties through which we can acquire knowledge of higher worlds confirmed Beuys's own conviction that everyone is an artist. In 1947 Beuys became friendly with the Krefeld writer Adam Rainer Lynen, who was to become known for his novel, *Centaur Journeys,* a "vagabond's logbook," published in 1963. Beuys and Lynen spent a great deal of time arguing—about Steiner's anthroposophy, among other things. Lynen's rejection of Steiner's ideas drove Beuys time and again to grapple with Steiner's complex intellectual world.

In Düsseldorf, Beuys kept in occasional contact with anthroposophical circles (though he never became a doctrinaire Steinerian, he did finally become a member of the Anthroposophical Society in 1973). What fascinated him about Steiner's theosophy was the concept of redemption, in which the mineral, plant, and animal kingdoms are seen as three stages in nature that lead upward first to man; then to the "fourfold structure" of physical body, etheric body, astral body, and "I"; and finally to an absolute human cognitive faculty. All this Beuys eagerly absorbed and later integrated into his own teaching. Just as Steiner linked scientific knowledge with art, culture, and the humanities, so Beuys, in his mature period, was to adopt this as one of his essential tasks, which he—like Steiner—tried to impart through countless lectures and Actions.

That Beuys had an unconscious affinity with Rudolf Steiner's world from a very early date is evident from a watercolor he painted in 1948 and titled *Tourmaline Tongs.* This is the name for a simple polariscope consisting of two plates of tourmaline mounted on a tongs-shaped support. The watercolor was done on a yellowish notebook page on which, some time between 1942 and 1944, when he was on the Eastern Front, Beuys had written the following:

Work of love
On earth people, animals, plants
mountains, rivers, winds, lights
that start up as we do
signs suffice, Down upon us Christendom
Start up through the
Christ-power in me
Look up as a new being
stretching with ampler breath
to find oneself requires
infinitely total conversion

**and love-blood
and to flow out of oneself + redemption
weaving
inductive pharmacy
metamorphoses
thoughts.**

This sounds confused, and it *is* confusing, just like Beuys's "Nordic Spring" text written in 1941. Once more, Beuys seems unconcerned with the war, with death, with his own wounds, and deeply concerned with nature and Christian myth, all at a time when everything was falling apart, when monstrous, hideous events were occurring, and the world was on the brink of complete change.

During the 1950s, after studying under Mataré, after a succession of heated arguments with his friends Heerich and Lynen, and while absorbing the philosophy of Steiner, Beuys seems to have had an insatiable appetite for philosophy, science, and literature. Expanding his knowledge of many of the themes that he had taken up as a student at the Academy, he now read Karl Marx, Aristotle, and James Joyce, who particularly captivated him.

Beuys paid his own tribute to Joyce in 1950 by giving a reading from Joyce's *Finnegans Wake* at Haus Wylerberg, overlooking the Wylermeer, on the Dutch-German border between Kranenburg and Nijmegen. Built in the 1920s by the German architect Otto Bartning for the art collector and singer Alice Schuster, this lakeside villa had subsequently been sold to the Dutch government and turned into a cultural center.

Beuys was given to discourse on the "stretching process in Joyce," which took on a formal significance for him. He perceived a linguistic mobility in *Dubliners* and above all in *Ulysses*. In order to come to terms with the idiosyncrasies of *Ulysses*, with its references to classical antiquity and to Irish myth, and with the many layers of its complex action, in 1961 Beuys added two chapters to the work, on an imaginary assignment from Joyce himself (as reported in "Life Course/Work Course"). Setting out to give a "sculptural" notion of the Joycean dynamic, he used drawing as his medium and drew his way through the structure of the text, taking it several drawings—or two chapters—past the end.

It is curious but characteristic of Beuys that he not only knew a lot about great literature and great minds but also maintained close, pleasurable, and intimate ties with marginal cultural issues, with creative outsiders, and with shadowy doctrines

and movements. One example is Joséphin (or Joseph) Péladan, also known as Sâr Péladan, who was born in Lyon, France, in 1858 and educated at a Jesuit school. In 1884 Péladan began his twenty-one-volume series of novels published under the general title of *Décadence latine,* which concerned the future of the Latin race. He also wrote numerous tracts on the theory of art and of religion, and translated into French the complete dramatic works of Richard Wagner. In 1888 Péladan founded the Order of the Rose + Croix and appointed himself its Grand Master, or Sâr. Beuys knew Péladan's books, and in the mid-1950s he was fascinated by the Rosicrucians. The spiritual father of Rosicrucianism is said to have been the seventeenth-century Lutheran theologian and writer Johann Valentin Andreä. With his call for a Christianity of practical charity, and for a social order based on Christian values, Andreä had a great influence on John Comenius and on the Pietistic movement in Central Europe. His name became inextricably associated with that of the legendary Christian Rosenkreutz, believed to have lived from 1378 to 1484. Nothing is known for certain about Rosenkreutz; his pamphlets were said to have circulated at an early date, but some alleged that he was a figment of Andreä's imagination. A number of anonymous texts on Rosenkreutz were said to have originated in Andreä's circle in Tübingen, or even to have been written by Andreä himself.

41

Whatever the truth of all this, something mysterious was going on. Secret Rosicrucian societies were formed, and their theological and philosophical bent soon led them to adopt cabalistic and alchemical traditions. The Order of the Golden and Rosy Cross, which was strongly marked by the ideals of German Freemasonry, became highly influential.

Beuys's fascination with the Rosicrucians was shared by the twentieth-century French artist Yves Klein. With his concept of "le monochrome," culminating in his pervasive use of International Klein Blue; with his philosophy of the void and the immaterial; and with his imprints of the naked bodies of female models, who "bathed" in blue paint in public Actions and were then "conducted" with a wave from Klein to imprint themselves on the canvas, Klein exerted a strong influence on certain artistic developments after 1945, especially on Op, kinetic, and Conceptual art, as well as on the Happening. In 1948, in his native city of Nice, Klein came across a book on the Rosicrucian Order. He was twenty

years old. The mystery and the metaphysical appeal of the Rosicrucian ideology struck a responsive chord, and Klein became a corresponding member of the Ancient Mystic Order of the Rosy Cross, based in San Jose, California. He wrote in his journal in 1948: "The discipline that the Rosicrucians recommend to us is very beautiful, but it is not to be borne for long if one is inexperienced. . . . Smoking, drinking, sexual intercourse, enjoyment, movies, bars—it's easy to do without them, but then comes the backlash."

Even though the thought and work of Beuys and Klein were worlds apart, it is intriguing to see that there are certain points in common. Along with the fascination with Rosicrucianism, they shared a serious interest in the music and philosophy of Wagner—in particular his concept of the *Gesamtkunstwerk,* or total work of art—and in the idea that art equals life. "The painter must paint a single masterpiece: himself, unceasingly; and thus he must become a kind of atomic reactor, a kind of generator with a constant output of energy, filling the atmosphere with his whole artistic presence, which remains in the room though he leaves it. This is painting, the true painting of the twentieth century. . . ." Klein entered this in his journal in 1957. It is understandable that Beuys, the "Generator," had, as Hans van der Grinten says, "an affectionate enthusiasm for Yves." Beuys dedicated a large drawing to him called *Demonstration Hour of Death Yves Klein 1962,* which is now in the collection of the van der Grinten brothers. In Paris in 1962, at the age of thirty-four, Yves Klein died of a coronary—as Joseph Beuys was to do twenty-four years later.

42

The van der Grinten Family

Joseph Beuys and the brothers van der Grinten: an intense and fertile episode in the postwar history of German art. On one side, the inspired, ascetic, fervent artist from Kleve; on the other, a Kranenburg farmer's thoughtful, taciturn, scholarly sons, whose youthful response to Beuys's charisma led them to collect and exhibit his early works: this is the stuff of a novel. But then, truth is often stranger than fiction.

The protagonists first met in 1946, at the home of Beuys's revered former English teacher, Dr. Schönzeler, who had always held a protective hand over his unruly student. The brothers van der Grinten had added to their mainly graphic collection some prints by the painter Hermann Täuber, who had won in 1950 the prestigious Karl Ernst Osthaus Prize awarded by the city of Hagen. Early in 1951 they took Täuber's advice and added works by Beuys as well to their small collection of modern art. The first works by Beuys that Hans and Franz Joseph van der Grinten bought were a drawing, *Lotus Ornament,* and a woodcut, *Animal Encounter,* for five dollars apiece. Beuys was overjoyed, for his finances were in an appalling state. According to Franz Joseph van der Grinten, he lived in an indescribable state of penury that was remedied, slowly, only after he got his teaching job at the Düsseldorf Academy. The brothers made a considerable contribution to the alleviation of his distress, but their own means were extremely modest. The twenty-two-year-old Hans van der Grinten and his brother Franz

Joseph, four years younger, each received from their parents a weekly allowance of $1.15: $9.20 a month in all. They both regularly gave Beuys a portion of this.

As early as 1950 a few drawings and objects inspired by Beuys's encounter with Leonardo were displayed at the van der Grintens' farmhouse under the title of *Giocondologie*, after Leonardo's celebrated portrait of the Mona Lisa *(La Gioconda)*. But Beuys's first real exhibition, including drawings, sculptures, and his complete woodcuts, took place there in February 1953. This exhibition reflected the van der Grinten brothers' collecting habits, which—and this is the unique thing about their collection, even down to recent years—owed a great deal to the personal influence of the artist. It was Beuys who suggested to the brothers that they collect whole groups of works, and so they did at the start. Since the installment payment system operated to the satisfaction of both sides, the Beuys collection in the farmhouse at Kranenburg grew, portfolio by portfolio and object by object.

The van der Grinten brothers now own several thousand Beuys pieces, including more than seven hundred watercolors and drawings, a few hundred paintings, several hundred objects and sculptural images, and large holdings of sculpture and early prints. The collection represents thirty-five years of joint decisions and acquisitions, as does the cataloging of the material and the exhibitions. Since that 1953 show, Hans and Franz Joseph van der Grinten have organized for some of Europe's leading museums and art institutes forty exhibitions from their Beuys collection, some of them major, and have written numerous catalogs, all in close collaboration with Beuys.

Over the years—after they gave up the farm—the van der Grinten brothers found themselves increasingly able to indulge their passion for collecting. Hans had studied agriculture in preparation for carrying on the thirty-seven-acre farm, with its fifteen cows, twenty pigs, and a number of young animals. But instead, he ably built up the Kranenburg municipal art collection and became deputy director and curator of modern art at the Museum Commanderie van St. Jan in Nijmegen, a stone's throw away across the Dutch border. Franz Joseph first studied law, followed by art history and philosophy, and then taught art for several years at the Grillo-Gymnasium in Gelsenkirchen. He moved on to a boarding school, the Gaesdonck Collegium Augustinum at Goch

on the Lower Rhine, to teach art and look after a considerable collection of art and historical artifacts.

Art collectors can be eccentric people. They can range from inconspicuous individuals who give not the slightest hint of the extraordinary collections they own to pompous characters who demand that a temple be built to house their treasures. The van der Grinten brothers are of quite another breed. They remain what they always were: farmers' sons of the Lower Rhineland, close to their roots. No glitter, no spectacles, no scandals, no demands on the state or on society. Their one proposal to the state of North Rhine–Westphalia has been to create a foundation for their collection and open it to the public. For this purpose they have chosen Schloss Moyland, between Kalkar and Kleve, which was almost totally destroyed by British artillery at the end of World War II and was on the verge of collapsing into ruins. Originally a castle, Moyland was built in 1332 for the counts of Kleve. From 1695 onward it was the property of the Electors of Brandenburg (after 1701, the Kings of Prussia), who used it as a residence on visits to Kleve. It was in Schloss Moyland—by then a moated Baroque palace—that Voltaire and Frederick the Great first met, in 1740. In 1854 the building was remodeled in the Tudor style. It is now being restored and will house the van der Grinten collection.

In addition to the huge group of works by Beuys, the collection includes small sculptures of the Neoclassic period (by Bertel Thorwaldsen and Gottfried Schadow); prints by John Flaxman and other nineteenth-century artists, among them Francisco Goya and James McNeill Whistler; a large portfolio of Expressionist prints, notably by the Die Brücke artists (Ernest Ludwig Kirchner, Erich Heckel, Karl Schmidt-Rottluff, and Otto Mueller); and series of prints by Pablo Picasso, Georges Rouault, Marc Chagall, and Marino Marini—about twenty thousand prints in all. There is also an Art Nouveau collection; a collection of medals; another of illustrated books; and several thousand historical, documentary, and artistic photographs, including a unique series of shots of the Boer War and of the legendary Transvaal President Oom Paulus Kruger. The inclusion of photographs in the brothers' collection was inspired by Beuys, who first directed their attention to the artistic significance of photography. The brothers estimate that their collection contains more than thirty thousand items, including a considerable number of individual works and

groups of works by such outstanding modern artists as Franz Gutmann, Erwin Heerich, André Thomkins, Gottfried Wiegand, and Erich John.

However, it is Joseph Beuys who remains the focal point of the van der Grinten brothers' efforts in both art theory and collecting. They grew with him spiritually, and their admiration for him runs deep. But they were not his acolytes. Nor have they ever presumed to be the sole custodians of the truth about him—an arrogance that their origins and clear-headed thinking have preserved them from. Their interpretations of Beuys, always in perfect harmony, are of a remarkable level not easy to achieve, with Franz Joseph as perhaps the more philosophical, mythologically inspired thinker and Hans cooler, more inclined toward structural ideas.

Early on, both recognized the ambiguity, the individuality, the conflicts, and the existential depth in Beuys's work and character, and found manifold entryways to his strange, disconcerting, alienating art. Their earliest commentaries on the artist (published in a slim catalog, financed by the Kleve district council, for the 1961 exhibition *Joseph Beuys: Drawings, Watercolors, Oil Paintings, Sculptural Images from the van der Grinten Collection,* held in the Städtisches Museum, Haus Koekkoek, Kleve), give the impression that they already fundamentally understood "their" artist. In his essay Hans van der Grinten praises Beuys as a draftsman for his "deep involvement with the essence of today's language of line, its energy, tension, expressive powers." And he stresses the significance, for Beuys, of "the combination of a totally controlled and sparing, at times even parsimonious, use of the resources of drawing with a vast and varied repertoire of ideas." In the same catalog Franz Joseph van der Grinten assesses Beuys the sculptor. He concludes that Beuys uses "sculptural means" to achieve "effects that are not sculptural but pictorial," that the defining quality of Beuys's sculptural work is purity, that his art is "maskless, art as art, implacable." Beuys's true theme is his material; his goal is "to develop the material in all its uniqueness."

Few collectors are capable of discussing art and artists with such passion, and with such a grasp of theory. Beuys consciously inspired "his collectors," the van der Grintens, to do so. He regarded the steadily growing collection of his art in the farmhouse at Kranenburg as a resource that he wanted to participate in creating. Every time the brothers acquired a new batch of works

from him, Beuys added something from his own collection. He was an obsessive collector, but he collected things in order to pass them on. For instance, he owned works by Enseling and by Mataré, African sculptures, Native American masks, and Art Nouveau pieces, as well as letters, theoretical pamphlets that interested him, photographs, and other works—paintings, sculptures, and objects—acquired by exchange from a number of artists, among them Martial Raysse, Arman, and Horst-Egon Kalinowski.

Two years after the Haus Koekkoek exhibition, Hans and Franz Joseph van der Grinten organized Beuys's famous stable exhibition at their family farmhouse. The opening, on October 26, 1963, was spectacular. By that point Beuys had already made a name for himself as a professor at the Düsseldorf Academy, and—more important, from his point of view—had received the blessing of the international Fluxus movement, which, as a successor to Dada, had abolished the traditional boundaries between art forms. The name Fluxus meant that everything flowed into a single stream: visual art, music, theater, words, sound, gesture—it was all one big show, and spectators were welcome. The performers, with Beuys at the fore, promised exciting entertainment, with wrecked pianos, fat, flickering televisions, headstands, dead animals, primal sounds, pandemonium, and all varieties of tomfoolery.

By the time the van der Grinten brothers launched their Joseph Beuys show with Fluxus objects from their own collection, he had already demonstrated his *Earth Piano* and exhibited warm fat; he had already embarked on a great but arduous and anguished future as an artist and prophet. But before he could begin, a grave psychic sickness remained to be overcome. Without the help of the van der Grinten family, he could never have done so.

Early in 1954 Beuys left his master studio at the Academy and rented a studio in the Heerdt district of Düsseldorf. Due to his multiple war wounds he was anything but physically fit. To this were added material privations. Gaunt and drained, he had very little resistance left and was bitterly disappointed by the persistent failure of his attempts to succeed as an artist. Then, at Christmas in 1954, his fiancée, a postal worker from Düsseldorf who was much younger than himself, sent her engagement ring back to him. Beuys was thrown into a state of shock and a severe depression.

Terrible times followed. He drifted around and sought treatment at psychiatric clinics in Düsseldorf and Essen, without success. Once, in Heerdt, he locked himself for weeks in the apartment of his writer friend, Adam Rainer Lynen, who was away on a trip. Friends eventually broke in through the window to find Beuys in a totally dark room, his legs swollen with edema. The floor was littered with torn drawings. He kept saying that he wanted to disappear and needed nothing more more than a backpack. During this phase Beuys had a carpenter from Kleve make him a wooden crate, which he insisted on having smoothly planed and finished. Then he smeared tar all over this beautifully finished crate, inside and out, and took it to his studio in Heerdt. His idea, as he later recalled, was that the crate was a black, empty, isolated space, in which investigations could take place and new experiences could occur. He felt compelled to sit inside it, to not be anymore, to simply stop living. As Beuys also later recalled, he harbored a desire at that time to immure himself in Tibet.

Utterly worn out, Beuys felt estranged from humanity; he lost even more weight, lapsed into mental inertia, and without energy, became a wreck in every sense. This went on for two years or so. Then something happened that triggered a turn of events. Beuys's extraordinary recovery from psychic, mental, and physical affliction is a wonderful story. No one can tell it better than the person who ultimately saved him, the mother of the van der Grinten brothers. This story has hitherto existed only in a mimeographed transcript, in Dutch, of her interview with Piet van Dalen, director of the Zeeuws-Museum in Middelburg, Zeeland, on the occasion of the 1971 Sonsbeek Sculpture Biennial, which was devoted to the theme "Beyond Limits." Here, for the first time in English, is the full text:

> Beuys had a lot of influential friends, who all very much wanted to help him, and so a lot of things were tried. He had spent a lot of time staying with all these various friends, and they had completely different attitudes to life. Toward the end he was staying with a doctor.
>
> Hans went to visit him there, and Beuys still wasn't any better. So Hans came home and said: "I've been thinking, he always liked to come here, and

so many people are comfortable with you. Why don't we invite Beuys to stay with us?"

And I said, "I've got nothing against it. But ever since Papa died I'm still so sad that I don't feel capable of helping anybody else. It's enough just to help myself."

But Hans would hear nothing of it. He said, "You can try." And out of love for my sons I said, "Yes, I'll do it." So Beuys came, but he wouldn't come in and he turned back. And Hans said: "It's no use if *I* say it. If you don't tell him yourself, he'll just go away again."

So I went running after him and caught up with him at Kranenburg, and I said: "Mr. Beuys, surely you're not going off to Kleve without saying hello, that is, without saying hello to *me*."

"No," he said.

I said, "Then come with me." And he turned around and came back and stayed for six straight weeks.

I was still in mourning, dressed in black. Beuys took Franz Joseph's little room. Franz Joseph was in Bonn, and Hans was here taking care of the farm, which had gone to rack and ruin. The next morning, after we had eaten breakfast, Beuys finally got out of bed, and then I said he might as well go out in the fields with Hans. And he did, though not every single day, and not regularly. He relapsed into a state of shock, and he hadn't the heart for it. And then he didn't get up but stayed in bed until he felt a little better; then he went out with Hans again.

He could do any work, no matter what. Such skill I had never seen. And the mealtime conversations—that was a great thrill for me. We talked about the war, about art, about politics, about foreign countries, about flowers—he had mastered so many subjects.

But in the end he didn't enjoy work anymore, he lay in bed all day, smoking, and refused to eat. And then Franz Joseph came home for the week-

end, as usual, and he said to me: "You look terrible. If you go on this way, you'll get sick instead of Beuys getting well."

And then I told him how things were, that I wasn't getting anywhere with him, that he was angry with himself, and Franz Joseph said, "Okay, then he'd better go, we've done enough for him."

So I told Beuys. And the next morning, when he had packed his bags and was ready to leave, he came to me and thanked me and said, "Mrs. van der Grinten, I like being in your house, and I'm sorry to leave."

And I said, "I know, but the way things have been these past few days, I just can't go on. The way you rage against yourself and the good Lord and all common sense—I can't bear to see it."

The Lord, he said, was not with him.

"Oh, yes, he is," I said, "he certainly is with you. He put talent and art in you. And when you promise your mother, 'I'm coming home,' and you just stay here and don't let her hear anything else from you, do you think your mother isn't hurt? That sort of thing I can't accept, and I can't get over it. You don't imagine my life has been all sunshine. Beside my work, I've had plenty of worries and troubles. And in the same hour that my husband died in an accident, I had to milk the cows and feed the hogs—duty never stops, it must be done, and that's how you've got to think too. A person has to have some duty. And once you've found your duty, all the rest will follow."

He listened quietly. I didn't say it harshly or severely; I liked him, and I really wanted to help him. And I'm sure he knew that. He asked if he could come back some day. And I said, "You can come as often as you want."

Then he left, and two days later he was back for a short visit. So the friendship continued, and he got well again.

In a subsequent taped interview with van Dalen, the van der Grinten brothers also gave an account of this period.

To them, the most important thing that happened in their time together was the blossoming of Beuys's creative power—aside from the work in the fields, which he did with pleasure and great skill. He produced drawings, watercolors, and a large number of sketches for sculpture, in many cases with unprecedented results. Conversations centered mainly on artistic productivity and on his new ideas. And so it was that Beuys was finally delivered from the idée fixe that he had lost the ability to work as an artist. He realized that the connection with his works from 1946 to 1954 had not at all been destroyed by his crisis; continuity was maintained in his new drawings and watercolors.

Beuys made a remarkably quick recovery. In his work, old subjects and ideas combined with new insights. One subject was directly inspired by the brothers: that of the elk, either alone or with a woman riding on its back. As Franz Joseph van der Grinten recalled:

> There were reversions to earlier subjects, such as pictures about the intelligence of swans, or the life of bees, or the mother-child problem. What frequently emerged during the crisis and later diminished somewhat was the notion of death: sepulchral images. The dominant form here was that of the crouched burial, in which the person sits in the grave like an Egyptian cubic stool. He drew this image frequently during the crisis. And there were a number of things in that crisis that he otherwise would never have done, almost reflections of his own work, such as depictions of the sculptor—strangely enough, a sculptor at work—things like that.
>
> Otherwise his later works are consistent with his earlier ones, even in his biggest public work, the only one that succeeded in spite of public outcry: the Büderich war memorial, where the the crucifix, an early subject of his, is treated on a grand scale for the last time.

51

The van der Grintens, and especially the mother of the family, with their simple, direct words, achieved (as we learn from Piet van Dalen's preface to his interviews) what no one before could: they restored Beuys's shattered faith in himself. Illness had

gripped him for two years, but within four months, from the end of April to the beginning of August 1957, he made a complete recovery. After an interlude at his parents' home, Beuys took a studio in the Kurhaus, the old health resort near the Tiergarten in Kleve, where he remained until he was appointed to the Düsseldorf Art Academy in 1961.

The drama of Beuys's depression is documented in numerous drawings and watercolors, with titles that accurately recount its development. Noticeable in his works from 1948 onward is a tall, slender girl appearing in many different poses and contexts. Between 1948 and 1954 Beuys made *Girl at the Ball, Girl with Paper Lantern, Love Dream, Pregnant Girl, Dancing Girl, Green Girl, Girl with Raised Arm,* and *Dancer.* In 1955 this subject disappeared from his work, and bees, elks, fish, and swans reappeared: the fauna characteristic of Beuys in the 1940s.

Works from the darkest days of Beuys's depression, from 1956 to 1957, include *Farewell, Woman's Grave, Woman with Head Bandage,* and a wonderful, infinitely sad drawing, *Miserere.* There is a very strange and forbidding series of drawings that show barred, dark rooms. Other titles include *Bleeding Stag, Man on Cross, Shock, Elk and Reindeer with Women, Elk and Fauness, Hares in the Snow, Soaring Female Figure with Rose, White Girl,* and finally *Death and the Maiden.*

In later life Beuys repeatedly harked back to his phase of mental illness, regarding his depression as a kind of purification. By the end of it he had become a different person. In the early 1970s, in conversation with Götz Adriani, Winfried Konnertz, and Karin Thomas, he told them:

> Wartime events no doubt played a part in that crisis, but present events did too, because basically something had to die out. I think it was one of the most essential phases for me; I totally reorganized myself, even constitutionally. I had spent too long just dragging my body around. Initially it was a general state of exhaustion that quickly transformed into a true process of renewal. Things inside me had to change completely, there had to be a metamorphosis, physically as well. Illnesses are nearly always also mental crises in one's life, in which old experiences and thought processes are rejected or recast as entirely positive changes. . . .
>
> Sure, many people never go through this process of reorganization, but when you get through it a lot of things that were previously unclear or only vaguely

outlined take on a completely viable new direction. This sort of crisis is a sign of either a lack of direction or of too many directions being taken at once. It is an unmistakable call to rectify things and to come to new solutions in specific directions. From then on, I began to work systematically, according to definite principles.

In a different context Beuys once said of his period of depression that in his youth, indeed until the outbreak of his crisis, he had long been dominated by the will and that it would have ruined him if he had stayed that way. He said that others had played a part in his recovery and mentioned by name the van der Grinten mother and sons, who with their practical, solid psychology had contributed to the recovery of his mind and soul. But, he added, "There is much that helps us—not just people."

53

Animals

Animals have played a major role in Joseph Beuys's life since early childhood. From his childhood game of pretending to be a shepherd with an imaginary flock and the little private zoo that he maintained at home to his studies in biology at the Reich University in Posen and expeditions with Heinz Sielmann, it is clear how important animals were to Beuys. To him, as he often said, animals were absolutely synonymous with nature itself.

The influence of Mataré, particularly in matters of form, is unmistakable in the early work of Beuys. Like Mataré, Beuys set out to express the essence of the animal, through drawing and sculpture. But unlike Mataré, who reduced physical volume almost to planar geometry, Beuys stressed the existential nature of the animal. He was interested in conveying discontinuity, inwardness, and what Franz Joseph van der Grinten once called "the intelligence of animals, their mythical or totemic status."

Beuys' special animals are the hare, the stag, the elk, the sheep, the bee, and the swan. In many contexts and in the most varied combinations, they appear in his drawings, sculptures, and Actions to the very end of his life. The swan motif connects with the history of his native region. The heraldic emblem of those counts of Kleve who claimed descent from Lohengrin, the swan stands high as a weathervane on the Schwanenburg—the Swan Castle—in Kleve. In 1961 Beuys designed a swan relief for the Kleve city hall. He knew the Lower Rhine legend of Lohengrin, the knight of the swan; he knew that the swan was the sacred bird of Apollo

and that Zeus appeared to Leda in the guise of a swan. The Leda motif appears in various forms in his drawings.

The sheep, the stag, and the elk were important to Beuys because all are herd animals and the role of shepherd had stimulated his childhood imagination. The stag was initially chosen to play a role in Beuys's first major Action, *Siberian Symphony* (1963), but since no dead stag could be procured, he used a hare instead. Stag monuments did, however, become an important part of his work. Since time immemorial, the stag has been associated with magical forces. Its antler, pulverized and burnt, is said to be a talisman against evil spells. In ancient Greece the stag was the sacred animal of Artemis, goddess of the hunt, whom the Romans identified as Diana and also frequently depicted with a stag. The East Germanic peoples also regarded the stag as a divine animal. On the whole, the stag appears in Beuys's work as a creature doomed to die, according to Armin Zweite, the Munich expert on Beuys, who points to titles such as *Bleeding Stag, Wounded Stag, Dead Stag and Moon, Dead Man on Stag Skeletons, Dead Giant Stag.* Of similar significance to Beuys was the elk or moose, a creature that always suggested to him a fragile, imperiled quality.

55

Taking all of Beuys's animal images together, it becomes apparent that his essential concern was to convey the psychic and spiritual energies of animals and to draw behavioral analogies that would embrace the life of all creatures, including human creatures.

The bee and the hare—like fat and felt—were "materials" of particular importance and fascination for Beuys. He concentrated intensively on the functions and activities of bees. His gigantic *Honey Pump at the Workplace,* installed at the Documenta 6 exhibition in Kassel in 1977, was the quintessential artistic product of his study of the bee, which had been initially stimulated, in part, by his interest in Rudolf Steiner. Beuys knew the fifteen lectures that Steiner delivered in 1923 to workers at the Goetheanum in Dornach, in which he spoke of the bee as a holy creature of great antiquity:

> . . . holy, because in all its work it makes manifest what happens in man himself. . . . And if you take a little bit of beeswax, what you really have is an intermediate product between blood and muscle and bone. It goes through a wax stage inside

56

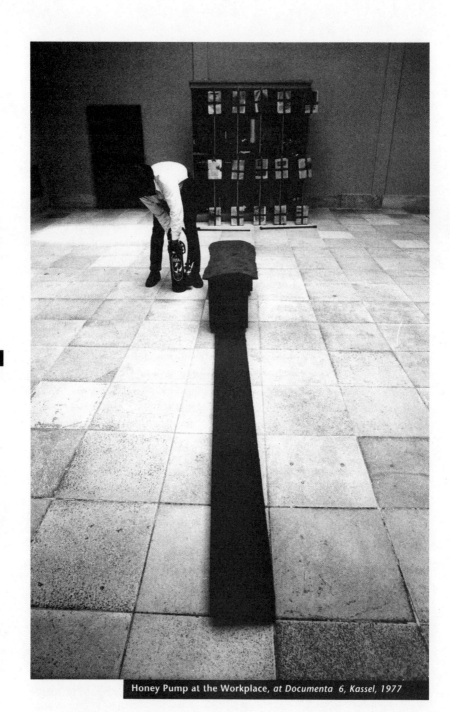

Honey Pump at the Workplace, *at Documenta 6, Kassel, 1977*

the human body. The wax never sets but stays fluid until it can be transformed into blood, or muscles, or bone cells. In wax, you see the same forces that you have within you. . . .

The worker bees bring home what they have gathered from the plants and convert it into wax in their own bodies and make this whole wonderful cell structure. The blood cells of the human body do the same thing. They travel from the head all through the body. And if you look at a bone, for instance, . . . there are these strong hexagonal cells all through it. The blood circulating through the body does the same work that the bee does in the beehive.

Beuys's idea of sculpture derives from this bee-specific metabolic process: sculpture as "organic forming from the inside out." In an enlightening interview with B. Blume and H. G. Prager, printed in the December 1975 *Rheinische Bienenzeitung,* the oldest established German beekeeping journal, Beuys took a thorough, highly original approach to the issue:

> **The bee likes to live in an environment that has a certain organic warmth. The most straightforward was the old beehive made of straw. Wood is a relatively hardened material, more or less. The later box beehive no longer has this quality of warmth. So here you have what has interested me in all my sculptures: the general quality of warmth. I later worked out a kind of theory of sculpture in which the quality of warmth—warmth sculpture—played an important part, and this ultimately extends to the whole of society. . . . And it has to be seen in this whole context with the bee**
>
> **The quality of warmth is there in honey, but also in wax, and also in pollen and nectar, because the bee consumes from the plant the thing that has the greatest possible quality of warmth. An alchemical process is going on somewhere in the flower, where the actual warmth process primarily develops, where fragrances are created, which disperse, and where nectar forms, which is really the plant's own honey. This one could call a honey stage, produced by the plant itself. The bee takes this away, lets it go through its body, and turns it into something higher, a higher activity in this general honey operation. Because you have to proceed on the assumption that there is a general honey operation in nature. The bee simply collects what is there and takes it to a higher level.**

It's important to recognize that in a certain way all of this is a cultural asset. The beehive, as we know it, is a disciplined creation of man. In the wild, bees work as wasps do, fairly anarchistically. Their only honeycombs are small and irregular. The beehive, as we know it today, is a very ancient cultural form: it is derived from a wild form belonging to the wasps, who live in plants or mostly in trees. And it has been cultivated to its present form. This in itself is a deeply sculptural understanding—and a therapeutic understanding, of course. Originally, honey was used therapeutically; it still is, but nowadays it is also used as a popular food item or as a delicacy. . . .

Honey as such also used to be seen in a mythological context as a spiritual substance, so of course the bee was divine. There is the Apis cult. The Apis cult is a very widespread culture, basically a culture of Venus that concerned itself specially with bees. What mattered was not having honey to eat; it was the whole process that was regarded as important, a link between cosmic and earthly forces that absorbed it all. . . .

Basically, my sculptures too are a kind of Apis cult. They are not to be understood as a statement about the biological processes in a bee hive but are meant to extend to the Apis cult, for example, which signifies socialism. There once was a Republic of the Bees at La Chaux-de-Fonds. One of the first socialist movements was at La Chaux-de-Fonds, in Switzerland, where they make watches. That's why you see so many carvings of bees all over the walls there. They used bees to symbolize the idea of socialism.

It is worth following Beuys's train of thought here, for in practical terms he evolved both his expanded concept of art and his idea of Social Sculpture from the example set by these tiny insects. The *Rheinische Bienenzeitung* asked him about the idea of the bee colony as a kind of perfect state. Beuys did not accept this idea. A colony of bees, he said, is not a state composed of individuals, as our states are; the single bee has no individual function, only a joint function within the whole. A bee, he said, corresponds to a single tiny hair on a human body. "Seen that way," said Beuys, "my body is also a perfectly functioning state." There are, he went on, various functions in the body, just as there are in a bee community. The heart has a function that is different from that of the brain. In a human being, the functions that parallel those of the queen bee are divided between heart and brain. The elimination of decayed cells takes place daily, in that the human being excretes waste. And

about the drones, which are eliminated as superfluous, Beuys explained:

> **This isn't the murder of individual existence but the elimination of cells that have served their purpose in keeping the process running, that will be renewed again and again, whereas other cell units have a longer life. There is something like this in human physiology too, so you have to keep yourself from looking at one bee in isolation and saying "That's an individual." The bee is one cell in the whole organism, just like a skin cell or a muscle cell or a blood cell. The best analogy is with the blood cells that swarm through the whole body. There, too, are different kinds of cells, some that break down in the bloodstream very fast and some that last longer. . . .**
>
> **So, in practical terms, the human being is also a swarm of bees, a beehive.**

Beuys's quest for knowledge embraced a variety of influences from zoology, medicine, and natural history, as well as social theory. The strongest influence, as his remarks in the *Rheinische Bienenzeitung* confirm, was that of Steiner, who superimposed apian nature on human nature, and whose unconventional ideas clearly inspired Beuys's own interesting analogies between bee and man.

And the hare? Pure Beuys. "I am not a human being," Beuys once said, only half jokingly, "I am a hare." Another time he went so far as to assert: "I am a really horny hare!"

The cultural history surrounding the hare goes back a long way. It was sacred to the Germanic spring goddess, Ase, and also to the anthropomorphic goddess Unut, in Upper Egypt, who bore on her head a banner of a couchant hare. Plutarch tells us that the Egyptians attributed divine qualities to the hare because of its superb sensory organs and its fleetness of foot; they sacrificed hares to the goddess of fertility, just as the Greeks sacrificed them to Aphrodite. Many peoples, including the Aztecs and the Chinese, have regarded the hare as a lunar creature, because they believed its form to be visible on the surface of the moon. Medieval Christians saw the hare as an emblem of Christ's resurrection.

From fossils, it is known that the hare family was present in the Eocene period, approximately fifty million years ago. This mammal, found all over the world, has a total of about forty-five species. Its anatomical specialty is its extra-long hind legs. Thus

it is able to run very fast in moments of danger, and to double back in zigzag fashion to get its pursuer off the trail. Its hind legs swing forward past the forelegs when the hare is suspended in a fast run, the maximum speed of which has been measured at thirty to thirty-five miles per hour.

For a time Beuys even drove a Bentley with a hare as a hood ornament. He ascribed extraordinary qualities to this creature of the steppes. For him, the hare had a direct connection with birth and with the earth into which it burrows. It is the symbol of incarnation and is closely associated with woman, birth, menstruation, and all the chemical changes that take place in the blood. All this is exemplified in *Hare's Grave,* of 1962–67, which contains no hare but rather a collection of chemical substances: pigments, alkaline solutions, medicaments, acids, iodine, colored Easter eggs. With this sculpture Beuys may have been deliberately reducing *ad absurdum* the realistic or naturalistic image promised by the title, in order to find a way to break through general, ingrained habits of seeing and thinking.

Clearly, the hare was the creature through which Beuys believed he could bring to life buried myths and rites. he interpreted the hare as an organ of the human body, an external organ. Its enormous fertility, its ability to double back, its mobility over borders, its descent from the steppes, its obsession with digging itself in, its dark, mysterious aspect: all this moved Beuys to see the hare as his very own animal. He was firmly convinced that the hare, and along with it all other animals, acted as a catalyst of human evolution. "The animals," he said, "have sacrificed themselves to make humanity possible."

The Expanded Concept of Art

"Wherever I am," said Joseph Beuys, "Academy is." He also said, "Whenever anyone sees my things, then I myself appear to him." Sentiments of positively biblical quaintness. It is not always possible to tell how serious Beuys was when he delivered pronouncements. He could say deadly serious things with a laugh. "Wherever I am": a profound statement. Wherever I am, Academy is. Where Academy is, Beuys is. Academy is the world. Wherever Beuys is, art is, life is, sculpture is, Social Sculpture is. Beuys's claim to unlimited authority is unmistakable.

How is all this to be understood? The difficulty and the obscurity lie at the very core of Beuys. His experience, his origins, his studies, the war, his scientific education, and his realization that the positivist definition of science was a one-way street all ultimately led him to art and to a definition of art entirely related to the human individual.

When Beuys said that everyone was an artist, he did not mean that everyone was a painter or a sculptor. He meant that everyone possessed creative faculties that must be identified and developed. He spoke of this countless times, now patiently, now impatiently, his observations often ranging far and wide and from widely diverging viewpoints. If we attempt to summarize the ideas, thought processes, and tenets involved, what emerges is roughly as follows.

Creativity belongs to everyone. As an anthropological concept, the term *art* refers to universal creative faculties.

An early outline of the "expanded concept of art," handwritten by Joseph Beuys

Programmierung ist die Übertragung einer Aufgabe
an die Maschine.

Maschen. d. mechanistische Methode =
= das Vorstellen in technischen
Modellen.

Nachrichtenübermittlung – Mitteilung
technische Hilfsmittel (Radio, Telephon
Verstärker!)

1.

§ Gesetz für Erste.
Du kannst deinen Gedanken nicht so ohne weiteres
einem anderen Menschen entgegenbringen

aber: Gedanken kann man nur übermitteln durch
ein sinnliches Mittel : Wort, Schrift, Bilder
Gesten, Zeichen . Aber diese Mittel haben
gemeinsam, daß sie sinnl. vorstellbar sein
müssen . Frage: Wie hängt die sinnl. wahr-
nehmbare Welt mit der übersinnlichen
zusammen.

Wahrnehmen und denken
(durch das Sehen wahrnehmen)
u. durch das Sehen denken)

They manifest themselves in medicine or in agriculture, just as they do in education, law, economics, or administration. The concept of art applies to human work in general. The principle of creativity is one with the principle of resurrection: the old form is paralyzed and must be metamorphosed into a living, pulsating shape that cultivates life, soul, and spirit. This is the "expanded concept of art," which Beuys called his finest artwork. To him, it was no mere theory but a basic principle of existence that transformed everything.

The expanded concept of art inevitably leads to what Beuys called Social Sculpture: an entirely new category of art, a new muse to set against the traditional muses. Rudolf Steiner's "contemplative aesthetic" comes into play here, as does his Threefold Commonwealth of culture, law, and economics—the tripartite structure that is the precondition for the realization of liberty, equality, and fraternity. With Social Sculpture, Beuys moved beyond Marcel Duchamp's Readymade. His concern was no longer with the museological but with the anthropological context of art. Creativity, to him, was a science of freedom. All human knowledge comes from art; the concept of science has evolved from creativity. And so it is that the artist alone is responsible for the emergence of historical awareness; what counts is to experience the creative factor in history. History must consequently be seen sculpturally. History is sculpture.

As for Duchamp, Beuys naturally acknowledged his importance. A taciturn figure still shrouded in mystery, Duchamp preferred the role of a chess player after having earned world fame as an "anti-artist" with a relatively small oeuvre. At age twenty-five, in 1912, he definitively broke away from painting. *Nude Descending a Staircase* was his last statement as a painter, a fascinating depiction of spatially active, space-filling movement employing elements of Cubist and Futurist form. One year later he produced his first Readymade: a bicycle wheel and fork, mounted upside down on a stool. This found object was followed by others: a bottle rack, a snow shovel, a typewriter cover, a coat hook, and his most spectacular museum piece of all, the urinal exhibited in 1917 with the title *Fountain*.

Duchamp, who died in 1968 at the age of eighty-one, was undoubtedly the great inspirer of modern art. He influenced Conceptual art, just as he had influenced kinetic and Concrete art with his optical precision instruments and Rotoreliefs.

Happenings and Fluxus, too, bore the mark of Duchamp. He dragged art off its pedestal and undermined its dogmas and traditions. He was constantly trying, as Beuys later was, to abolish boundaries, to expand the field. In 1941 Duchamp published his major works in miniature form, in an enigmatic portable museum called *Box in a Valise.*

To Beuys, Duchamp represented a challenge. In November 1964 Beuys took part in an Action entitled *The Silence of Marcel Duchamp Is Overrated,* which was televised live from Düsseldorf. Other participants were Wolf Vostell, Tomas Schmit, and Bazon Broch. Beuys performed with felt and fat in a variety of sequential movements. Later he explained that the statement about Duchamp made in the title of the piece was highly elusive and ambivalent, and that it implied a criticism both of Duchamp's antiart concept and of "his attitude and how it was cultivated when he gave up art and pursued nothing but chess and literature." Beuys was also piqued by Duchamp's remark that the Fluxus artists had produced no new ideas and that he had anticipated everything they had done.

Beuys's principal concern in this Action was probably to challenge Duchamp's concept of antiart, which Beuys claimed to have systematically applied purely "to make a statement about the problem in general." His own "anti," Beuys stated, was directed against a conventional concept of art; it was the polar opposite of Duchamp's concept of antiart, where "anti" referred to Duchamp's own new works of art, such as the Readymade. What counted for Beuys was the bipolar relationship: art and antiart, physics and antiphysics, math and antimath. Only thus, he said, could expansion take place.

Beuys's definition of sculpture was all-embracing. Human thought is sculpture made inside the person; we can look at our own thinking just as an artist looks at his work. In a lecture in the series "Talks on My Own Country," delivered at the Munich Kammerspiele in 1985, Beuys made it clear that he assigned a crucial sculptural significance to his own thinking and speaking.

My path went through language, strangely enough; it did not start off from what is called artistic talent. As many people know, I started out studying science, and in doing so I came to a realization. I said to myself: Perhaps your potential lies in a direction that demands something quite different from the ability to

become a good specialist in one field or another. What you can do is to provide an impetus for the task that faces the people as a whole. The idea of a people is linked in a very elementary way with its language. Mind you, a people is not a race! The belief that this was the only way to transcend all the racist impulses, the abominable sins, the indescribable black stigmas without ever losing sight of them for a second, made me decide in favor of art, an art that has led me to a concept of sculpture that originates in speech and in thought, that learns through speech to form concepts that can and will give form to emotion and to desire. If I do not weaken, if I strictly adhere to this course, then the images that embody the future will come to me, and the concepts will take shape.

In these words the mature Beuys—at the height of his powers and fame—expresses an idea important to him in his own existence as an artist, a prophet, and a teacher, obscure though much of it may still seem. He sets out from the premise that although great and definitive "signals" have emerged from the traditional concept of art, "the great majority of human beings have remained untouched by this signal quality." This tragic situation is itself a signal, but of what?

To me, the work of art became a riddle to which the solution had to be man himself—the work of art is the supreme riddle, but man is the solution. This is the threshold that I want to identify as the end of modernism, the end of all traditions. Together we shall evolve the social concept of art, the newborn child of the old disciplines.

Social art, or Social Sculpture, Beuys believed, is art that sets out to encompass more than just physical material. Even for architecture, for sculpture in bronze or stone, for theater performance, for our own speech, we need the spiritual foundation of social art, on which every individual experiences and recognizes himself a creative being and as a participant in shaping and defining the world. Beuys's statement "Everyone is an artist"—which had aroused so much attention and which Beuys found was still so widely misunderstood—refers to the reshaping of the "social body," in which everyone not only can but must participate, "so that we can carry out the transformation as quickly as possible."

The energy with which Beuys proclaimed and developed his sculptural doctrine all over the world during the last years of his life suggests that he had come to see this as his true

vocation. In that remarkable 1985 lecture in Munich, he concentrated on the hope that art might show its human face, and in this context he also spoke of its evolutionary significance. He marked ". . . the threshold between the traditional concept of art, the end of modernism, the end of all traditions, and the anthropological concept of art, the expanded concept of art, social art as the precondition for all capability."

With his principle of Social Sculpture, Beuys decisively called in question the conventional definition of art as a unique work created by an artist. In his tireless conceptual work on Social Sculpture, he made it clear that his prime concern was the artistic education of humankind. Not until art had been integrated into every area of education and life could there be an effective spiritual and democratic society. He was totally certain of this. That many people identified Social Sculpture with Beuys himself did not deter him. He was patient with critics, up to a certain point, but he could also be sarcastic and caustic. And since he had a ready smile and quick wit, he often had the last laugh.

"I am in favor of art," he used to say, "and of anti-art." To answer contradictions that might arise in his line of reasoning, he had an unsurpassably ambivalent response: *"Jajajajaja, nänänänänä!"* At a public debate at the Kunstring Folkwang, in Essen, on January 19, 1972, someone called out in exasperation, "You talk about everything under the sun except art!" To which Beuys replied, "Everything under the sun is art!"

Beuys's efforts to establish Social Sculpture as a new model for the world were herculean. He constantly pondered the issue and spoke of it in numerous interviews, lectures, and articles. In 1972 he told his friend Hagen Lieberknecht:

> **The evolution of Western thought, in philosophy, and of the resulting concept of science—especially what is called exact scientific thought—has been a quest to attain matter. . . . [But] you only attain matter when you attain death. . . .**
>
> **Brain as the material substrate of thought: an organ of reflection, hard and shiny as a mirror. Once you realize that this is a mirror organ, it also becomes clear that thought finds its consummation only in death, and that thought then faces something higher: its resurrection in the freedom that death gives, a new life for thought. And that in the future this can happen in a completely different way; that it is conceivable that**

67

in some future age one will be able to think with the knee. And I maintain that one already can.

Here again, much remains obscure; once more we encounter the idea of death, which occupies so important a place in Beuys's thinking and work. But Beuys was confident that regeneration will come from art, from the expanded concept of art. He said: "Man must once more be in contact with those below, animals, plants, and nature, and with those above, angels and spirits." Again and again, he spoke of the changes, or rather the transformations, that man could set in motion. If the work of art is the ultimate riddle, man is the solution.

Beuys viewed present-day humanity as passing through an early or experimental stage of its potential, in which even art has yet to appear. Even so, man is no longer dependent on his creator but has already emancipated himself and can define his own future: "To hell with creation—man is the creator himself!" This conceptual rigor, with its endearingly comic side, reflects Beuys's concept of human self-determination. If everything is not to collapse, then the future of the world must be a work of man. And for that, as Beuys well knew, man will need "the quality of a god."

For all the intensity with which he explained his teaching, Beuys did not see himself as an educator. He once said that all he ever wanted to do was to come out of his laboratory with something new and ask: "Is this it? Is this what you've been longing for?" He saw his expanded concept of art as an opportunity to set the social healing process in motion: "Living conditions must change—regeneration comes only from the expanded concept of art."

All this relates to the warmth that characterizes Social Sculpture. In the December 1975 *Rheinische Bienenzeitung* interview, Beuys addresses this connection in detail. The warmth process, he said, could be illustrated by the bee organism. He drew an analogy with humankind with its potential for further socialist evolution—not in terms of a state, which supposedly has to function perfectly, but "in terms of an organism, which does indeed have to function perfectly." Beuys had nothing against perfection, as long as it was human, that is to say truly warm and social.

This idea of warmth is also connected with the idea of fraternity and mutual collaboration, and

that is why socialists have chosen the bee as a symbol, because that is what happens in the beehive, the total willingness to put one's own needs aside and do something for others. That happens in the beehive: sex, for instance, is largely given up for the sake of the whole, as is true of the workers, and it is symbolized in a single figure, the queen, in which such processes take place. The others set it aside and work in completely different contexts based on the division of labor. . . .

Beuys constantly reverted to the quality of warmth present in the flower, which is taken into the hive and then organizes itself on a higher level. He went on to speak of the transference of this sculpture of social warmth:

This led me to the point where I said there has to be another concept of art, one that relates to everyone and is not just a matter for the artist, but one that can be proclaimed in a purely anthropological sense. That is to say: Every person is an artist in the sense that he can create a form . . . and that what must in the future take shape is what is called the social warmth sculpture. This would overcome alienation in the workplace; it is a therapeutic process, but it's also a warming process. And this in turn clearly goes together with the principle of fraternity, which contains the concept of warmth within it.

This means everyone works for everyone, no one works just for himself; rather, everyone satisfies someone else's needs. While I live off the achievements of others, I pass on something to others, and it's mutual. This is wonderfully clear in a discontinuous physiological organism like the beehive, in which the individual cells are not so entrenched as they are in a higher organism—such as the human body—but actually live detached from each other and can still move. This is important.

In relation to sculpture Beuys emphasized the polarity that emerges between the warm and chaotic and the geometric, crystalline principles. And so he distinguished between the two German synonyms for sculpture: *bildhauerei* (carved, or subtractive, sculpture) and *plastik* (modeled, or additive, sculpture). In practical terms *bildhauerei* is geometric and has to be approached through a geometric conception, whereas *plastik* offers the possibility of internal movement. The bee, according to Beuys, creates both kinds of sculpture; it knows, and works by, both the crystalline, geometric principle and the warm, rounded principle.

It is by no means inconceivable that Beuys elaborated his sculptural theory essentially through his observation of bees. He systematically pursued the interests and explorations of his early youth when he began to study art, and he made a number of drawings and sculptures of the queen bee. What interested him was the instant of fusion between plant and bee: "It's like this: when the bee comes to the plant, that's a unity. Bee and plant belong together as one process."

In the *Bienenzeitung* interview Beuys gives more precise information on his theory of sculpture, describing the distinction between subtractive shaping of a solid *(bildhauerei)* and fluid, additive, organic accumulation from within *(plastik)*. A rock in which a cleft has been hollowed out by a glacier would belong in the realm of *bildhauerei;* a bone, on the other hand, basically formed through the action of fluid processes that have solidified, is *plastik*. Beuys explained: "In human physiology, everything that is ultimately hard has begun its existence in a fluid process; this can clearly be traced back to embryology. Gradually it firms up, emerging from a fluid, generalized motion, from a basic evolutionary principle, and that means movement."

This differs fundamentally from the carving process of *bildhauerei*. The sculptor starts out from a block and says, This is the back, this is the front, this is left, this is right. He orients himself according to a reticle, as Beuys puts it. You take a corner off here and a corner off there, and at the very end there emerges an individual object. This may well then become an organic sculpture *(plastik)*, even in stone; but the process, the sculptural process, is closer to the opposite principle. Clay is basically a fluid, although a stiff one: clay modeling is working in a stiff fluid.

And this, according to Beuys, is why he used fat; because fat is even lighter and more mobile, even more fluid. According to the degree of coldness or warmth with which he worked, the fat either melted and became a liquid oil or solidified and became more or less firm. This has a function within Beuys's theory. He does not choose fat gratuitously, because of its unsightly appearance, but to clarify how it operates in this whole theory. Thus we come to the totalized concept of art, which he expressed through fat and felt and all his other materials, and which he related to all forms in the world. For "all human questions can only be questions of formation—and that is the totalized concept of art."

In the self-portrait that he presented in 1972 to an audience at the Kunstring Folkwang, Beuys started off by taking the inevitable fat question fairly lightly. So what was so unattractive about fat? Fat was a beautiful yellow color! Nothing unaesthetic about that! No, Beuys said, in his view there was something in fat that demonstrated the warmth principle best. He referred back to his own theory of warmth in sculpture, in relation to the principle of evolution, and said that at the same time the idea of fat as the most appropriate material for demonstration had come to him. Because of its absolute flexibility and its responsiveness to fluctuations in temperature, it was possible for fat to appear in Beuys's Actions in a totally chaotic way, by "for example, simply being hurled into the space."

Beuys then went through a list of the things that fat can do in sculpture. It can be treated with heat, and then it melts completely. It can be left to cool down again, and so heat and cold can be demonstrated as two principles within the sculpture. Fat can be rolled together and molded into a shape. It would be possible to model the Winged Victory of Samothrace in fat, "just as well as the ancient Greeks did," and then cast it in bronze. In Beuys's own Actions, however, fat plays a completely different role. "Fat," he told his audience in Essen, "traverses the path from a chaotically dispersed, undirected energy form to a form. Then it appears in the famous fat corner." Then he pointed to the fat corner in his famous *Fat Chair* of 1964—a wedge of fat in the angle between seat and back—"which," Beuys said, "now intersects the human body in the region that houses certain emotional forces." He laughed, and so did everyone else in the room.

Fat and felt provided Beuys with the clearest artistic expression of his theory of sculpture. These are materials that people are used to seeing in a totally different context. But it is with these everyday materials that Beuys had had the crucial experiences of his life. It was fat and felt that the Crimean Tartars used as therapeutic substances in their initial medical treatment of Beuys the wounded Stuka pilot. Fundamental facts of sculptural creation are touched on here, which were later to come together in his work and in his theory. Sculpture—*plastik*—is not something rigid but a dynamic process that can be experienced as pulsating energy. This is why Beuys could maintain that sculpture is heard before it is seen: the vortices formed by running water, the rhythm

71

of the heartbeat, are movements that create sculpture. Beuys thus evokes a different, dynamic, anthropological understanding of sculpture.

The same is true of felt. Beuys wrapped objects in felt, and once he rolled himself up in it. He designed a felt suit as a multiple and wrapped a grand piano in felt. He juxtaposed felt with the cross and built large sculptural ensembles from layers of lengths of felt capped with a copper plate, copper being a conductor of energy. Felt, in all these contexts, is a reservoir of heat; felt sculpture is a powerhouse in which energy is produced. This is Beuys's vision, the expanded concept of art that is meant to evolve, when applied to the whole of society, into Social Sculpture.

Beuys's belief that his art, governed as it is by the idea of warmth, had a therapeutic effect exemplifies the consistency of his line of thought. Art, as he saw it, is a medicament, a salve to rub in, a pill to swallow. He talked expressly of the "art salve" and the "art pill," and he announced that he had literally baked sculptures as cakes.

The historic date when Beuys first exhibited fat—the day the fat hit the fire—was July 18, 1963. He recorded the event in "Life Course/Work Course": "On a warm July evening on the occasion of a lecture by Allan Kaprow in the Galerie Zwirner, Cologne Columba churchyard, Beuys exhibits his warm fat."

The American artist Allan Kaprow is regarded as the father of the Happening. From 1957 on, he organized about 270 Happenings or Events in America and Europe. After his lecture at the Zwirner, he conducted a debate with Beuys, mainly on the differences between the Happening and Fluxus, which did nothing to bring their respective positions any closer together. It was already clear to Beuys that he had nothing whatever in common with the Happening, and very little with Fluxus. He was already on the way to a form of Action art all his own—without working with other performers, as was usual in Fluxus, and essentially without any of the audience participation that was part and parcel of the Happening.

At the Galerie Zwirner, Beuys showed a little cardboard box, a *Fat Chest,* incorporating a fat corner. This first work with fat was followed in 1964 by the famous kitchen chair with its wedge of fat. In 1965 he made *Chair with Fat,* its whole seat covered with a layer of unrefined animal fat. On the right-hand side, a

thermometer projects from the congealed mass. This sort of exercise baffled most of those who saw it.

The problem of the meaning behind this alienation of an everyday object is ultimately that of the meaning of his art, overall. Beuys's art, as his life and work clearly show, has its roots in an existence marked by and obsessed with the myth and the science of nature. Beuys's art is thus always essentially relevant to those regions of the psyche receptive to myth, magic, ritual, and shamanic spells.

The shamanic side of Beuys, of his thought and of his work, has often been noted. He himself constantly emphasized that it was not at all his desire to revert to primeval conditions but to set up signs for the future. The art historian Udo Kultermann sees the artist as the shaman of modern society: the shaman as shaman produces no objects—although in primitive societies he is often also an artist—but like the artist he works through the abandonment of self, through a sacrifice to society. By committing himself, he activates healing patterns of behavior in others. Seen in this light, the Happening is the logical consequence of modern shamanism. The shaman of our age, says Kultermann, knows and commands the technology that our civilization has produced; he knows and commands the mass media. With these tools, he sets out in pursuit of new freedoms.

Beuys knew all about shamanism. To him, the shaman was a figure in whom material and spiritual forces could combine. In the present materialistic age, the shaman represented something in the future. Undoubtedly, Beuys himself had shamanic attributes, inwardly and outwardly. The shaman always wears a costume, whose most important part is a headdress. Beuys's costume consisted of a fisherman's vest over a white shirt, a pair of jeans, and a felt hat. The shaman, furthermore, is a chosen individual, who holds sole right of access to the territory of the sacred. As Mircea Eliade tells us, among all Siberian peoples the essential criterion of the vocation of shaman is sickness, the initiation process of dismemberment, ritual murder, and resurrection. But the shaman is not simply a sick person. Above all, he is a sick person who succeeds in healing himself. There is an obvious parallel to the phase of depression and recovery that Beuys underwent in 1957. Though helped by the van der Grintens, he undoubtedly recovered through his own strength of will. It is also of interest, in relation to

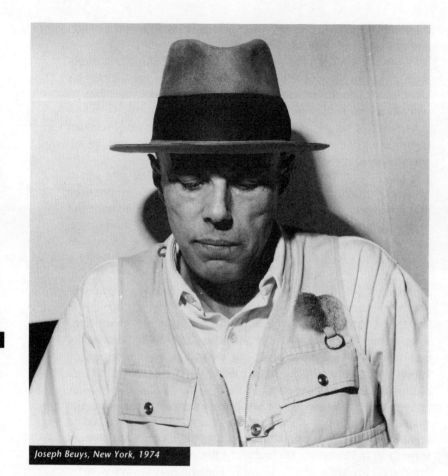

74

Joseph Beuys, New York, 1974

Beuys, that the shaman can converse with animals and even to some extent transform himself into them. Beuys's close relationship with animals is well known.

Just how deep, how alarmingly deep ran the connections between Beuys and the dark, the magical, and the shamanic emerges in the following story told by his friend, the Danish artist and scientist Per Kirkeby:

> My wife and I were on a summer vacation in Spain with Beuys and his wife. We were in the south of Spain, inland, a long way from any water, among vast expanses of vineyards, where the soil was dry and crumbling. It was a weird, dusty landscape, shimmering in the heat. . . .
>
> Beuys was in very bad shape, with a chest ailment; that was why we had come here. One day I was in the small town nearby and overheard a conversation between the local doctor, whom Beuys had consulted, and our two winegrowers, who were always together. The doctor told one of them that if his wife went on using that thing it could have very harmful consequences for the foreigner.
>
> Far away from any habitation, way out in the dusty landscape, they had set up a large tent. The kind that Roman generals have in spectacular movies. There lay the dying Beuys. I guess they were afraid of contagion. Some distance away from the tent stood the winegrowers with their wives. One of the wives was crying, screaming so loud that the sound carried all the way to the little group at the end of the tent, Beuys with eyes nearly sightless; my wife, who sobbed all day long; and myself. Beuys lay in that houselike tent with his head more or less out in the open, because one wall panel had been removed. His whole body was draped with a sheet, and his head was partly covered by a paper bag with holes for the eyes. The whole lower part of his face was ravaged by illness, wasted away, so that only the teeth in his upper jaw protruded, with the skin tightly stretched above them. In what had once been his mouth there were five or six cigars. Because he loved cigars. With his eyes he signaled to his wife to come and

he raised his head so she could lay her hand beneath it. That was his last act of love. To me he said in a strange voice, deep down in his throat, that his artistic career had been shorter than we thought, less than a year, and that he was departing in helpless anguish at his fate. . . .

Hagen Lieberknecht has shown that Beuys acknowledged this death scene, attributed to him by Kirkeby, as the biographical truth. The basic shamanic pattern is unmistakable. It would be wrong to overstate the case, but the trancelike, magical quality of this scene is all part of the effect that Beuys had on people. And there is certainly prophecy in it, too: Beuys was a compulsive smoker who ought never to have smoked, because, like his father, he was susceptible to a circulatory disorder caused by excessive smoking, which he struggled against in a number of his Action pieces. Later he was to contract a rare disorder of the pulmonary interstitial tissue that inevitably affected the whole chest cavity.

The trip to Spain was not imaginary. Beuys did indeed go to Spain with Kirkeby in 1966. Together they visited the village of Manresa, at the foot of Montserrat, a mountain in Barcelona province. There it was that Ignatius Loyola, who had undergone a religious conversion after a severe war wound, lived for a time in austere penance and composed his *Spiritual Exercises,* a manual for pursuing divine grace. Beuys admired the logic with which Ignatius mastered his self-appointed task; in the *Exercises* he found something like a model for his own artistic approach.

It comes as no surprise, therefore, that Beuys would recreate his Manresa experience in concentrated, enigmatic form in an Action performed at the Galerie Alfred Schmela in Düsseldorf in December of that same year, 1966, assisted by Henning Christiansen and Björn Nörgard. The musically structured Fluxus Action *Manresa* centered on two objects: Element I, a felt cross, half of which was cut away and replaced by a chalked outline; and Element II, a box containing all kinds of technical equipment and utensils, with which Beuys busied himself during the piece. On this box stood a plate holding a plasteline figure of the crucified Christ. At the end Beuys held up this crucifix-on-a-plate against the center of the felt cross. The victory of mystical experience over ratiocination?

Manresa is yet another enigmatic example of Beuys's fascination with Christianity, in which he constantly sought

With the Düsseldorf art dealer Alfred Schmela, 1962

and found material for his own idiosyncratic metamorphic pro-
cesses. These could be as outré as washing the feet of seven people
in Basel in April 1971, the prelude to the Action *Celtic + mm*, which
was dismissed by not a few of those present as pure "Jesus kitsch."

But Joseph Beuys the shaman was not easily dis-
couraged. He invariably worked with the utmost concentration,
often as if in a trance, expended enormous energy, and thus
enacted the paradox that, as he himself said, he nourished himself
through dissipation of his strength. He always did the different
thing, the seemingly unthinkable thing: talking for a hundred days
at Documenta 5, wrapping himself in felt, standing on one spot for
hours, living with a coyote, peeling gelatin off a wall, sweeping out
a forest, explaining pictures to a dead hare, organizing a political
party for animals, bandaging a knife after he had cut his finger.

The Academy

In 1958 Ewald Mataré had used his considerable influence to prevent the appointment of his outstanding student Joseph Beuys as a professor at the Düsseldorf Academy. But by 1961 the time had come: Beuys, although unknown to eighty percent of the faculty, was elected unanimously (though he was not to be given a contract until 1969). His application papers consisted mostly of photographs and drawings. He succeeded Josef Mages, who had been appointed in 1938 to the Chair of Monumental Sculpture, a designation that survived as a relic of the Third Reich. The new incumbent, Beuys, would lose no time in reducing it to absurdity.

Once more it was Mataré, unbending as ever, who warned, as he had in 1958, "You're not going to appoint Beuys, the man's insane!" Or that, at least, is what Mataré said to K. O. Götz, when by chance he ran into him in the Academy before the proceedings were finalized. (Götz, professor of painting from 1959 to 1979, records this encounter in his memoirs.) Ironically, Götz also remarks that Beuys's candidacy was helped along by the fact that he had studied with Mataré.

Now fully recovered from his severe depression, Beuys came to the Academy as a man to whom it was perfectly clear that the old concept of art, based only on the picture or sculpture, was outworn. In an age of declining values and growing material expectations, with science, technology, and increasing specialization encroaching on every side, the crucial priority was to

develop an anthropological concept of art, which would embrace all forms of human expression. This remained Beuys's goal. Through the expanded concept of art, he set out to restructure the concepts of education, law, and economics. All this would crystallize into Social Sculpture, the collective work of art that alone makes possible true, creative democracy.

Many people find this philosophy pretty hard to swallow, but Beuys was entirely serious. "I am no longer interested," he said, "in covering up maladies and wrongs. I consider it my democratic duty to shake things up and to teach large numbers of people." This may sound a little overcharged with missionary fervor, but Beuys was well prepared for this task, which became an academic one, having studied science, philosophy, political history, economics, and law, and also having had an interest in the anthroposophy of Rudolf Steiner.

In 1958 Beuys had the good fortune to get a number of rooms in Kleve's spa for his studio. There he made his largest public work, the door and crucifix for the Büderich war memorial. In the same year, at a Mardi Gras party at the Düsseldorf Academy, he met Eva Wurmbach, the daughter of an eminent zoology professor, who had completed her studies to be an art teacher. In 1959 they married. In March 1961, after his appointment to teach at the Academy, they moved from Kleve to the Oberkassel district of Düsseldorf, where they took an apartment with a studio at No. 4, Drakeplatz. That same year their son, Wenzel, was born; their daughter, Jessyka, was born three years later.

As a teacher at the Academy, Beuys found himself a subject of bitter controversy. Nevertheless, one fact is never disputed, even by those who vigorously reject Beuys, his theories, and his works: he was an extraordinary, charismatic, persuasive, spellbinding teacher. Mataré had predicted as much when he blocked Beuys's appointment to the faculty. It might be said that Beuys was a born academy professor, an artist who fulfilled himself best in the role of teacher. Teaching was a central component of his expanded concept of art. He saw teaching as the activity through which he could lay the groundwork for Social Sculpture. And because teaching was a matter of the utmost existential, psychic, and spiritual importance to Beuys, the eventual loss of his Düsseldorf teaching post came as a particularly hard blow. Eva Beuys remembers that she never saw Beuys so sad as on October 11, 1972, the day he

was notified of his summary dismissal. It was a major shock, and in her view it was the cause of the coronary that he suffered shortly afterward.

It is no wonder that Beuys was controversial as a teacher—with students as well as with faculty colleagues. Opinions of him and of his educational and artistic methods were bound to differ. From a negative viewpoint, he created nothing but confusion, aimlessness, and discontent. Those who took a favorable view found pride and happiness: what a teacher! Some students are said to have been reduced to despair by their professor and to have lapsed into depression. By comparison, Beuys liked to point out that eighty percent of his students graduated with first-class honors. In his large classes he operated with at least as high a success rate as his colleagues who worked with small groups of students.

There is no doubt about it: as a professor the man was a fanatic, completely unsparing of himself. He was at the Academy, day in, day out, even on Saturdays and during school vacations. This was important to the continuity of his teaching, he said. Unlike his own teacher, Mataré, who was the silent type and preferred to give nothing but hints, Beuys required intensive dialogue with his students. But just like Mataré, he placed great emphasis on craftsmanship. He himself had outstanding skill in this area, which Mataré had recognized and praised.

Beuys inevitably attracted students in increasing numbers. He neither exerted direct pressure nor tried to use his increasing authority to influence the artistic ideas of individual students, but his indirect influence was enormous. His skill, the depth of his thinking, his integrity, the new message of the expanded concept of art (which was certainly misinterpreted or abused by a number of his students as an easy entry into art), as well as his attempts to relax the teacher-student relationship—for instance, by exhibiting among the students at various Academy exhibitions in order to show that he was himself a student: every aspect of Beuys's utterly unprofessorial conduct left a deep impression on the young. Students poured into his class. Conflict with the Academy, his colleagues, and the bureaucrats was virtually inevitable.

Beuys did not much resemble the stereotypical benign, fatherly teacher. He was more of a role model, a focus for people's hopes, and this may well have overtaxed him as increas-

ing fame led him to take on greater and greater responsibilities, especially since his health was poor. On the other hand, he had found a kind of asceticism for himself that increased his capacity for concentration. Anyone who ever saw Beuys perform, wherever and however, can confirm this. As long as his class stayed at a manageable size, Beuys concentrated on each and every student, concerning himself closely even with their private problems. As their numbers grew and grew, this kind of individual tuition was no longer possible. Beuys now took his students in groups, encouraged them to put their problems in writing, talked with them about literature, and directed their attention to specific pictures in museums. Occasionally he would turn a discussion of a student's work into an all-out teaching session.

Beuys assigned great, indeed crucial, importance to aesthetic education. He expressed this view in many conversations, press interviews, and statements. Basically, he believed that anyone who wanted to study art ought to study art. He informed his colleagues that any applicants for admission to the Academy whom they rejected on the basis of portfolio submissions would be admitted to his class, because he could not accept that a student should be judged so summarily on the basis of submitted work. It was clear to him that aptitude needed to be assessed in different ways. He argued for a trial period of two or at most three semesters, and he found in practice that the process of self-elimination worked perfectly well without his having to intervene.

This hit the Academy at its core, as Beuys knew it would from the very start. Here, too, he wanted to be a pioneer, and he deliberately took the risk in the expectation that something would have to give, and that he could change things. As the conflict neared its climax, Beuys had four hundred students. This was dynamite. By ignoring the statutory limitation on student numbers, he was playing educational politics for high stakes. He was demonstrating, and at the same time tirelessly preaching, that universities and colleges could no longer do their job of supplying the growing human need for education without a reform in their structure.

Beuys the rebel saw the Düsseldorf Academy as part of a greater context. Just as his aim was, through an expanded concept of art, to set/make the beholder free (to borrow from the title of the 1969 Action I *Attempt to Set/Make You Free . . .*, which took place in Berlin and encapsulated the Beuys philosophy), he

Joseph Beuys lecturing at the New School, New York, 1974

83

now undertook to free the Academy for new tasks of a wider scope. It was quite conceivable to him that an academy might give an artistic education to people who would later turn out to be agriculturists, doctors, computer specialists, police, secretaries, housewives, and mothers.

The art academy as a traditional place of artistic education needed to be redefined because the whole educational system was in need of renewal. Beuys explored this idea in conversation with the painter and teacher Siegfried Neuenhausen. What was important, he said, was to bring the influence of art into every subject: there was no point in teaching art in school for two, five, eight, or even ten hours a week in isolation. A mathematics teacher, for instance, ought to be able to teach serial art. Mathematics, like art, depends on sculptural creative powers. But what was the use of even the best curriculum, if no teachers were available to make it a reality? The process simply had to be set in motion, and as intensively and as seriously as possible. Perhaps in thirty years something might be achieved. Beuys remarked: "The students I have are at least developing a feeling for these issues. It doesn't matter whether I'm teaching English, art, or botany. Everywhere, the artistic principle must take effect."

In this conversation Beuys constantly brought up his demand for the inclusion of artistic education in all subjects, especially in grade schools, so as to get a start at a much more elementary level. He saw puberty as a stage during which growing individuals are capable of great artistic achievement, "if they are prepared beforehand." When Neuenhausen objected that developmental psychology shows that the unity of naive and intuitive artistic work, which is dependent on a certain stage of development, breaks off with puberty, Beuys retorted that it breaks off because the teachers are so bad. The teacher as psychologist simply observes that a child paints this way at one age and that way at another. But that teacher sees no possibility of working rationally. "We need to revolutionize these beliefs and these concepts, because now they are all wrong. I strongly object to the teacher approaching the developmental process as a mere spectator."

With sculptural clarity, Beuys went on to express his views on a concept central to art education, that of so-called formal creativity:

It's all far too isolated. Isolated helplessness within the damned concept of "formal creativity." That is a term I reject utterly. During this stage, when someone has made a clichéd drawing, the marvelous thing to say is, "What a darling little nose you've drawn there! Just look at that! Here, I'll show you an anatomical atlas so you can find out what kind of nose you've just drawn." Then you show them all the different shapes there are. Maybe then the student takes an interest in anatomy.

It's important to expand, to get away from the unusable concept of formal creativity. It's creative when a person occupies himself with anatomy, or with geography. You can take the stupid little nose the student has drawn as a starting point and get some concepts across to him. There's no need to start going on about formal creativity. The person takes on a sculptural quality himself: he gets interested, and he'll see that forms have context, that they have responsibility. You can't just tell a person to do something "creative." You have to think about the extended connections.

I have to keep returning to the principle that the "artistic" must cross over into every subject in the curriculum. Even if it's the art teacher who has to take the initiative to get the process in gear. He needs to be trained to know how his specialty relates to other subjects. Basically, even for the young students, art should be the hardest subject. At the moment it's still the easiest subject, one in which people can often do anything they like. I believe that children really despise the art teacher, because he asks too little of them.

Beuys then went one step further:

The schools must become places of education in a new sense, education as sculptural forming. The human being needs to be formed in the right way, and that means being kneaded. He must be thoroughly kneaded from top to bottom. He is malleable, sculpturally moldable. And the education that children get nowadays mostly warps them. The children don't become sculptural: they stay unbending, lifeless. They grow old before their time. They turn into egoistical philistines. And this is the cause of the unapproachable and immoral society we live in today. Defective education has unimaginable consequences.

That was Beuys the teacher—the passionate teacher, as one must call him when one knows how expansively he interpreted the process of teaching and learning. But reality often

85

takes the shine off the ideal, as Beuys discovered when the Frankfurt Kunstverein had to alter an exhibition of the "School of Beuys," scheduled for November 1976. By presenting his students' work, the intention was to elucidate Beuys's educational concepts, to expound his methods, and thereby make a statement about the success or failure of Beuys's teaching. *With, Alongside, Against Beuys* was the Kunstverein's title for this explosive theme. Behind it stood the question of whether there was such a thing as a School of Beuys at all, or whether it was more accurate to say that the individual student of Beuys, more than the students of other teachers, was cast up on his own creative resources. A press handout announced:

> In accordance with Beuys's intentions, and in particular with his conception of teaching and learning, the exhibition is an open one, with no restrictions on selections. As far as possible, all those artists who have worked with Beuys in the past or who are now in Beuys's class have been approached. The large number of participants, and the abundance of material, make it likely that the show will transcend the conventional exhibition format.

The prediction turned out to be all too accurate. Shortly before the opening date it was announced that the exhibition was to be converted into a three-day event. Beuys himself, together with a number of other participants, had declared that the exhibition as planned was not authentic and had withdrawn from participation. He protested that the whole theoretical apparatus was missing, so that the pedagogical concept could not be made comprehensible. He also complained that the history of the ideas involved in his classes during his time as a professor at the Academy had not been documented. This conceptual deficiency was reflected in the material that the students had sent in: ninety per cent of it was mere handicraft, misconceived sculpture, misconceived examples of "expansion."

The *Süddeutsche Zeitung* wrote on November 9, 1976:

> To what extent has Beuys succeeded in communicating his conception of creativity? To what extent has Beuys's doctrine become an alibi for amateurism? For people who see an easy way out of the bur-

densome demand for quality? For clowns who believe that a revolutionary attitude is the same thing as creativity? Curiously, it emerged in debate that many students have clearly failed to follow the very fine distinctions that Beuys draws: they wanted him to proclaim his solidarity with the exhibition without understanding that Beuys distinguishes very sharply between the duty of solidarity, where rights are concerned, and the duty of individual responsibility in matters of the spirit. The stumbling block for many people is that Beuys refuses to submit artistic issues to democratic decisions; he has complained that the exhibition was "swamped by democracy."

On the same day another paper, the *Frankfurter Rundschau,* voiced its own objections to the Kunstverein project:

> If the intention was to convey something of the expansion of the concept of art, which has always been important to Beuys, then something of the tension between different working methods and between divergent views of the politics of art and something of the changing approaches to the problem of communication ought to have been shown. Instead, many people sought only to use the opportunity of airing the wretched contents of their own closets.

87

Also on November 9, the *Frankfurter Allgemeine Zeitung* came to a positive evaluation: "Beuys's students are now to be found in educational and social work, in schools, shelters, hospitals. The utopian ideal of art as something that permeates the whole of life has begun to be realized."

Such reactions are typical of those that greeted Beuys, his art, his Actions, his installations, his teaching. He was and surely remains, now and for the future, a puzzling figure in many ways. And again and again will be asked just what, and where in the social organism, are the changes that Beuys made or will make. He was convinced that the day when Social Sculpture would become a reality was not too far in the future, and it was this hope that shaped his teaching. "I try to look for the individual strengths in everyone—as best I can." Is there a hint of resignation in those words?

Dismissal

On October 10, 1972, Professor Joseph Beuys, along with fifty-four rejected applicants for enrollment and a number of students, occupied the administrative offices of the Düsseldorf Academy. It was the first day of the winter semester. In a thick notebook Beuys wrote the names and addresses of the 125 candidates who had been rejected in August on the basis of their portfolio submissions; by doing so he confirmed their admission to his class. Beuys then demanded that all the rejected applicants be formally registered.

That same morning, in a conversation with senior officials of the Ministry of Science and Research for the state of North Rhine–Westphalia, Beuys was made aware of the possible consequences of the occupation. Called upon to vacate the offices, he refused: "If necessary, we'll stay here for fourteen days." Nor did Beuys comply with a written ministerial summons to leave, which was personally handed to him. On the evening of that same day Beuys was sent the following letter by registered mail:

> With the letter from my representative dated October 6, 1972, you were informed that the occupation of the offices of the State Art Academy constitutes the crime of trespass, and I am not prepared to tolerate any such criminal actions.
>
> In the same letter it was also made clear to you that, should this nevertheless take place, I would have no alternative but to terminate immedi-

ately your employment with the state of North Rhine–Westphalia.

In disregard of that letter, since 11 A.M. today you have occupied the administrative offices with some 60 to 80 other persons and have complied neither with the instructions conveyed to you on my behalf by the departmental head in charge, Ministerial Director von Medem, nor with my own demand, communicated to you at 2 P.M., that you vacate the offices forthwith.

This conduct is irreconcilable with your duties as an employee of the state and as a professor at the State Art Academy. The state of North Rhine–Westphalia can no longer be expected to continue your employment.

In accordance with Paragraph 626 of the Civil Code, I therefore give notice that the contract of service entered into with you on March 12, 1969, is terminated, effective immediately.

In addition, I call upon you once more, in accordance with the terms of the Criminal Code, to vacate the offices of the State Art Academy without delay.

Johannes Rau, Minister of Science and Research, state of North Rhine–Westphalia.

This letter has since become a historic document; its author went on to become a successful premier of his state and has been endowed with a sculptural quality in the sense of Beuys's expanded concept of art. In the artist's "Life Course/Work Course," Rau is explicitly credited with Beuys's dismissal, and one year later he provided the inspiration for Beuys's multiple *Democracy Is Merry.*

Since Beuys's initial appointment in 1961, there had been practically no peace at the Academy, and he was essentially responsible. According to Erwin Heerich, who consistently stood by him in times of crisis, Beuys saw the Academy as a world model, a wonderful instrument for the development of new ideas, by which he certainly meant his own expanded concept of art. What was that he said? "Wherever I am, Academy is." Heerich does not hesitate to describe Beuys as antidemocratic. He deliberately courted conflict. He saw no point in compromises. "Time for Action," he said. Heerich acknowledged that it was Beuys's nature

to demand too much of people—just as he incessantly demanded too much of himself.

Did Beuys have enemies, inside and outside the Academy? Yes and no. The term people tend to use in connection with him is "love-hate," which had also been the keynote of his relationship with Mataré. It does seem that no one could ever remain indifferent to Beuys. It also seems that he did not scrutinize the people he attracted. His motto seemed to be "If anyone can help me along, let him." Understandably, many people had no desire to go along with this.

Heerich sums up his time at the Academy with Beuys: "It was all enormously exciting. The Academy suffered as a result of Beuys's actions, and the faculty was split. But the fact is that in many respects he opened our eyes and gave us profound insights into the whole situation of the artist today. In essence, as I sensed at the time, his ideas pointed in the right direction."

Beuys turned out to be not just a teacher but also a practitioner of the art of the Action, quick and increasingly assertive. He made no distinction whatever between his activities inside the Academy and outside it. That is to say, Academy is out there, too, and Academy, of course, is Action. Beuys the introvert had ceased to exist. He had come a long way from the cozy nest of his home in the Lower Rhine. He brought to his teaching at the Academy all his experience of war, death, and depression, as well as a vast and multifarious store of knowledge. He was now a new and different kind of artist, who courted publicity and was consumed with the mission of proclaiming his expanded concept of art and shaping his Social Sculpture.

In 1961 Beuys had been appointed to the Chair of Monumental Sculpture, but after the customary five-year probationary period he was not granted tenure in this civil service position. By that time he had already earned enormous fame for his exhibitions and Actions: at the Academy itself with his piece at the Fluxus-Fest, in Kranenburg with a Fluxus demonstration in the van der Grintens' stable, and in Cologne with the *Fat Chest* at the Galerie Zwirner. All this was quite enough to foster doubt among the bureaucrats about his suitability as a teacher. Then, on July 20, 1964—at the New Art Festival in the great hall of the Institute of Technology in Aachen—Beuys, his nose bloodied by an indignant

spectator, held aloft a cross. Rumor has it that Heinrich Lübke himself, then the president of the Federal Republic, contacted the local minister of Culture and Education to say that such a man could not possibly be a professor. It is also rumored that in response all the other professors had closed ranks to protect Beuys.

Beuys continued working under a contract that remained subject to periodic renewal. It stipulated that he was to undertake the duties of a full-time nontenured teacher of sculpture and that for the duration of his teaching engagement he was permitted to use the title "Professor of the Düsseldorf State Art Academy." Article 1 of the contract specifically excluded any entitlement to transfer to tenured status. The employee was to be paid according to Salary Group H3, Grade 10. The contract of March 12, 1969, for instance, states his monthly salary as $502 and that of January 1972, nine months before his dismissal, as $924. There is also a rumor that envious tongues in the ministry said that Beuys was earning quite enough already with those crazy things of his, and so any old grade was good enough for him. It is a fact that on one occasion the contract renewal process took so long that Beuys and his family had to get by without a salary for a whole year.

Quite apart from the issues of tenure, contract renewal, and salary—personally important though these were to Beuys—higher education in general was experiencing problems that eventually led to a student revolt all over the Federal Republic. On June 2, 1967, in a West Berlin demonstration to protest a visit by the shah of Iran, a student, Benno Ohnesorg, was shot dead. Twenty days later, expressly in reaction to this tragedy, Beuys formed the German Student party (DSP). Since all political gatherings inside the Academy had been banned by the principal, Eduard Trier, the inaugural meeting of the DSP took place on the lawn in front of the building.

It was clear that the DSP was going to prove a disruptive factor in the Academy. Beuys saw himself as the party's natural spokesman, but he also regarded the party—in accordance with his expanded concept of art—as an actual sculpture. There is no doubt that this particular sculpture had its effect on the Academy, which in the winter semester of 1967-68 was compelled by the force of events to introduce student participation. There were repeated organized disruptions, and even faculty meetings

were affected. A normal course of study became practically impossible. The Academy rapidly became politicized. And the driving force behind it all was the DSP, with Beuys as its chief ideologist.

A lengthy open letter sent by a faculty member, Karl Bobeck, to the German journalists' union on January 20, 1969, notes that the issue of student participation in running the school had been raised as early as 1966, when a new constitution for the Academy had been drawn up, but at that stage neither the students' representative council (AStA) nor Beuys himself had taken up the opportunity. Bobeck, who had taught at the Academy since 1962, also recalled that on January 25, 1967, one of his colleagues, Gerhard Hoehme (who had been on the faculty since 1960), had submitted a memorandum in which he argued that the Academy should become more open, in both internal and external relations; that the separation of departments should be dissolved and all subject areas should be integrated; and that the Academy should take its work out into society.

Had the time not been ripe for such changes in 1967? Did it take Beuys, with all his charisma, to get things moving and speed up the pace? In any event, the result for Beuys was not triumph but his own personal defeat, the permanent loss of his position at the Academy.

In the winter semester of 1968–69 there were 321 students at the Academy, of whom Beuys had 49. Before the formation of the DSP he had averaged only eighteen students. Beuys and his Student party—whose founding members included his student Johannes Stüttgen, who was an AStA spokesman, and Bazon Brock, then a Fluxus artist—mobilized their forces for a restructuring of the Academy in keeping with the expanded concept of art. The first priorities were the establishment of autonomy for the school and of a new, democratic admissions procedure, with no censorship of portfolios.

As the conflict escalated—the result of Beuys's supporters taking actions that were widely regarded as militant— ten faculty members decided to take a stand. They wrote a letter to Principal Trier, which was leaked, giving Beuys the opportunity to spread his claim that they were trying to oust him from the Academy. Thereupon, on November 12, 1968, the professors circulated their letter to all faculty members, class representatives, and the AStA. It included the following passage:

We, the undersigned professors, are of the view that the Academy is in a crisis that threatens its very survival. The force behind this development, which endangers the internal and external structure of the school, and which jeopardizes its members' ability to work, is a spirit of disruption born in essence of the ideas and the influence of Mr. Joseph Beuys. Presumptuous political amateurism, an addiction to making up other people's minds for them, demagogic practices, and—in consequence—intolerance, defamation, and inconsideration of colleagues are meant to destroy existing organizational structures, to disrupt both the artistic and the educational spheres, and to maliciously debase human values. We do not contest the artistic eminence of Mr. Joseph Beuys, nor do we underestimate the fascination that emanates from him. His talents and the artistic status that he has won could be of great benefit to the school, were they not coupled with an increasingly well-documented desire for power and for undue influence within the school. By making his class into a center of agitation, he has used it not only to extend his exertion of influence within our institution and its teaching, but he has used the school itself as a means to spread his ideas into society at large. With the aid of the German Student party, which he founded, Joseph Beuys has exerted a sinister influence on the reform movement within our school. The student representative body, which the professorial faculty has, on an experimental basis, invited to participate alongside representatives of the instructors and assistants in the running of our school, has increasingly fallen prey to utopian and anarchistic thinking and is becoming the mouthpiece of this ideology. Meetings degenerate into pseudopolitical babble and provocative criticism, culminating in unrealistic demands that reveal an open hostility to parliamentary democracy.

The professors went on to outline the consequences: "The faculty has repeatedly expressed its confidence in Mr. Joseph Beuys—at first unanimously, then with considerable reservations. In view of the present alarming situation, we consider a reevaluation of this

confidence to be necessary. For our own part, we declare that we must withdraw our confidence from Mr. Joseph Beuys."

This letter to Trier was signed by Gert Weber, Norbert Kricke, Karl Bobeck, Walter Breker, K. O. Götz, Gerhard Hoehme, Günter Grote, Karl Robaschik, Manfred Sieler, and Rolf Sackenheim—ten out of twenty-one full-time professors.

The storm of protest that greeted this manifesto both within and beyond the Academy was like a hurricane. Beuys was once more on the verge of becoming a martyr. He hurled back at his enemies: "You're just upset because you're unproductive!" He regarded the whole affair as a conspiracy against him. At a press conference held in the Academy, feelings ran high. No, said Trier, cautious as ever, none of Beuys's adversaries had intended, by writing the letter, to force their colleague out of the Academy. Beuys called out, "That's a lie!" The accusations against him were, he said, entirely trumped up by his opponents. "I will remain at the Academy to the end," he declared heatedly, "unpaid if necessary."

Exactly what part was played in this conflict by Norbert Kricke, a shrewd tactician who was to succeed Trier as principal in 1972, is not entirely clear. His ability to attack with a smile on his face was fearsome. Beuys found him no easy opponent. In reaction to the events of the fall of 1968, Kricke wrote in the December 20 issue of *Die Zeit*, "Beuys and his students are enthusiasts. The Master's fanatical disciples swarm through the Academy like mediums under remote control; they whisper and buzz like so many busy insects; they are clever, eager, bustling, like Mao's little Chinese. . . ."

And then he proceeded with an implacable analysis of Beuys's activities:

Fear seems to be his mainspring; it is deep and ubiquitous within him. Technology is evil, today is evil, automobiles are dreadful, computers inhuman, televisions likewise, rockets are horrible, splitting atoms destroys the world. Backward-looking escapism, human betterment, yearning for the past; old paraphernalia, cords around bundles, dust and felt, things smeared with fat, wax and wood, tattered cloth, parched things and melted things: he serves it all up in gray, brown, and black, like blackened old paintings, museum dust and museum smell clinging to every

object as soon as it is made. The world of his things is a twilit, airless world. Continual play, concealment within concealment, wax on the box, fat in the corner, excruciatingly long confinement rolled up in a carpet: he takes this upon himself for us all. And this is his aspiration: to be a surrogate victim. He plays the Messiah; he wants to convert us. He wants the Academy to take over the role of the church. And that, for me, is Beuys's Jesus kitsch.

This was about the hardest anyone had ever been on Beuys, who was already an idol to many people. Outwardly he appeared unaffected by the attacks on him. He lived on a different plane of artistic reality, and nothing was going to divert him from his course of provocation and confrontation. In mid-December 1968, before Kricke's polemic was published, Beuys renamed his German Student party "Fluxus Zone West," to underline his demand for a fundamental restructuring of all the universities and seats of learning in Germany and in Europe. This grand gesture obscures the fact that the party had a membership of just twenty, all of them at the Düsseldorf Academy.

The wounds opened by the DSP controversy, by the professors' letter, and by the reaction to it, were still unhealed when yet another Beuys scandal shook the Academy. The police were brought in for the first time. The bone of contention was the so-called Lidl Academy, erected by Beuys's student Jörg Immendorff and twenty-five sympathizers in the entrance hall of the Academy on December 2, 1968. At first, this seemed no more than a student prank. A little cardboard house was built in the hall and dubbed the Lidl classroom. There, information and work assignments were to be issued. But Lidl was also an instrument for restructuring the Academy along Beuysian lines. The students had resolved to do everything for themselves; professors were unwanted. Not least of all, the Lidl activities led to the physical deterioration of the Academy building. Principal Trier spoke of the "atrocious mess," threatened serious consequences, and refused to accede to the demand from the Lidl supporters that all Academy events should be fully open to the public.

In May 1969 Immendorff organized an International Working Week of the Lidl Academy, to be held at the Düsseldorf Academy and to which he invited a number of guests. Professors Joseph Beuys, Walter Warnach, and Karl Wimmenauer

95

made their classrooms available for this. Trier's reaction was prompt and firm. On the grounds that the guests had been invited without prior consultation with him, he prohibited the Lidl Working Week and banned Immendorff from the premises—without success. Nevertheless, the action took place in the classroom used by Beuys, who knew full well that the event was illegal. On May 5 Trier called in the police, who ended the Lidl demonstration.

The same thing happened the following day; again the police were called. On May 7 Trier ordered the Lidl sympathizers off the premises; only registered students were permitted to stay. The situation deteriorated. Beuys was called in and finally succeeded in persuading the Lidl students to leave. This time, fortunately, the police did not need to move in, but on the orders of the Ministry of Science and Research, they closed down the Düsseldorf Academy. When it reopened five days later, no end to the unrest was in sight.

Beuys pursued his idea of an autonomous school with unimaginable pertinacity. Everything indicates that, for all his numerous exhibitions and Actions in Germany and abroad, this was the "sculpture" that mattered most to him. He had set his sights on a "Free University," and his activities within the Academy were directed to this end. Whether his colleagues and the bureaucrats liked it or not made no difference to him. And so, in mid-July 1971, the long-running saga of Beuys and the Academy took another turn. At the faculty conference on student admissions for the winter semester, out of 232 applicants for the course on art education, 142 were rejected—against Beuys's opposition. He then declared that he would admit the 142 rejected students to his own class.

In an August 5, 1971, press conference Beuys explained an open letter that he and his associate Johannes Stüttgen had sent to Principal Trier on August 2. Regarding the 142 rejected applicants, Beuys and Stüttgen had written, "We will have no part in playing such games with the fundamental rights of all, particularly of young people eager to learn." Accordingly, Beuys had promised the 142 applicants rejected by the six other professors that he would "accept them for trial semesters to objectively assess their abilities":

We reject, now and in the future, as a wrongful infringement of academic freedom, any attempt to impose an admissions policy on our class. The

same goes for any regulations regarding the number of
students in our classes. (The Academy is free.) And the
same goes for any other regulations that infringe on this
principle of freedom. It is thus possible for a teacher, if
he is willing, to admit 142 additional students, although
others—tenured teachers—feel themselves overburdened
with six or so students. Questions of Academy capacity,
shortage of space, shortage of service staff, shortage of
teaching materials, shortage of teachers, etc., have no
bearing whatever on admissions regulations.
Responsibility for such deficiencies, in relation to those
involved and to the people as a whole, lies with the
authorities concerned, with their officials, and ultimately
with the party politicians who rule in disregard of the
majority. An arbitrary limit on student numbers is a viola-
tion of basic rights and not a proper solution to the prob-
lem of capacity.

With 142 additional students in his class, Beuys
was going to have about 400 students the following semester. He
knew perfectly well that he could not handle such numbers, even
with the help of a group of older students who offered to assist
him without pay. But that was not the issue. Beuys declared:

97

The Academy is like a battleship under
fire. We are in an emergency. I want to portray a sick sys-
tem and to try, as far as possible, to work within it. The
school has a responsibility to society. The concept of lib-
erty plays an essential role here. I consider it my duty
above all not to turn away students who want to enter
my class. I shall not yield until the tanks draw up to the
Academy!

On August 6, 1971, the Ministry of Science and
Research issued a press statement: "The 142 applicants accepted
by Professor Beuys will not be granted admission. The ministry will
offer them a course of study at a planned relief academy in the
Westphalian region." This referred to the affiliate branch of the
Düsseldorf Academy, in Münster, intended for those studying to be
art teachers. It was to open in January 1972. Beuys was not satis-
fied. A relief academy would not do. Conditions had to be
improved in the place where the demand existed, and that meant
Düsseldorf. For this reason, he announced, he would continue
fighting for the admission of the 142 applicants. Any obstruction
to doing so would be an infringement of his academic freedom
and of the human right to education, as embodied in the West

German constitution. These weren't just words, as Beuys showed after he threatened to take action if the rejected students did not receive their registration papers for the Düsseldorf Academy. On October 15, 1971, Beuys and a group of students occupied the administrative offices at the Academy. Only 17 of the 142 rejected applicants were present; the others never showed up.

Beuys demanded the registration papers. He was prepared, he said, to stay there all night if necessary. Someone from the principal's office called the Ministry of Science and Research to announce that the offices were being occupied. Thereupon the head of the ministry's department of higher education appeared and emphatically notified Beuys that his conduct was illegal. He promised Beuys a meeting with the minister and with his state secretary. Every effort would be made to achieve a satisfactory conclusion, on condition that these seventeen applicants were the only ones involved and that the offices would be vacated forthwith. Beuys and the students accepted at once. And Beuys's campaign was successful: on October 18, 1971, the faculty accepted a recommendation from the Ministry of Science and Research that the seventeen applicants be admitted.

However, the Minister of Science and Research, Johannes Rau, had no intention of finding himself in the same situation again, and in an endeavor to forestall any future actions of a similar nature he wrote to Beuys, in a letter dated October 21, 1971, ". . . I would like to make it clear that I would regard it as a dereliction of your duty as a teacher in an institute of higher education if, in violation of a restriction on student numbers for the coming semester, you were to make any attempt to admit students to your class beyond the maximum limit." Beuys had been warned, but if he had heeded the warning he would not have been Beuys.

In February 1972 there were meetings at the Academy to discuss a new admissions process. Beuys took part in them, but he did not consider himself bound by the decisions that were reached, which established a limit of thirty students in any class. At the admissions conference in the summer, 227 applications were accepted and 125 rejected. There were now 1,052 students at the Academy, of whom no fewer than 268 were in Beuys's class. Beuys was in Kassel at the Documenta 5 exhibition, where each day from June 5 through October 8 he manned the information office of his Organization for Direct Democracy through

Referendum (People's Free Initiative). He declared that he would admit all 125 rejected students to his own class. Principal Trier duly informed the ministry of this statement on August 24, 1972.

On August 28 Beuys wrote to all of the rejected applicants to announce his readiness to accept them into his class. His notice, he said, superseded any official communication to the contrary that they might receive from the Academy. In an August 29 letter from the state secretary in the Ministry of Science and Research, Beuys was ordered "to refrain from any attempt to force the admission of further students." At the same time the ministry told Trier that in view of the number of places available, and in the interest of ensuring a properly organized study program, no applicants beyond the 227 selected by the faculty conference were to be admitted. On August 31 Minister Rau himself wrote to the Academy authorities to reiterate that the limit of 227 students must stand and that no teacher had any right to admit students beyond that number.

The word was that Beuys would come back to the Academy right after the closing of Documenta 5 and that something was going to happen. Even the date of his arrival was set: October 10. He was going to occupy the offices for a long time, or so the news from the grapevine ran. But before things reached that point Beuys sent an open letter to the ministry, confirming receipt of the August 29 letter. He stated that an understanding had been reached between himself and Principal Trier that any rejection of those willing to study was incompatible with a resolution passed at the Academy admissions conference, that the acceptance or rejection of applicants was a matter for the individual class teacher. According to his interpretation of the law, the method of selection and the arbitrary limit on student numbers amounted to a violation of the guaranteed constitutional rights of young people who were willing to study. He was in no way prepared to blame a manifest neglect of public duty on the very people who were its victims.

It was unacceptable that any criterion other than the aptitude and inclination of the students should govern admission to specific schools. Constitutional rights must not be emptied of meaning, and that included the right to remain free from governmental interference as well as the right to education, which in accordance with the Convention on Human Rights could not be denied anyone.

To respect these principles, Beuys wrote, was the duty of all the organs of state authority. This could not be obscured by the regrettable and irresponsible insufficiency of classrooms, teaching materials, and teaching staff. As long as it was to operate on funds from the national wealth—i.e., the fruits of the labor of all creative persons— the Academy must not act in such a way as to subordinate the interests of the young, the custodians of the future, to other interests. For his own part, he had managed, in spite of an excessive workload, to satisfy the just demands of a large number of students.

In response, the state secretary confirmed that in accordance with the admissions process, through individual selections by teachers as supplemented by the admissions conference, forty-two of the applicants accepted for the coming semester, or 60.96 percent, were assigned to Beuys's class. His letter closed with an unmistakable warning:

> On the basis of information I have received, I have reason to suppose that you persist in your intention, as before, to admit students, in contravention of my instructions dated August 29, 1972, and in excess of the numbers agreed by me. Should you, in pursuit of this aim, attempt once more to occupy the administrative offices of the Art Academy with your students, this would constitute the crime of trespass. With all due respect for your personal style, I am not prepared to tolerate criminal acts. Should this nevertheless take place, I would find myself compelled to immediately terminate your employment with the state of North Rhine–Westphalia.

Beuys, of course, shrugged off this warning. As predicted, he appeared at the Academy on the morning of October 10, 1972, fresh from the triumph of his spectacular hundred-day meeting at Documenta 5, and proceeded to occupy the administrative offices in the company of fifty-four rejected applicants. The consequences are well known. Minister Rau sent him notice of instant dismissal; Beuys and his students left the offices the next morning, flanked by thirty policemen lined up in two rows. The photograph of the laughing Beuys, in his long coat and felt hat, passing between the ranks of the guardians of law and order, was

personally inscribed by him with the statement *Demokratie ist lustig*—"Democracy is merry"—and found its way onto the art market as a multiple.

On October 11 Rau gave a press conference on the "Beuys affair." He described the dismissal as "the last link in a series of constant confrontations," and he accused Beuys of "clearly having trouble relating to public institutions" and of expressing his feelings about the state "in excremental language." At the teachers' conference that was immediately called, to which Beuys was invited, the dismissed professor went on record as follows: "The state is a monster that must be fought. I have made it my mission to destroy this monster, the state."

These words may well have been spoken in the heat of the moment. But one thing is clear: a meeting between Beuys and Rau would have been pointless. It had been suggested to the minister at his press conference that he might have done better to negotiate with Beuys in person, instead of dismissing him. Rau shook his head: "No, I cannot and must not allow myself to be used as a potential art object." He didn't know that he had already become such an object, in terms of Beuys's expanded concept of art, or that in the course of the events that followed he was to become ever more inextricably enmeshed in the artistic web spun by the man in the felt hat.

What followed was an international wave of protests over Beuys's dismissal:

> To repress those individuals who constructively support a better education policy and to ban their employment or their teaching activity seems to us the most inappropriate means of treating one of the ablest teachers in any German academy. . . . It would be an irreparable loss if one of Germany's most important artists were to be forced to abandon his successful teaching work.

This quote is from an open letter signed by Heinrich Böll, Jim Dine, Richard Hamilton, Peter Handke, David Hockney, Uwe Johnson, R. B. Kitaj, Gerhard Richter, Martin Walser, Günther Uecker, and others. Lucio Amelio, an influential progressive art dealer in Naples, wrote, "We regard the dismissal of Joseph Beuys as the dismissal of the entire European avant-garde." Even Henry Moore is said to

101

have expressed to Rau his disapproval of Beuys's dismissal. Students staged hunger strikes and marched in protest through downtown Düsseldorf, carrying banners proclaiming "Beuys—Another Heine" and "100 Raus are not worth one Beuys." The Academy was like a Beuysian playground. A planned police intervention to force out the Beuys supporters was prevented at the last minute by the arrival of the master himself. "It's like a wedding," Beuys joked. "Telegrams and flowers arrive all the time."

But there was not much to joke about. The situation was deadly serious. Beuys ignored the letter of dismissal and continued to regard himself as an Academy teacher. On October 16 he was present—uninvited, of course—at a meeting to discuss the appointment of new professors. Ministerial Director von Medem, who was clever in his dealings with the unruly Beuys, announced, "Because personnel matters are to be discussed, the meeting must go into closed session." In other words, anyone who was not a member of the faculty was excluded. But since Beuys refused to leave, the meeting broke up in disorder.

Beuys refused to recognize his dismissal, announced his intention to sue, and encouraged his former students to continue coming to him. "If four hundred students want to study with me, I'll stay here as long as they want—so I'm staying at the Academy. That is what I call autonomy." It looked as if Beuys were once more following in the footsteps of his great revolutionary model, Anacharsis Cloots, sticking to his ideal in the face of overwhelming opposition. Clearly these events reminded him of Cloots, for in Rome, on October 30, 1972, he dedicated an Action to the freedom-fighting baron from Kleve.

On that same day Beuys sued the state of North Rhine–Westphalia over his notice of termination. He asked the court to declare the dismissal invalid and unethical. Minister Rau, representing the state in this matter, had been putting out feelers for a compromise without offering to withdraw the dismissal. He wrote Beuys another letter on November 11—two days prior to the mediation hearing before the state labor court in Düsseldorf—firing him all over again, "as a precaution and as clarification," on the grounds that he considered the plaintiff's legal statement of his complaint to be insulting and grossly defamatory. Rau petitioned the court to dismiss the suit, on the grounds that the dismissal was

justified by Beuys's failure to vacate the Academy offices on October 10 despite repeated warnings.

Beuys's accusation of unethical conduct was based on the contention that Rau had been trying to show his voters that he could make "even internationally famous artists subservient to his will." The minister had a responsibility to art and had no right "to desecrate art; by basing himself on the model of totalitarian states—perhaps in imitation of Soviet practice, in order to give substance to the treaties with the Eastern Bloc—he was making artistic activity impossible for Academy teachers and for students alike." Rau, the document went on, wanted to show, "out of a reprehensible preoccupation with power politics," that, "like a Paul Klee in 1933, a Joseph Beuys in 1972 could be made to bend to the lawless will of a minister."

At the mediation hearing there was a surprise: Beuys disowned the comparison with Klee contained in the document that had been drawn up by his West Berlin lawyer, Klaus-Dieter Deumeland. The attorney confirmed that this had been his own formulation, inserted in his client's absence.

The hearing on November 13 was not successful. But at the main proceedings, on February 21, 1973, the court ordered Beuys's summary dismissal to be withdrawn on the grounds that: "It is unacceptable for an employer to cease to tolerate the conduct of his employee when only the employer, rather than other people, becomes the object of the employee's activities. The employer in question must be prepared to endure the same treatment that others, with his acquiescence, have suffered in the past."

The next step was already prepared. Rau filed an appeal, and did exactly what Beuys, in his own way, had already done: he bypassed the verdict and dismissed Beuys yet again, this time with notice, effective September 30, 1973. Beuys seemed to have met his match in Rau. The Düsseldorf court did remind the minister that some of the "constantly growing celebrity" of the artist's controversial activities had rubbed off on the state of North Rhine–Westphalia; the defendant had always benefited from the plaintiff's fame and had never previously objected. The occupation at the Academy, said the court, had been just another such activity, although the minister had chosen to take a different view of it.

103

After years of juridical coming and going, Rau's appeal finally came up before the federal labor court in Kassel in April 1978. Judgment: the summary dismissal of Joseph Beuys as a professor at the Düsseldorf Academy was unlawful. The Kassel court ruled that the state had a valid contract of employment with Beuys up to September 30, 1973, the date on which the due notice of termination given to Beuys by Rau was to be effective. In his occupation of the Academy offices on October 10, 1972, Beuys had "pursued no unlawful ends." On the contrary, he had acted on a justified, or in any case irreproachable, conviction that he was in the right, and through his activities he had lawfully provided the fifty-four student applicants access to probationary studies and thus afforded them admission to the Academy.

In November 1978 Beuys announced that he was accepting the appointment to a new Chair of Design Theory at the College of Applied Art in Vienna. Was he leaving Germany out of disappointment that he was no longer tolerated there as a teacher? After winning his case, Beuys had toyed for a time with the idea of negotiating with the state of North Rhine–Westphalia, not for financial compensation or for the use of a room in the Academy, but for full reinstatement. But he knew that there was no longer any chance of this in Düsseldorf. And so the Vienna offer came at the right time. "In Germany," Beuys complained, "nothing happens anymore, spiritually everything is at a standstill."

And then something happened. On November 23, 1978, the new Minister of Science and Research, Reimut Jochimsen, an art lover who had always been receptive to Beuys's work, succeeded in striking the following agreement with Beuys, "in order to remove all grounds of contention":

> 1 The parties are agreed that the employee-employer relationship ended as of September 30, 1973. Professor Beuys withdraws his suit before the labor court in Düsseldorf.
> 2 Professor Beuys may continue to use his studio in the Düsseldorf Art Academy until he attains the age of 65.
> 3 Professor Beuys is authorized to continue to use the title of Professor.

Jochimsen, an economist by training, then issued a statement declaring: "I welcome the conclusion of this agreement. It means

that Professor Beuys, even if he accepts the invitation to teach at the College of Design in Vienna, will maintain his ties as an artist with the state of North Rhine–Westphalia." And Beuys commented: "I welcome the solution that the Minister of Science of the state of North Rhine–Westphalia, Professor Dr. Reimut Jochimsen, and I have arrived at. I see the possibility of continuing to work from Düsseldorf for the expanded concept of art in the Federal Republic of Germany."

Beuys did not go to Vienna, where he had been promised star treatment, including three permanent full-time assistants. In February 1979 he told the Austrian Ministry of Science that he did not want to enter into a permanent bond with any college again and was therefore unable to accept the appointment. He was also frank enough to point out that he had no desire to apply for Austrian citizenship, which he would have had to do to acquire tenure.

A long, confusing, at times humiliating drama thus came to a conciliatory end. The leading man himself, Joseph Beuys, had matured over the years and learned some lessons. "The case cannot be decided against me," said he, "because my intentions are good—I must just get even better."

On October 20, 1973, Beuys had crossed the Rhine from Oberkassel, where he lived, to the Academy on the opposite shore, in a dugout canoe built by his master student Anatol: an appropriate symbolic journey to mark the return of the laughing master. Not until five years later was it possible—thanks to the sensitivity of Minister Jochimsen—to bring home for good the long-lost world-famous son.

105

The Politician

"I have nothing to do with politics—I know only art." Beuys meant this very seriously. It was in keeping with the principles of his expanded concept of art, which boiled down to the idea that art is the primary factor governing our existence and our actions. Politics, too, is art in this sense—not the "art of the possible" but of the liberation of all creative forces. Beuysian politics had nothing whatever in common with traditional politics. He once said that he had long been living a different state, by which he meant the state in which "political work is human work again."

In a certain sense, Beuys was an anarchist. He had no time for the mind-set of democratic compromise; what interested him was breaking through the limitations that had been imposed on democracy, in order to establish a kind of primeval democracy. His utopia was comprehensive: its goal was nothing less than the restructuring of society as a whole. To realpolitikers, Beuys was a crackpot; his own followers cheered.

Lukas Beckmann, one of the leading ideologists of the environmentalist Green party in Germany, has defined his party's position on Beuys as follows: "Beuys is not an everyday politician. His language sounds remote, a long way from the daily reality that determines all our efforts." The Greens nevertheless owe a lot to Beuys. He was already ecology conscious at a time when the Greens had not even formed into a party, and he had every right to consider himself one of the founding fathers of the Green movement in Germany. The story of Joseph Beuys the

unorthodox politician, like the many other stories in his life, is a gripping adventure that leads a long way off the beaten track. He had defined his objective as early as 1967, at the formation of the German Student party: "I want into parliament!"

The German Student party (DSP) emerged in 1967 from the great public debates that Beuys regularly held in his class at the Düsseldorf Academy. In these "discussion circles," Beuys constantly stressed the need for radical democratic solutions based on the purest interpretation of the West German constitution. DSP records reveal that Beuys saw it as an "educational party" that was to act "as it were, as counsel for the true feelings of the students," and whose essential task was "to find a rational formulation for these feelings and to assist their positive implementation."

Beuys defined the objectives of the DSP as follows: total disarmament, the elimination of nationalistic interests and of civil emergency laws, the unity of Europe and of the world, the dissolution of all dependence on East or West, and the formulation of new attitudes toward training, education, and research as the foundations of a world economy, world law, and world culture. Beuys was putting into operation his expanded concept of art, defining art as a stream that "flows out of the dilemma, the wrongs, the schizophrenia of our age, and melts away coldness and numbness." Art, Beuys believed, lies within the capabilities of all people and constitutes the foundation of true healing and development in every area of human activity, and of progress and commitment in science, technology, vocation, and everyday work. This obviously implied a fundamental change in the nature of education in schools and colleges.

The DSP opposed restoration of traditional methods of education and outside influence in the schools. Nor was Beuys content with just this; rather, he and the DSP marched on to dizzying heights. Between the landmarks of individual existence— birth and death—human beings have collective work to do on earth, and the party accordingly would take it upon itself to confront and resolve the issue of life and death. By giving form, new forms are created. All is made by man. To raise this into consciousness, Beuys said, was the sacred duty of the German Student party, so named because every human being is a student. And this kind of thinking, he emphasized, was not based on occult fantasies or sectarian esotericism of any kind, but on a real perception of the

existing material, which applies to all human beings equally, both in their past and in their future.

Beuys saw his German Student party as an anti-party, as a "metaparty"—he once described it as "the biggest party in the world—but most of the members are animals." In 1968, one year after its formation, the party transformed itself into Fluxus Zone West, Beuys's way of indicating a shift to other forms of political activity.

On March 2, 1970, in a former retail store in the old center of Düsseldorf, Beuys set up an Organization of Nonvoters, Free Referendum Information Point, which attracted a membership of two hundred or so. On May 1, 1970, at the opening of an André Masson exhibition at the Museum am Ostwall in Dortmund, an encounter took place between Beuys and Willy Brandt, the chancellor of West Germany at that time. Beuys complained to Brandt that the free and uncensored information promised in the West German constitution was not yet a reality in the mass media. The opposition outside parliament, in particular, never had its say. Beuys explained to Brandt his ideas about referenda on such questions as the distribution of property and the means of production, on education and armaments, and on freeing the earth, water, and air from pollution. A breath of Green politics touched Willy Brandt, who listened seriously and thoughtfully, even showing some sympathy, but made no pertinent comment on the issues raised by Beuys.

On June 14, 1970, Beuys and his associates Jonas Hafner and Johannes Stüttgen launched a campaign to boycott the state elections in North Rhine–Westphalia. "No More Party Voting" was the slogan. The parties, they said, would represent the interests of those in economic power and exploit the productive strength of the majority. The power of the people rested on the right to self-determination: "Govern yourselves! Nonviolently!"

With the foundation of the Organization for Direct Democracy through Referendum (People's Free Initiative), in Düsseldorf on June 1, 1971, Beuys provided an important instrument for the presentation of his expanded concept of art. The spiritual basis for this was Rudolf Steiner's concept of the Threefold Commonwealth, which had interested Beuys from very early on: liberty of the spirit, equality before the law, fraternity in the economy. Beuys did not envisage his organization as a party but as a

kind of research apparatus, a testing ground for democracy, through which models of true democracy could be devised, debated, and publicized.

The target of criticism was the established party state, in which the political voice was created from the top downward, the authoritarian state, as it was called in one of the organization's countless manifestos:

> Unchallenged, through the legislative process, the parties create for themselves the partisan instrument they intend, legally, to play. . . . Minorities (top officials) thereby dominate unhindered the millions who make up the productive majority of the people. They autocratically administer the national wealth that is created by everyone. They call that democracy. We consider it to be party dictatorship, pure and simple.

Beuys worked tirelessly for the organization. On Hohe Strasse, a busy street in Cologne, he handed out shopping bags printed with a multicolored diagram of the Organization for Direct Democracy program. This street Action was a trial run for his grand demonstration at Documenta 5 in Kassel in 1972: one hundred days of debate with the public on democracy, art, and all related issues.

Earlier, in May 1971, he had caused a furor at Experimenta 4, the Frankfurt performing arts festival, when, swathed in an African costume, he acted alongside a student from Togo in a drama entitled "Why Not Make a Democratic Decision on the West German Armed Forces?" The Beuys organization was ready to take the stage, and another drama followed—"Who Still Cares about Political Parties?"—one act of which Beuys performed at the same Experimenta 4.

In November 1971 Beuys combined the opening of an exhibition at the Modern Art Agency in Naples with an Action, *Free Democratic Socialism: Organization for Direct Democracy through Referendum*. In Düsseldorf, one month later, the Action *Overcome Party Dictatorship Now* took place as a demonstration in the Grafenberger Wald, a wooded area threatened by a proposed extension of the Rochus Club tennis courts. This environmental protest by Beuys and fifty of his students was a huge success. Many citizens wrote to city hall in support and joined the artist in protest-

ing the planned development and its consequent destruction of a large tract of woodland. Beuys and his followers swept the wood with birch brooms and painted white crosses and rings on all the trees that were due to be felled. Beuys promised further Actions: "Everyone talks about protecting the environment, but no one acts." And he issued a threat: "If anyone ever tries to cut down these trees we shall sit in the branches!"

Beuys was now making practical use of nearly all his exhibitions, Actions, and lectures to propagate his radical democratic ideas and programs. This activity, which he regarded as inherently artistic, culminated in his work at Documenta 5. It was the third Documenta in which he had played a central role (previous occasions had been in 1964 and in 1968), and he was to do so again in 1977 and 1982. At Documenta 8, in 1987, his work appeared in his stead. At Documenta 5, for one hundred days on end, Beuys found the enthusiasm and the strength to answer questions and to debate from morning till night with a constant flow of curious visitors to his information office of the Organization for Direct Democracy through Referendum—never forgetting the rose that always stood in a vase on the paper-strewn table. He talked patiently, intensely; not without humor, but mostly in dead seriousness. This was his artwork, his sculpture, and he himself was a sculpture—a talking, philosophizing, proclaiming sculpture.

Women who visited Documenta 5 had reason to applaud Beuys: in his office they found themselves confronted by a board on which he had written in his beautiful, characteristic German script the following text:

> **In North Rhine–Westphalia we are planning a popular campaign to enact through referendum an important point of law. Our proposal: equal rights for man and woman! Twenty years of party rule have not secured the fundamental right to recognition of housework as an occupation. This occupation is to have equal status with other occupations and to be rewarded with wages for housewives. Wages for housewives!!! Genuine freedom for women!**

It is always remarkable to see how resolutely and skillfully Beuys pursued his objectives, and how surefootedly he moved on the tricky terrain of politics. Who could keep up with him, contradict him, or refute him? Beuys had become an authority. Even those who did not understand him—and there were cer-

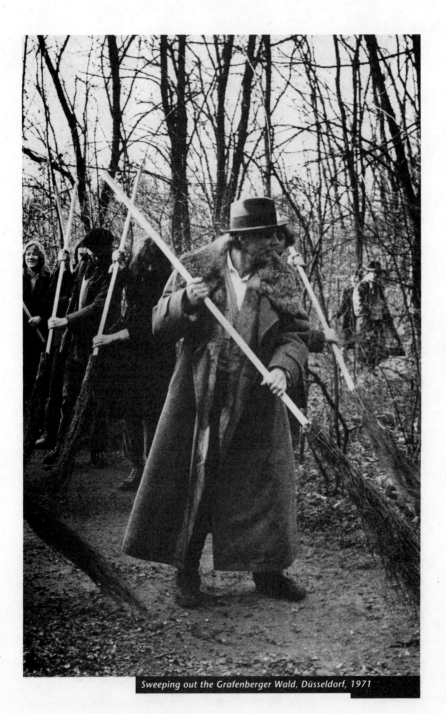

111

Sweeping out the Grafenberger Wald, Düsseldorf, 1971

tainly very many who did not—could do nothing more than shake their heads. Beuys was a great man of integration. Wherever he appeared, things orbited around him. He was the darling of the international art world—rather like Andy Warhol, whom he met with a few times (although, in spite of the efforts of a number of art market operators, no close friendship sprang up between the two).

During Documenta 5, Beuys talked with supreme confidence of his "political struggle for human self-determination" and lastingly impressed on all his audience that this was a struggle for art, for the expanded concept of art, and ultimately for the Social Sculpture in which human self-determination would become a reality.

That was Beuys's vision, but what of the political reality? During the campaign for the election to the Bundestag, West Germany's federal legislature, on October 3, 1976, a flier was issued by a group calling itself Action Group of Independent Germans (AUD). On it was a photograph of Beuys; the text read, in part, as follows: "At last—something new! Free culture! Free people's universities! Fifty percent women in the legislatures! Vote for the AUD nonpartisan candidate, Professor Joseph Beuys, for Electoral District 74, Düsseldorf 1, and for the AUD state candidate list in North Rhine–Westphalia." The candidate, recently awarded an honorary doctorate by the Nova Scotia College of Art and Design in Halifax, Canada, and celebrated all over the world as an Action artist, received six hundred votes in his own district of Düsseldorf-Oberkassel and was as pleased as Punch: "A terrific result!"

In 1979, in the elections for the European Parliament, Beuys was the candidate of the Green party, but without success. A poster was made with a Beuysian motif: *The Unconquerable,* an object dating from 1963. It consists of a little hare on a wooden board and a tiny toy soldier aiming his gun at the hare. Even if the Greens were not exactly overjoyed with the poster, they had to get along with Beuys, whose Organization for Direct Democracy had played a major part in the formation of the Green party that same year.

When the Greens made their plans for the 1980 Bundestag elections, they once more involved their art professor, Joseph Beuys, and initially his name even headed the list for the state of North Rhine–Westphalia. But when it came to the crucial

vote Beuys lost, and his adherents promptly struck him from the ticket. Beuys made them feel uneasy. He lacked the necessary sense of political realism. What do you do with a man who thinks your party is a sculpture? Unusual, not to say absurd. It didn't help matters when a leading Green, Lukas Beckmann, later wrote (in a festschrift published for the artist's sixtieth birthday) that Beuys had predicted the importance of the Greens as a new ecological and political force long before they came into being. In terms of politics—or, shall we say, in terms of everyday politics—Beuys was no longer popular with the Greens. Although this left him embittered, it strengthened his resolve to intensify his activities on behalf of the "sculpture" that had increasingly developed into the true central focus of his teaching: the Free International University.

Beuys's point of departure was the fact that the Düsseldorf State Art Academy was running out of space, a fact undisputed even by his opponents on the faculty. As early as the beginning of 1971, in a number of papers written for the faculty conference, Beuys had propounded the idea of a "Free College." His initial concern was to get equal status for those opting for "free graduation" and those taking the state final examination. At the Free College, proclaimed the nontenured Beuys, the teachers would all be nontenured, freelance professors who would take personal responsibility for the certificates of competence that they issued to their students.

The educational concept of the Free College, which was to be linked to an international communication center, was based on the "anthropological" concept of art, inspired by Rudolf Steiner, that enabled Beuys to interpret his own thinking and action as part of the process of making Social Sculpture a reality. By occupying the Academy offices in Düsseldorf in 1971 and 1972, with the purpose of forcing the admission of numerous rejected students, he sought to direct attention to the disastrous conditions at the Academy. To Beuys, it was simply a necessary consequence of his rigorous concept of education—a concept that he considered confirmed by his summary dismissal and the subsequent labor court hearings. Beuys knew exactly what he was doing. Therein lay the moral justification for his efforts.

Beuys wanted another kind of Academy, a school in which the students could experience creativity as the shaping of freedom. The bounds would be set wider: the new school would

not merely train artists and art teachers but would offer many other disciplines—practical sociology, science, economics. It is evident from this early educational model how firmly Beuys stood against all patronage and for the principle of self-determination.

He went on to apply these same principles to the mechanisms of the art market, which he challenged in his own way. On the occasion of the Cologne Art Fair, in September 1970, Beuys joined with the artists H. P. Alvermann and Wolf Vostell and dealer Helmut Rywelski in issuing an open letter directed "against the further consolidation of the monopoly on sales created by the Union of Progressive German Art Dealers, which over the past four years has been supported by the Cologne city administration, which has made the Kunsthalle and the premises of the Kunstverein available without charge." On opening day Beuys and his fellow campaigners stood outside the locked doors of the Kunsthalle and demanded entry, hammering on the glass with keys. They were admitted.

A few months later, on February 10, 1971, Beuys —this time supported by Erwin Heerich and Klaus Staeck—issued a manifesto against the Cologne Art Fair that was widely circulated in the international art scene. It called for a free art fair, a free artmakers' fair. Beuys incorporated this idea into his concept for a Free College with two levels: the school level and a presentation level, which he pictured as a permanent Documenta, a forum for the presentation and sale of art from all over the world. Teaching, learning, showing, communicating: an exchange of ideas between one discipline and another.

Again, Beuys's approach was strikingly systematic. Two weeks after his somewhat inglorious first occupation of the Düsseldorf Academy offices, on November 1, 1971, he founded the Committee for a Free College. Then he traveled through Germany and elsewhere, speaking in museums, galleries, and cultural centers about his teaching ideas, about the conception of his college, and about the expanded concept of art. His lectures included "The Political Problems of European Society Today" in Naples and "Art Equals People" in Krefeld and in Essen; he debated in Rome with the Italian painter Renato Guttuso on the theme "Free Democratic Socialism." On Labor Day, May 1, 1972, he swept out the Karl-Marx-Platz in West Berlin. He endured the stress of one hundred

information-packed days at Documenta 5, on the last of which he fought a *Boxing Match for Direct Democracy.* He occupied the Düsseldorf Academy offices for the second time, on October 10, 1972, and lost his job. And somehow, in the midst of all this, he still found time for "ordinary" exhibitions in Amsterdam, Belgrade, Naples, Rome, Düsseldorf, Milan, Darmstadt, Hanover, and Bonn.

Then, on April 27, 1973, came the foundation of the Association for the Promotion of a Free International College for Creativity and Interdisciplinary Research. This association, dedicated to the institution of a future Free International College (founding principal, Joseph Beuys), took as its first task the remedying of the acute shortage of space at the Düsseldorf Academy. It set out to negotiate with the city administration for the realization of Beuys's long-formulated plan of freeing the city's derelict former exhibition halls for Academy use. In addition, the association intended to pursue the thoroughly Beuysian objective of opening the Academy to nonartistic disciplines.

Its presiding board included some illustrious names. The chair belonged to Klaus Staeck, attorney, political cartoonist, and later one of the most prolific publishers of multiples by Beuys; his deputy was Georg Meistermann, a professor of painting and a man of political influence. The secretary was the art journalist and originator of *Kunstkompass,* Willi Bongard, a close friend of Beuys. Other board members were three of Beuys's colleagues from the Düsseldorf faculty—Erwin Heerich, Gerhard Richter, and Walter Warnach, and two museum directors, Paul Wember of Krefeld and Eugen Thiemann of Dortmund.

The founding manifesto of the Free International College, approved by the board of the association, begins as follows: "Creativity is not limited to those who practice one of the traditional forms of art, and even for these individuals, creativity is not confined to the exercise of their art. Everyone has a creative potential which is masked by the aggressiveness of competition and pursuit of success. To recognize, explore, and develop this potential is the task of this school."

In this Beuysian school—which, as the master and his fellow campaigners constantly reiterated, was not intended as a private teaching venue for Beuys himself—the primary objective was to reactivate the "life values" that had been buried by indiffer-

ence, habit, disenchantment, aggression, war, violence, and environmental decay; and to do so through a creative interchange, on a basis of equality, between teachers and learners. The syllabus was to offer, along with the traditional art specialties, "intermedial disciplines": cognitive theory, social behavior, solidarity, criticism of criticism, criticism of art, "literality theory," perceptual theory, imagery, stagecraft, and performance. Institutes of ecology and evolutionary science were also to be included.

In a number of notes on this syllabus, Meistermann, who had years of experience as a teacher in the Düsseldorf and Karlsruhe academies, pointed to the dangers of technological progress: it often leads, in Meistermann's view, to physical and psychic depression, "because the individual can no longer remain open to what is within himself." This is where the Free University comes in, "to liberate creative individuals from their isolation":

> The most sensitive of human beings, they prefer inner withdrawal over contact based on misunderstandings. . . . The state of the art schools is not one that promotes an integration of artists with society. Therefore the Free University proposes to explore comprehensively the interaction between the life of the individual and that of society, and to this end it intends to concentrate on the issue of social behavior.

This attempt to set out for new shores of creativity was to have its successes, but Beuys and his association failed to persuade city hall to cofinance a Free College in the former exhibition buildings. Beuys gave vent to his disappointment in a much-circulated, signed postcard, which read (in the English version): "JOSEPH BEUYS NEW ADDRESS: KUNSTAKADEMIE DUSSELDORF RUINED BY STATE."

Nonetheless, it was in Düsseldorf, in February 1974, that Beuys and his friend Heinrich Böll founded a Free International University for Creativity and Interdisciplinary Research, the FIU. At a press conference convened in Beuys's room at the Academy, the association announced that it had applied to the state of North Rhine–Westphalia for the sum of one million marks to run the school and that the city of Düsseldorf was prepared to make an old warehouse available rent-free as soon as financial matters were settled. The participation of the founders in financing this venture was essential.

116

Beuys saw the FIU as an experiment in education across the board. He stressed once more that there were to be no tests, no examinations, no limitation on number of students, no age limits. The school was to be public and under control of the public. The teachers would receive limited contracts instead of official tenure. Heinrich Böll, a winner of the Nobel Prize for Literature, was prepared to make himself available—initially as a consultant, and later as an "instructor in literality theory," which meant that he would help with difficulties in articulation and, conceivably, with bringing the vocabularies of the various disciplines closer together. As for the interdisciplinary syllabus, no limits on subjects were set. Böll even suggested setting up a professorship of politeness.

It is typical of Beuys that he was not discouraged even by such setbacks as the failure to find financing. Undaunted, he went right on campaigning for his Free University "sculpture." He continued lecturing; immediately before the founding of the FIU in Düsseldorf he had returned from a grueling tour through the United States, and subsequently he went to Paris, Oxford, Edinburgh, London, Dublin, Belfast, and back to Paris (where he debated with the Greek composer Mikis Theodorakis), then back to America, England, Switzerland, Italy, England again, and Ireland— all in the year 1974. After one Düsseldorf debate on the FIU, Georg Jappe reported in the September issue of the Swiss journal *Kunst-Nachrichten:* "One is forced to acknowledge that the strongest guarantee of the realization of these educational ideas, which seem utopian to many people, lies in the person of Beuys himself: in his optimistic will to shape people with the same dedication with which he shapes a work of art."

In November 1974, at the Arts Council Gallery in Belfast, there closed an unusual exhibition of 266 Beuys drawings and gouaches, which had previously been seen in Oxford, Edinburgh, London, and Dublin. It was unusual because it comprised a portfolio of previously unknown works: *The Secret Block for a Secret Person in Ireland*. This was a cycle Beuys compiled from works done in the period 1936–72. Over the years, without any apparent plan, he had kept certain drawings to himself and stored them away; finally, he identified them as the very works that served to clarify his working process over many years. He later augmented *The Secret Block* by adding sixty-four, and then another twenty-three, additional works. A collector in Berlin acquired the whole

cycle, and in 1987 it was placed on limited loan in the Wilhelm Lehmbruck Museum in Duisburg, for the opening of a new wing.

This *Secret Block for a Secret Person in Ireland*—as Heiner Bastian, the Berlin writer who worked for years as Beuys's secretary, confirms—contains everything that was decisive in the development of the artist, all of his thoughts that found expression through drawing, in a spiritual process that followed many intersecting paths.

Beuys's dedication of this crucial work to a "secret person in Ireland" is characteristic of his thought and actions. Beuys had always had a fondness for that country. He liked being in Ireland and had many friends and admirers there. He once remarked that he had found that his ideas of creativity, self-determination, liberty, equality, and fraternity met with far more interest in countries where economic activity and established parties had collapsed—referring particularly to Northern Ireland—than they did, for example, in Germany.

It is no wonder that the first concrete realization of the Free International University idea took place outside Germany—or that the place was Dublin. Beuys told Rainer Rappmann in 1976:

> **So Ireland is the first place where the whole thing ought to turn intensely political. We just might come to the conclusion that Ireland could be a model for Europe. . . . In a sense, Ireland is economically still a developing country; it has a simpler structure, it's basically an agrarian country. . . . Cooperation between [the Republic of] Ireland and Northern Ireland is very poor. Cooperation with Great Britain doesn't work at all. . . . So Ireland satisfies some of the preconditions for working out a model that would make people say, "They're doing it completely differently!"**

At Documenta 6, in 1977, Beuys was present along with the Free International University for Creativity and Interdisciplinary Research and with his own gigantic *Honey Pump at the Workplace*. Likewise, the Northern Ireland Workshop of the FIU was present, supplying detailed information on the country and people of Northern Ireland and on its folklore, art, symbols, and industries, with the express purpose of generating "feedback to the Northern Ireland community," as one briefing paper put it.

The members of the Northern Ireland Workshop also gave information on other initiatives outside Germany. The FIU

had started work in Dublin. Its first permanent base in Northern Ireland was in Derry, where its main inaugural project was a survey of trades dying out in an area where unemployment was at thirty-three percent. There were cultural activities in Belfast, too. In Glasgow, prisoners in a special section of Barlinnie Prison were involved with the FIU, and ex-prisoners and prisoners' families were working on the FIU's behalf with young people in new housing neighborhoods, as the Kassel declaration said, to "keep them out of the snares of the system." Later, activities took place in Sicily and in Bologna, in London and in Wales, where the FIU planned an itinerary that would run from prehistoric and Celtic times through industrial history and into the present day with its problems of linguistic minorities and high unemployment.

Beuys had clearly set something in motion. His expanded concept of art was beginning to operate as he intended: as a political instrument through which society would be transformed in accordance with his ideas. At Documenta 6, alongside *Honey Pump,* he discussed social change with, among others, Rudi Dutschke, who was there in the capacity of an FIU teacher. Dutschke was a former student leader, severely wounded in an assassination attempt in 1968, who maintained a lively exchange of ideas with Beuys until he died just before his fortieth birthday in 1979. This dialogue was of particular value to the Green party, with which both men initially had hoped they would turn politics, social policy, and cultural policy into Social Sculpture.

The public has perhaps never been sufficiently aware that Beuys saw the FIU as a fulfillment of his conception of art, which culminated in Social Sculpture; or that he worked hard laying extensive and varied foundations for the realization of that conception. He never spared himself, taking every opportunity that came his way to make his ideas known to a wide public, and of course such opportunities were frequent. Beuys was a star—to many, he was a superstar. He always played to full houses, and few could resist his charisma. He also knew where he could operate to best effect. The Documenta exhibitions provided just such a base of operations, and he had no qualms about saying so. No less important to him were the media: newspapers, radio, television. Beuys had been something of a media favorite since his earliest days as a teacher at the Düsseldorf Academy. This did not always work in his favor, because the media tended to concentrate on

119

only the spectacular appearances. But he did not care. The main thing, he used to say, was to get reported—whatever happened, it would serve in the propagation of his ideas.

Another important institution for Beuys, along with Documenta, was the International Culture Center (INKA), at Achberg on Lake Constance. A congress took place there each summer in which he lectured and debated under the auspices of the Institute for Social Research and Developmental Theory. The tripartite concept of theory, education, and practice promoted at Achberg corresponded to Beuys's idea of the threefold social organism: awareness, teaching, action. Not for nothing did Beuys in his celebrated "Appeal for the Alternative" (first published in the newspaper *Frankfurter Rundschau* on December 23, 1978), list the "Free International University at 8991 Achberg" next to his own address in Düsseldorf, as sources of further information.

The "Appeal" was a lengthy manifesto that embodied all those ideas, utopias, realizations, and demands that Beuys had been pondering ever more deeply and expressing ever more firmly since the formation of his German Student party, the ideas that he had so tirelessly expounded and debated at his information offices in Kassel and during the Achberg congresses. It is clear, too, that the "Appeal" was a fundamental document for the Greens and that it helped them to consolidate certain vital social and ecological aspects of their platform.

Beuys's Free International University developed as a grassroots initiative, as did his Organization for Direct Democracy through Referendum. The Greens were the reservoir into which these initiatives flowed, and Beuys was farsighted enough to see the potential. "How can the new social movement achieve a political dimension?" he asked in his "Appeal," meaning, How can it get into parliament? His answer: "By concentrating all its strength upon a common electoral initiative." His slogan was Unity in Diversity:

> **The environmental, peace, and woman's movements, the Praxismodelle movement, the movements for democratic socialism, or for humanist liberalism, or for a third way, the anthroposophical movement, tendencies associated with various Christian denominations, the civil rights movement, and the Third World movement must all recognize that they are indispensable components of a single alternative movement . . . effective only as an alliance of many autonomous groups that**

**define their relationships with each other and with the
public at large in terms of a spirit of active tolerance.**

The fact that the Greens were so soon to cast
Beuys overboard shows how quickly this "active tolerance" can fall
victim to the power struggle, even among "alternative" people. It
seems all too likely that the "alternative" movements failed to
understand Beuys's radicalism or his depth. They found him
strange, and they were reluctant to be too closely linked to him
politically. After respectfully distancing himself and his movement
with the remark that Beuys was no everyday politician, the Green
spokesman Lukas Beckmann went on to widen the gulf that sepa-
rated him from his erstwhile idol: "The revolutionary content of the
message he conveys inevitably remains inaccessible to many peo-
ple. There are biographical overtones in everything he says. He sets
out to strip everyday perception bare, to reveal, through the cre-
ativity of his own thought, what lies concealed behind mere per-
ceptible reality."

Beckmann wrote this after reading the 1978
"Appeal," in which Beuys identified a series of "symptoms of cri-
sis": the "danger of nuclear destruction of the world," the "intensi-
fication of the bitter arms race," and—as the result of this
"collective insanity"—the "gigantic waste of energy and raw mate-
rials, and the monstrous squandering of the creative abilities of mil-
lions of people." In addition, wrote Beuys, "we practice an
economic system based on unlimited exploitation of natural
resources. . . . Between the mine and the garbage dump
stretches the one-way street of modern industrial civilization,
whose expansive growth destroys more and more lifelines and the
circulation within the ecosystem." Worldwide unemployment, the
wasting of "vast quantities of valuable foodstuffs that accumulate
as a result of subsidized overproduction . . . while in other parts
of the world thousands die of starvation every day"—these, to
Beuys, were more symptoms that, for many people, lead to a "cri-
sis of consciousness and meaning" and to the "destruction of their
inner life."

The "true causes of the whole mess," according
to Beuys, were "money and the state—i.e., the roles assigned to
money and to the state in these systems." He makes no distinction
in this respect between capitalism and communism: "both have led
humanity up a blind alley." Beuys attached to his idea of self-reflec-

121

tion and renewal a truly disturbing question: "Why, in a society that has reached a certain level of democratic evolution, should not the necessary further evolution be frankly debated? Far too many people are afraid of being suspected of subverting the constitution. They deny themselves creative thought or expansion of established concepts of law when the progress of consciousness demands. And that is what it demands." Beuys stated his firm conviction that the way out lay within the individual: "He is the creator of Social Sculpture, and the social organism must be arranged according to his measure and his will."

Once more, Beuys adopted a tripartite means to sketch the basic requirements:

1 **Free development of human talents and personality.**
2 **The individual is an equal among equals.**
3 **He seeks to give and to receive solidarity.**

This led, for Beuys, to the necessity of reshaping the traditional structures of work and income. Income was defined as a basic human right: "In principle, any work done is work for others."

Beuys had adopted the "Integral System" devised by Eugen Löbl, the economic theorist of the Prague Spring of 1968, according to which, as interpreted by Beuys, it was no longer possible "to regard the income of employees as equal to the value of the work they do":

> **The individual's contribution to the production of a particular consumption value, or the contribution of an enterprise to the gross national product, can no longer be objectively assessed. . . .**
>
> **The most workable principle of assessment for income as a basic human right is democratic agreement on the basis of need. The quantity and kind of work are also questions that must be settled by the democratic community in general, and by the working collective in particular, in accordance with their form of self-government.**

Of one thing Beuys was sure:

> **All the coercion, injustice, and frustration that result from the present anachronistic system of payment for work thus disappear; labor unions and employers' associations become superfluous. If income differentials still exist, they will be clear to all and democratically determined. And the end of dependence on wages will have favorable psychological consequences. No**

one will buy or sell talent or work. All employees will belong, as far as income is concerned, to the democratic community of equal citizens.

Some may laugh at these ideas and dismiss them as the naive fantasies of a dreamer. But there are also many who are favorably impressed, even fascinated. Utopians are constantly laughed at by so-called realists. But artists have often been the first to sense the distant tremors of social change and scientific developments to come. It is in the nature of the artist to take a revolutionary, intellectually radical stance in relation to society.

Beuys's "Appeal for the Alternative" took just such a revolutionary stance, with a foundation in social policy on which it erected far-reaching ideas and proposals. This applied to the topic of money, too, which Beuys no longer recognized as a reflection of economic value. He assigned it the function of a "regulator of entitlement for all processes of creation and consumption," and prophesied, "Without any bureaucratic measures, or fiscal acrobatics, the acknowledgment of the transformation of the concept of money will lead directly to the abolition of the principles of property and profit in the field of production."

All this—the teaching, the philosophy, the politics, the agitation, the prophecies, and the missionary activities—must be regarded in terms of the indissoluble relationship between art and life, life and art in Beuys's expanded concept of art. The "Appeal for the Alternative" itself was, in Beuysian terms, a sculptural entity; it was part of what drove him as an artist: an immense labor of integration.

Beuys expressed his political and economic ideas—as set down in the "Appeal"—in numerous Actions, installations, visual works, and multiples. In attempting to grasp him, to understand him, one must never disregard the totality of the aspiration with which Beuys approached his work as an artist. Everything that he thought, said, or did was tied by an inexorable logic to his interpretation of the nature of art.

Beuys believed in the artistic quality of "a new society of real socialism." He believed that the only way to get there was through "nonviolent transformation." His "Appeal" exemplifies the rigor of his moral position:

Nonviolent, not because at this time or for particular reasons violence does not seem to promise

123

success. No. Nonviolent for reasons of human, spiritual, moral, political, and social principles. Human dignity stands or falls by the inviolability of the person, and anyone who disregards this departs completely from the plane of humanity. And yet the very systems that require transformation are themselves based on violence in every imaginable form. For this reason, the use of violence in any way is an expression of conformity with the system, and reinforces the very thing that it seeks to destroy.

For Beuys, the Free International University was the place where vision could be translated into action: "The vehicles that will travel the new road are ready to go. There is room and work for all."

The **Actions**

The work and the influence of Joseph Beuys are too complex to be described in all their detail and in all their facets; there will be much new material to be discovered and investigated in the future. Between his enrollment in the Düsseldorf Academy in 1947 and his death in 1986, Beuys carried out some seventy Actions and fifty installations. To these must be added some 130 solo exhibitions and all the countless activities that occupied him from the mid-1970s on in connection with his political involvement: lectures, discussions, seminars, interviews. All of this drained his strength, passionate as he always was in his commitment—a commitment that also extended to the numerous group exhibitions he took part in. "I feed myself through dissipation of my strength" is a statement of his that constantly comes to mind.

Beuys devoted immense mental and physical energy to his work. From his first public appearance onward, he was practically always the focus of public attention. The number of published references to him and to his work is virtually beyond reckoning. Beuys was an enigma; he did everything differently. But everything he did was unmistakably the man himself: the sculpture *Joseph Beuys*. His Actions, installations, objects, drawings, and multiples all reveal—as does his political work for society—the same strong will for a sculptural form that unites all the parts of his multifarious output.

If we follow his development from his first childhood investigations of plants and animals in the woods and fields

around Kleve to his deeper studies during the war years, it is not difficult to detect in Beuys's artistic work a strong echo of his scientific propensity. Beuys transformed images of nature—images of energy, matter, and radiation, images of the forming of human beings and animals by nature—into the dimension of art, as he interpreted that term: as sculpture, as an expansion with the goal of realizing Social Sculpture. This remained his vision, his whole life long. He saw it as the fulfillment of his artistic career.

The components of his work were those of his scientific world view, as enriched by the anthroposophy of Rudolf Steiner. In his Actions, installations, sculptures, and objects, Beuys used energy-rich materials in the metamorphosis of his artistic ideas. If he had "only" painted those ideas, in whatever way, they would have remained "only" paintings. And so Beuys worked with the fat that protects, the felt that warms, the copper that conducts, the honey that nourishes, the battery that takes a charge. He used aggregates, receivers, filters, transmitters, condensers, dynamos, tape machines, video recorders, telephones, Leyden jars, X rays. He worked with blood and with filth, with bandages, plaster, gauze, hypodermic needles, bones, hair, fingernails, gelatin.

Franz Joseph van der Grinten wrote in the catalog for Beuys's 1963 Kranenburg exhibition:

> The contents of Beuys's works are simple. With small outlay, with a limitation to a few indispensable elements, and with the utmost economy of means, entities are created that are simultaneously tender and reserved; poetic, but unsensuous. Shrewdly ascetic, the artist excludes materials that might captivate us through their intrinsic beauty. Splendor is never achieved, nor is reverie or fairy-tale enchantment. The accents that Beuys introduces are gentle ones, just pronounced enough to be unmistakable. Almost imperceptible sounds are made to resonate; innermost stimuli are traced in every detail and manifested through his interaction with the things around him.

Beuys's imagination, as van der Grinten describes it, played a silent, introverted game. His eye, eluding the constraints of methodical, empirical vision, captured the impulses that emanate from objects, perceiving the moment in which traces of

soul become manifest in them: "Associations crowd forth from the world of his ideas and memories; his hand improvises, adjusts, joins, completes."

The material that Beuys assembled was vividly described by his great admirer Willi Bongard, writing in the September 5, 1968, issue of *Die Zeit:*

> Decayed rats in withered grass. A frankfurter painted with brown floor paint. Bottles, large and small, stoppered and unstoppered. Dead bees on a cake. Nearby a loaf of black bread, one end wrapped with black insulating tape. A tin box, filled with tallow, with a thermometer in it. Crucifixes made of felt, wood, plaster, chocolate. Blocks of fat as big as bricks, on top of an old electric stove. A baby's bottle. Brown choco- late bars, painted brown. Gray felt scraps. Bundles of old newspapers, tied with cords and painted with brown crosses. Moldy sausages. Two kettles wired to a piece of slate. Toenail clippings. A preserving jar filled with pears. Copper rods wrapped in felt. Sausage ends. Colored Easter egg shells. Dental impressions in tallow.

127

This was Bongard's response to the exhibition of the Ströher collec- tion at the Kunstverein, Hamburg, in August 1968. Karl Ströher, an industrialist from Darmstadt, had bought the entire 1967 Beuys exhibition from the Städtisches Museum, Mönchengladbach: 142 items! The seventy-six-year-old patron explained his acquisition as follows: "After being with Beuys a few times, I am totally con- vinced that he is virtually the only one who expresses what is par- ticular to this age."

Monsignor Otto Mauer, a legendary figure of the Austrian avant-garde, the founder and prime mover of the cele- brated Galerie Nächst St. Stephan in Vienna, declared in a lecture on Beuys in Mönchengladbach in September 1967 that this artist totally alienates, estranges, or distances the implements he uses; the word he used was *transfinalize,* a term of Eucharistic theology. This suggests a completely new significance for Beuys's objects. Mauer also called his work "bleak" and "Kafkaesque." Beuys, said Mauer, is no progressive: he belongs much more "to our old world, with its wisdoms."

Beuys's career as a creator of Actions began in

1962 with the concept of *Earth Piano*. Although never carried out, this idea marked his entry into the Fluxus movement. He had in mind an Action for piano and earth, either literally or in the form of an earth sculpture. This would have been a typical Fluxus work. Beuys was already in contact with the Korean-born artist Nam June Paik, one of the leading lights of the Fluxus movement, and for everyone who was around at the time there was no doubt that Beuys belonged with Fluxus. Beuys himself was quick to realize this. His thoughtful friend Erwin Heerich commented: "The contact with Fluxus endowed the issue of art and life, in Beuys's mind, with a radically different significance. In Fluxus he recognized a vital current that released new impulses in himself—and here the other side of Beuys emerged, his powerful sensitivity to, and talent for, the public arena and the media."

What was Fluxus? It was a neo-Dadaist movement that arose in the early 1960s with the aim of making the separate arts—as well as art and life—flow into one another. It set out to overturn the traditional concept of art and to bring art and life into harmony with each other. The chief ideologist of Fluxus was George Maciunas; its most prominent early members were avant-garde composers, such as Paik and John Cage, and Action artists, such as George Brecht, Robert Filiou, Dick Higgins, Yoko Ono, Daniel Spoerri, Wolf Vostell, and Emmett Williams.

In the Happening, initiated in the mid-1950s by the American artist Allan Kaprow, the audience was an active participant; by contrast, Fluxus events were performance pieces. The artists worked on stage, in front of their audience. Maciunas, who like Kaprow was something of a polymath, was born in Lithuania and died in New York at the age of forty-seven, in 1978. He once defined the aims of Fluxus as "social, not aesthetic." Ultimately this meant the abolition of fine art and a pursuit of what Maciunas termed socially constructive goals, such as "the applied arts."

There can be no doubt that Beuys found in Fluxus an artistic base that suited him. His midlife crisis was behind him, and he was already absorbed in formulating his own personal conceptions of art and creativity. It was clear to him that the magic of Dada was gone and that it was time to give artistic reflection to the conditions of a new and different social reality. In this situation, the Fluxus movement seemed a suitable initial instrument. Beuys got to know Maciunas, as well as Paik, and he was soon integrated into

the Fluxus group. He liked the interdisciplinary character of Fluxus, the lightness of the individual Actions, the improvisatory nature of the "pieces": apart from the large "furnishings," such as pianos, tables, and ladders, each participant could bring along whatever he wanted.

In 1963 Beuys organized the first Fluxus concert at the Düsseldorf Academy, under the banner of Festum Fluxorum Fluxus, on February 2 and 3. Along with Beuys there was an all-star lineup, including Brecht, Alfred E. Hansen, Higgins, Arthur Köpcke, Maciunas, Paik, Tomas Schmit, Spoerri, Vostell, Robert Watts, La Monte Young, and Williams. On the first evening Beuys performed *Composition for 2 Musicians,* on the second his *Siberian Symphony, 1st Movement,* in which, for the first time, he introduced a dead hare into the proceedings. He improvised a free-form piece, faded in some music by Erik Satie, hung his hare on a blackboard, affixed little dabs of clay on a piano's keys, stuck a twig in each, strung a wire from the hare to the piano—and pulled the hare's heart out.

With this Action, Beuys set himself apart from his Fluxus colleagues. It was a provocation. Even though the hare was dead, the violence of the Action took some spectators' breath away. Beuys himself regarded it as a breakthrough for himself, for what he called "associative art." He was fundamentally opposed to involving the public prematurely. He clearly wanted to use an initial shock to set off a creative process. He viewed Actions as a kind of therapy. Interpretations, in his view, were unartistic; and that went for self-interpretations in particular. He regarded them as a total negation of the effect of a work of art.

It was the Festival of New Art, in the Audimax at the Institute of Technology, Aachen, in 1964, that brought Beuys into the first rank of international Action artists. The bill for the festival listed "Actions / Agit-Pop / Dé-Collage / Happening / Events / Antiart / L'Autrisme / Art Total / Refluxus." Beuys contributed the following pieces: *Kukei, akopee-Nein!, Brown Cross, Fat Corners,* and *Model Fat Corners.*

Beuys's former dealer Helmut Rywelski, of Art Intermedia in Cologne, described the show in the magazine *Neues Rheinland:*

> The Absurd: Professor Joseph Beuys of the Düsseldorf Academy of Art had come to Aachen to fill a piano with Omo brand powder detergent. The per-

129

former lifted the lid of the piano, sprinkled the powder in, strummed on the keys, and expressed dissatisfaction with the resulting volume of sound. But a remedy was at hand. Beuys found a wastepaper basket containing all sorts of trash and dumped it into the piano. The sounds now seemed to please him better, although Beuys's sounds were not notes but noises, produced on but not from the piano. The Düsseldorf art scholar procured an electric drill and plunged it into the wood of the piano; *that* was music to his ears.

Let there be no mistake: Professor Beuys was drilling according to a score, according to brown splotches that he had dabbed onto music paper with a brush. Other manifestations of the absurd could be listed, but that would still not create a valid image of the Happening performers' intentions. The Aachen students prevented their invited guests from completing the Happening. What the Happening was getting at, whether the absurdities would have made any sense on reflection, or whether the Happening format would ultimately have had to be dismissed as so much insubstantial foolery: all this never become clear, because the new undergraduate class imposed censorship with its fists. Herein lie the difficulties of the evening of July 20, 1964, in Aachen.

A lot more happened that evening. One of the performers played a doctored tape of the notorious Berlin Sportpalast speech by Hitler's propaganda minister, Joseph Goebbels. His voice rose to a screech above the tumult in the Audimax: "Do you want total war?" An indescribable uproar broke out. Meanwhile Beuys was melting blocks of fat on a stove. Then there was an explosion; a flask of acid tipped over and spectators stormed the stage. A student found a hole in his trousers and blamed Beuys for it. But Beuys declined responsibility. Incensed, the student punched Beuys on the nose, which began to bleed. And at just that moment the legend of Joseph Beuys was born. For behold, miraculously, he had with him a wooden crucifix on an expandable base. He held up this *Pneumatic Cross* in his left hand and stretched out the right in greeting, with blood streaming from his nose. A photographer was on hand to record this shamanic scene.

The evening was very prematurely brought to a conclusion, the police were called, and damage to property was considerable. What is more, the July Twentieth 1944 Working Committee, a body formed in West Berlin to commemorate the abortive July Plot against Hitler, lodged a complaint with the state court in Aachen against all the artists involved, and explicitly against Professor Joseph Beuys, for disorderly conduct.

Disorderly conduct, or worse, was what the responsible officials of the Interior Ministry of North Rhine–Westphalia surmised when they took a hard look at the "Life Course/Work Course" of their unruly Academy professor, as printed in the program for this event in Aachen. There they hit upon the entry "1964: Beuys recommends that the Berlin Wall be heightened by 5 cm (better proportions!)." They asked Beuys for an explanation, and he replied in a memorandum dated August 7, 1964:

This is an image and should be seen as an image. One should resort to interpretation only in emergency or for educational purposes. It is incomprehensible to me why you fail to grasp the obvious meaning without an interpretation. 1st questionanswer: Is it a paradox, with which artists throughout the ages have worked in order to tap into a deeper-lying stratum? 2d questionanswer: Is it a code? I make a gesture with my hand to indicate that the answers are at least not wrong; but now I take over, to switch the matter off the paradox track.

I will start with the real/banal (the method of understatement!). It is surely permissible to contemplate the Berlin Wall from an angle that takes only its proportions into account. This defuses the wall at once. Through inner laughter. Destroys the wall. One is no longer so hung up on the physical wall. Attention is redirected to the mental wall and how to overcome it, and surely that is the real issue.

First of all, then, the wall is overcome by me and for me. Motto: under my Heart's Regime, the wall would never have been built. Spontaneously arising question: What is it in my nature, or in that of other people, that has allowed this thing to be built? How much has each of us contributed to the possibility of this wall's existence, and how much do we still contribute? Is every person sufficiently interested in the disappearance of this wall? What antiegoistic, antimaterialistic, reality-oriented spiritual schooling do the young receive, ever to overcome it?

131

> Quintessence: the wall as such is totally
> unimportant. Don't talk about the wall so much! Establish
> a better moral sense in human beings through self-educa-
> tion, and all walls will disappear. There are so many walls
> between me and you. A wall in itself is a fine thing, if the
> proportions are right.
> When I go to Berlin, within five minutes
> at most someone pulls me around asking, "Have you been
> to the wall?" Yes, I know the wall from inner experience. I
> know exactly what it is, that wall. Furthermore, I declare
> myself ready to solve the wall problem in my lifetime, if I
> am given the opportunity. For many years, research data
> that make this possible have been in existence. These
> tried and tested data have recently been supplemented by
> new data that are not only well intentioned but actually
> good. There is a healing power in them. This has already
> shown itself. It will show itself more and more.

Aachen in 1964 thus marked a turning point, in
several senses, within Beuys's artistic career. He had clearly seen
that he could no longer work with the neo-Dadaistic tendencies of
Fluxus. He wanted a platform, a goal. Provocation alone would not
suffice. So Beuys launched, in opposition to the spectacle of Fluxus,
an "energy impulse" of his own, with which he hoped to achieve
an expansion of consciousness. He was completely sure of his
ground: he had the more profound approach, the wider dimen-
sion. With his shamanic gifts, Beuys was an individualist by nature,
one who carried others along with him. He always stood out in any
group, as even his early Fluxus events had shown, and whether in
high school, or as an Academy student, or as a professor, he always
ended up—intentionally or not—as the center around which every-
thing else revolved. Conflicts with the other Fluxus people were
inevitable. Beuys was fated to go his own mysterious way.

He had prepared himself for this as early as 1959,
when for the first time he boarded his own mental *Trans-Siberian
Railroad.* This was a shed that could not be entered: the interior
could be seen only through a peephole in one wall. A sculpture
with the same title was made in 1961, and in 1970 Ole John fol-
lowed the concept through in his film *Trans-Siberian Railroad,* with
Beuys in the leading role. Just as Warhol, in the 1960s, filmed the
Empire State Building from a fixed angle and pointed his camera
through the keyhole of a hotel room, the camera in *Trans-Siberian
Railroad* records the space as though through a peephole, with the

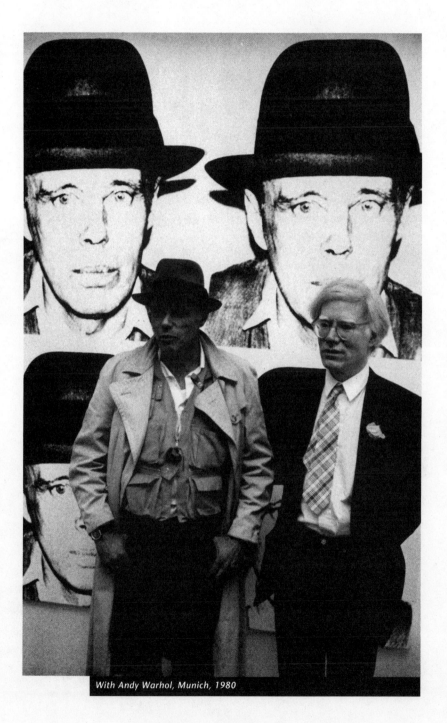

With Andy Warhol, Munich, 1980

single eye of the beholder. The sense of enclosure is perfect. Every now and then Beuys enters, wrapped in his long fur coat, stands against the near wall, and bangs on it. Otherwise the scene is empty. Toward the end of the twenty-two-minute film the picture begins to oscillate, quite slowly, and objects start to appear double.

Beuys's first solo Fluxus performance, *The Chief*, took place at Charlottenborg Palace in Copenhagen, in August 1964; Beuys repeated it on December 1 at the Galerie René Block in Berlin, as *The Chief, Fluxus Song*. The piece was designed for two performers, but Beuys's co-performer was thousands of miles away: he was the American artist Robert Morris, a fellow fan of felt, who performed the same "Fluxus Song" in New York at exactly the same time—in sync, as it were.

This is how it looked in Berlin. At precisely 4 P.M. Beuys wrapped himself in a roll of felt. At each end was a dead hare. On the wall to the left, parallel to the baseboard, was a line of fat—margarine to be precise—with a tuft of hair and two fingernails above it. Three of the corners of the space were fat corners, and in the fourth, a fat square. To the left of the roll containing Beuys was a copper rod wrapped in felt, and to the right, a loudspeaker. At irregular intervals Beuys uttered noises through a microphone and amplifier: he breathed audibly, groaned, coughed, hissed, whistled, and sighed. In addition, a tape recorder played, also at irregular intervals, compositions by Eric Andersen and by Henning Christiansen.

After eight hours, precisely at midnight, Beuys climbed out of his felt roll, smiling and very hot, and announced to anyone who wanted to hear that this had been the demonstration of a sculptural principle: it had been his intention to convey information on behalf of the dead hares, to the extent that human language incorporates animal elements. On the other hand, Beuys pointed out that the title of the Action, *The Chief*, might—like many of the titles of his Actions—be taken as a kind of code. What the boss says goes, but every individual is the boss, if he takes self-determination seriously. The boss is your own head.

On June 5, 1965, Beuys presented his piece *and in us . . . under us . . . landunder*, as part of the *24-Hour Happening* at the Galerie Parnas in Wuppertal. His fellow performers were Bazon Brock, Charlotte Moorman, Paik, Eckart Rahn, Schmit, and Vostell. Vostell lay on the floor and stuck pins into animal lungs; along the

whole length of the room he had laid a strand of barbed wire that was agitated by the mechanism of an old washing machine. His assistants lay on shelves like goods. Brock stood on his head, and behind a cutout window a revolving disk showed a different letter of the alphabet every fifteen minutes. By the end of the twenty-four-hour event, the letters had completed the following German sentence: "Nach experimentellen Ergebnissen tötet ein Gramm Kobragift 83 Hunde, 715 Ratten, 330 Kaninchen oder 143 Menschen" (According to experimental data, one gram of cobra venom kills 83 dogs, 715 rats, 330 rabbits, or 143 human beings). This is the label on the glass enclosure containing a cobra in the Frankfurt Zoo. Rahn made noises with a loudspeaker and two musical instruments—a double bass and a recorder; Schmit sat in the middle of a circle of plastic pails and halted his "performance" every time spectators appeared. Paik controlled a robot made from technological waste material, and Moorman played cello, wrapped in plastic.

Beuys squatted for twenty-four hours, mostly on a little orange crate, and listened to the inside of a fat chest. Nearby he had installed on a simple desk a sculpture made of margarine, on which he laid his head from time to time. At his feet were two blocks of margarine that looked like footstools. From his position on the orange crate he tried now and then to reach tools that were lying around, to no avail. Then he stood, picked up a two-handled spade with a heart-shaped blade, and held it aloft. He remained in this pose for a long time.

On November 26, 1965, Beuys put the hare into the leading role in an Action. The title: *How to Explain Pictures to a Dead Hare.* The place: Galerie Alfred Schmela, in Düsseldorf, a gallery that had committed itself early and strongly to Beuys and had done a great deal to promote his reputation. Beuys sat on a chair in one corner of the gallery, next to the entrance. He had poured honey over his head, to which he had then affixed fifty dollars worth of gold leaf. In his arms he cradled a dead hare, which he looked at steadfastly. Then he stood up, walked around the room holding the dead hare in his arms, and held it up close to the pictures on the walls; he seemed to be talking to it. Sometimes he broke off this tour and, still holding the dead creature, stepped over a withered fir tree that lay in the middle of the gallery. All this was done with indescribable tenderness and great concentration.

135

It may be that this piece was Beuys's way of expressing, in the most vivid and most simple way possible, what impelled him. He said once that his Actions and installations were intended to arouse in other people "counterimages": to provoke a spiritual response, to release an "energy impulse." What was this impulse intended to achieve? Beuys was certain that his images, as well as the counterimages, released something in human beings: mental and physical powers long buried by habit. What he set out to do was to make such images concrete, rather than to symbolize processes or acts. "I do not work with symbols," he once said, "but with materials." And he used materials in specific combinations to create concrete "still lifes": images that reveal new connections between existence and time. There is, after all, no such thing as a blue horse; and yet the German Expressionist artist Franz Marc, for instance, painted them. Nature is full of secrets. When Beuys set out to generate counterimages, he was clearly making a deliberate attempt to cross boundaries. And the expansion of art, and thus of human vision, is an utterly persuasive objective.

So it was that Beuys was able to say, in all seriousness, "The greatest composer of the present day is the thalidomide child." He placed this sentence at the center of a blackboard diagram, in an Action in the main hall of the Düsseldorf Academy on July 7, 1966. On stage was a grand piano wrapped in felt, and beneath it was a toy duck that could quack and flap its wings. The piano, robbed of its function, mute, even—if you will—suffering; the horrendous quacking of the duck; the diagram: Beuys was aiming to evoke a counterimage of the sorrow embodied in the tragic fate of the thalidomide child, in whom the outer and inner experience of suffering are "composed" to form a unity.

"Joseph Beuys. If you go by appearances, he is a fantastic figure, half-way between clown and gangster." Thus the Danish writer Troels Andersen began his account of the Beuys Action *Eurasia and 34th Movement of the Siberian Symphony,* with its introductory motif *Division of the Cross,* enacted at Galerie 101 (Handcart 13 group), in Copenhagen on October 14 and 15, 1966. Andersen continued:

> As soon as he goes into action he is transformed. Absorbed in his performance, he is intense and suggestive. He uses very simple symbols. His longest

performance during the two evenings was a ninety-minute excerpt (34th movement) from his *Siberian Symphony*. The introductory motif was *Division of the Cross*. Kneeling, Beuys slowly pushed two little crosses, which lay on the floor, up to a blackboard. On each cross was a clock equipped with an alarm mechanism. On the board he drew a cross, half of which he then erased, and underneath it he wrote *Eurasia*.

The rest of the piece consisted of Beuys's slowly maneuvering, along a previously drawn line, a dead hare whose legs and ears were extended by long, thin, black wooden sticks. When he held the hare on his shoulders, the sticks touched the ground. Beuys went from the wall to the board, where he laid the hare down. On the way back, three things happened: he scattered white powder between the legs of the hare, put a thermometer in its mouth, and blew through a tube. Then he turned to the blackboard with the half-cross on it and made the hare's ears quiver, while his own foot, to which an iron sole was tightly bound, hovered over another iron sole on the floor. From time to time he stamped on this sole.

137

Andersen went on to describe *Division of the Cross* as "the division between East and West, Rome and Byzantium." He interpreted the white powder as snow, the thermometer as cold, and the blowing into the tube as wind: and all these are associated with Siberia. So is the iron sole plate, which Beuys had also used in *Explaining Pictures to a Dead Hare* at the Galerie Alfred Schmela: "The going is hard," wrote Andersen, "and the earth is frozen."

Two weeks or so later Beuys repeated *Eurasia* at the Galerie René Block in Berlin, omitting *Division of the Cross* and incorporating the *32d Movement of the Siberian Symphony, 1963*. A work closely connected with *Eurasia*, as the title indicates, is *Eurasian Staff*. Beuys first performed it on July 2, 1967, in the Action *Eurasian Staff fluxorum organum op. 39*, at the Galerie Nächst St. Stephan in Vienna, to an organ accompaniment by the composer Henning Christiansen. The staff is made of copper, twelve feet long, and weighs 110 pounds. It has a handle like an ordinary walking stick. Beuys built a fat corner; wedged felted angle-beams

between floor and ceiling; ran the staff up the felt uprights, laboriously hoisting it into a vertical position; pointed toward the four cardinal points, then to the fat corner; and wrote on the floor: "Image head—mover head—the moving insulator."

Beuys and Christiansen performed another Action on March 20, 1967, at the opening of the *Fat Room* installation at the Galerie Franz Dahlem in Darmstadt. This was *Mainstream*. While Christiansen manipulated four tapes of music and speech fragments, Beuys performed for ten hours in a room along whose walls he had built a low rampart of margarine, which he constantly adjusted. From time to time he bit into lumps of fat, laid the resulting dental impressions on the floor, pressed margarine into the hollows behind his knees and into his armpits, and deposited the resulting casts on the floor as well. Intermittently he sprang around the room like a hare.

In these Actions, Beuys operated in numerous ways. Sometimes he repeated his established repertoire; sometimes he varied it. Familiar props reappeared in different positions. Beuys's talent for combining the most disparate materials, constantly creating new tensions and surprising relationships, once again seems remarkable. Everything merges together. A component of one Action becomes a relic to be incorporated in an installation or presented as an object in an exhibition—this is Fluxus in another sense: Beuys's work has the power to integrate all of its parts into one flow.

With Christiansen, Beuys gave another Fluxus concert in the Städtisches Museum, Mönchengladbach, in March 1969. Its title: . . . *or should we change it?* Beuys played piano, his partner violin. Beuys swallowed cough syrup and took nose drops. Christiansen played a tape of a man's voice saying, "*Jajajajaja, nänänänänä,*" as well as of birdsong, wailing sirens, street noises, electronic sound. Beuys played on a child's flute and occasionally on the piano, took more and more cough syrup, coughed into the microphone, and garnished the music stand with sauerkraut. Meanwhile, Christiansen drew squeaks from his violin, smoked a pipe, picked up a violin that was painted green, scraped on it, squeezed rubber balls.

Beuys said once that sound, too, is sculpture, that sculpture can be heard. He frequently presented sound sculptures. At the matriculation ceremonies at the Düsseldorf Academy in the

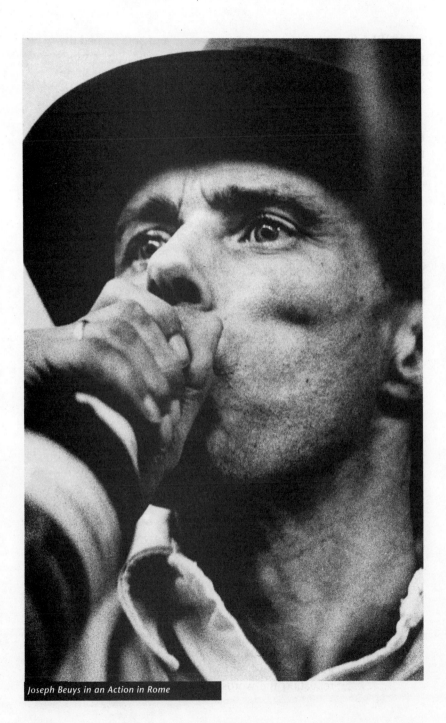

139

Joseph Beuys in an Action in Rome

fall of 1967, Beuys appeared with an ax in his hand and opened the proceedings with a ten-minute solo of barking, whistling, hissing, and bellowing into the microphone. To see Beuys talking in an Action was to observe the degree of sculptural shaping that he imposed on his speech.

At the end of May 1969 Beuys was to be seen in the exalted company of Goethe, William Shakespeare, Claus Peymann, and Wolfgang Wiens. This was at the Experimenta 2 festival staged by the German Academy of Performing Arts in Frankfurt. On stage was a white horse, which stood eating hay in a roped-off enclosure. Beuys worked in front of this, with microphone, sugar, and margarine; occasionally he placed a piece of iron on his head or played an orchestral cymbal. Wearing a long fur coat, he quoted, interpreted, and commented, through corresponding gestures, on extracts from Shakespeare's *Titus Andronicus* and Goethe's *Iphigenia in Tauris*. A tape played a montage of texts from both plays, monotonously intoned by Peymann and Wiens.

In a special issue of the magazine *Theater heute* surveying 1969's theatrical productions, the playwright Botho Strauss described Beuys's Action *Iphigenia/Titus Andronicus:*

> Beuys confronts us with the pictorial image. The horse is his personal epiphany. As he read out the texts, it continuously stood before him. The horse embodies an interpretation and a medium between the plays and Beuys. The text runs as a voice tape, an unsculptural, undifferentiated sound-continuum, apparently spoken quite some distance from the microphone; above all, one is aware of the speed with which the dramatic structure of the twin play proceeds toward its end. As for the contents of the collage, one has only to remember what the two plays are about and reduce them to a single idea: barbarism and control, the theme and the form.
>
> Beuys does not allude to the text, or illustrate it; it is not a score of stimuli for him, nor does it cramp or manipulate his actions. And yet it remains acoustic material, a ready-made substance to which Beuys lays himself open, with which he concerns himself in various ways, and which he is unable to internalize. By repeating the words, he transfers the text into his own

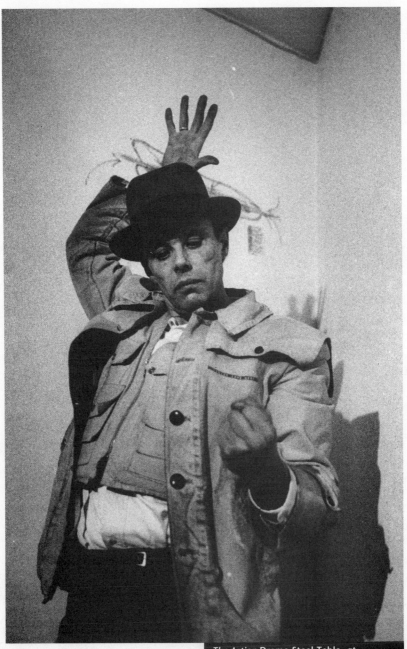

The Action Drama Steel Table, at Creamcheese, Düsseldorf, December 5, 1968

sphere, into a realm of such untheatrical spontaneity—
and also of such unflustered awkwardness—as could
never hold the stage in any other way. He imposes on
the theater, on the traditional space and on the literary
imagination, his own fictionless art.

Palms flat on hips, he strolls back and
forth before the microphone and displays movement in
the form of a number of idiosyncratic stereotypes: the
attempt to imitate the flight of a bird; emblematic ges-
tures, such as squatting down and raising hands to fore-
head and chin, palms outward, reminiscent of Indian
temple dancers or the like. Everything he does seems
unpremeditated, intuitive. Then his actions—loose in
sequence but controlled—take on, in relation to the
monotonous unfolding of the intact text, the nature of
counterploys, even acts of resistance.

Under the headline "Titus, Iphigenia, and the
Horse," the playwright Peter Handke remarked in the June 13,
1969, issue of *Die Zeit:*

> One thing must be absolutely clear: the
> more distanced and hermetic the presentation of the
> events on stage, the more clearly and rationally the spec-
> tator can relate those abstract creations to his own situa-
> tion on the outside. . . .
>
> The hermetic events in Beuys's produc-
> tion evoked such thoughts as did no other event at Ex-
> perimenta. . . . Beuys, instead of maintaining an utterly
> remote and hermetic demeanor, occasionally reacted to
> the audience on a trivial level: for instance, when the
> horse urinated and the audience clapped, he clapped
> back. His movements, his crouching, his splendidly
> unprofessional way of reciting the lines: all this ought to
> have been much stricter, more desperately illusory. . . .
>
> But the further the event recedes in
> time, the less important these aberrations become, and
> the more powerfully the horse, and the man walking
> round the stage, and the voices from the loudspeakers
> merge into an image that might be called an ideal
> archetype. In retrospect, all this seems to have branded

itself upon one's own life, as an image that inspires not only nostalgia but also the will to work on such images oneself; for it begins to operate within one only as an afterimage. And an excited serenity comes over one when one thinks of it: it activates; it is so painfully beautiful that it becomes utopian—and that means political.

At Edinburgh College of Art, at the end of August 1970, the Action *Celtic (Kinloch Rannoch) Scottish Symphony* took place. Once more, Beuys's partner was Henning Christiansen. Beuys told Hagen Lieberknecht that as soon as he arrived in Scotland he began to sniff the air, his antennae went out, and he immediately received a signal: "All of that had been alive inside me for a long time: Scotland, Arthur and the Round Table, the Grail legend. The elements coalesced and emerged. By virtue of the prior work. And this does not have to be regarded simply as a score. The prior work has to do with my life."

Beuys used cassette recorders, tape machines, film projectors, a piano again, a microphone, a spear, a stick, an ax, a big round silver salver, a blackboard, a ladder, some gelatin. The room was darkened, and a tape of piano music played. From the tip of the spear hung a red string: blood. Beuys drew a diagram on the blackboard, which lay on the floor, pushed it across the room with the stick, and gave the cue to run the film of *Eurasian Staff* to the accompaniment of the *fluxorum organum* music. As the Action went on, there was Beuys suddenly in the center of the room. He twisted round, hopped on one foot, held his stick behind him, stuck it forward between his legs, went into the wildest contortions, grimaced, and laughed. Then new elements were introduced, such as a film called *Rannoch Moor,* showing Beuys and other performers in the Highlands, with music by Arthur Köpcke. Then organ music thundered forth from the loudspeakers, and cries were heard. Beuys climbed the ladder and patiently, bit by bit, scraped blobs of gelatin from the walls, tossing them onto the silver salver, which he balanced on his left hand. When he had finished, he stowed away the ladder, lifted the salver above his head, and dumped the wobbly mass of gelatin over himself. He set down the salver, picked up the blackboard with the diagram on it, cried out "Ö, Ö, Ö," lay down, sprang back up, grasped the spear in his right hand, and remained motionless for one hour.

Beuys and Christiansen staged this piece—as part of the Edinburgh Festival—ten times in five days, in private performances. At the beginning of April 1971 they repeated it, under the title *Celtic + rrm*, in the civil defense shelters in Basel. This version differed markedly from the one in Edinburgh.

The curtain raiser in Basel was a public washing of the feet of seven people. Beuys, with spectators crowding around him, carried out this spectacular first act of the Basel *Celtic* drama with great discipline. What followed was more or less identical with the sequence in Edinburgh, except that Beuys had some initial difficulty in moving as he wanted to, surrounded as he was by the throng of spectators. It was not until he scraped the gelatin from the walls and laid it on the silver salver that the crowd thinned out. Once more he dumped the mass of gelatin over his head, raised the blackboard, which bore a scene from the Grail legend, above his head, uttered unintelligible noises, and for more than half an hour stood, spear in hand, behind the board as it lay on the floor: Beuys, guardian of the Holy Grail. Then he strapped a flashlight to each of his thighs and stepped into a tub of water; his partner, Christiansen, poured a can of water over his head.

Beuys once said that it was a good idea to describe what one saw; this was the way to get into the realm of what he meant. Even guesswork was all right, because it set something in motion, but one should resort to interpretation only "in emergency, or for educational purposes." By rational criteria, much of what Beuys did is impossible to grasp. The emphasis is all the more on intuition, which he described as a higher form of reason. The counterimages that Beuys sought to create were images that spring from intuition. They were the images of a mysterious but powerful inner world. "I have no desire to talk about the telephone," Beuys said. "I am interested in the forces it involves."

The power of signs, the fascination of rituals: here Beuys consciously accepted the risk of being misunderstood. Foot washing and baptism are, of course, images to which Christian tradition lays prior claim. For an artist to repeat such actions, so full of Christian symbolism, is to take a considerable risk. The accusation of kitsch all too readily springs to mind. But again, the rigor with which Beuys gave concrete reality to his ideas is impressive. He had a remarkable way of evoking complex contexts through basically

simple acts. Few still complain, these days, when stage directors rework, distance, and "alienate" classical dramas, perhaps in order to interpret the old content in terms of the contemporary. Through his Actions, Beuys gave old signs new meanings, which each person confronted with them must ultimately clarify for himself.

Beuys's counterimages provide abundant cause for astonishment and reflection. Whatever he said and did, wherever he appeared, surprises and extraordinary events lay in store. He took the blame for snowfall from February 15 through 20, 1969; ten years later he declared blood sausage to be the most convincing form of sculpture. For his fiftieth birthday, on May 12, 1971, he had his students adorn him with raw eggs, rice, and leaves, and in March 1977 he planted potatoes outside the Galerie René Block in Berlin. To cover the living costs of his Free International University co-workers at Documenta 6 in 1977, he made an offset print, *Food for Thought*. On June 9, 1982, he went to the Turkish embassy at Bad Godesberg, near Bonn, and protested torture in Turkey by performing *Blood Action*. At a peace demonstration on the Rheinwiesen, in Bonn, on June 10, 1982, Beuys appeared as a singer, performing a number entitled *Sonne statt Reagan* ("Sun Not Reagan" [a play on the German word for rain, *Regen*]). In his "Life Course/Work Course," he noted meetings with the Dalai Lama, with Chancellor Bruno Kreisky of Austria, and with the influential German banker Hermann J. Abs.

In November 1970 Beuys strung together the bones from a fish dinner at home and hung them from the ceiling of the Eat-Art Gallery in Düsseldorf, then run by Daniel Spoerri. He called the Action *Friday Object 1a Fried Fishbones*. He rubbed ashes over his face, wrote sale certificates for the fishbones, and positioned himself in one corner of the gallery, in a long dark coat and leaning on a stick. He stayed there for hours on end. This, if you will, was an anti-Action: an Action against himself. He had circulatory problems and ought not to have smoked. Often he smoked a cigarette halfway and tucked the butt into a pocket of his fishing vest. He was supposed to rest a lot and keep on a strict diet. With his Friday fish Action he invoked a counterimage of his own suffering.

In 1971 Beuys immersed himself in the Zuider Zee—or more precisely, at the water's edge. There is a large area of

marshland there; to drain it for land reclamation would destroy the wetland ecology. With this *Bog Action,* Beuys once more raised into consciousness something that would increasingly become recognized as a vital social priority: protection of the environment.

Twelve years later, Beuys initiated a second environmental initiative, the Spülfeld Altenwerder pilot project, on the south side of the Elbe in Hamburg. The Altenwerder flats are a tract of highly polluted Elbe and North Sea mud where dumping has occurred over the years. Nothing remains of the village of Altenwerder but the church; all the rest—including extensive orchards—lies buried beneath the mud. When the Hamburg city arts administration asked Beuys to suggest a project for "Art in Public Spaces," he responded with a proposal to plant the polluted area with trees and bushes. It was Beuys's scientifically based idea that the plants would bind the toxic substances in the soil and prevent them from leaching out into the groundwater.

In the center of the area he sought to reclaim was to be placed one of the basalt blocks from his *End of the Twentieth Century.* The work remained only a vision, even though the city arts administration supported Beuys's project and there seemed to be no problem with financing it. But then the mayor of Hamburg, Klaus von Dohnanyi, intervened. On ZDF television's arts magazine program "Aspekte," he disputed "the artistic character of this undertaking." Beuys's project came to nothing.

Another project, however, was a glorious success: *7,000 Oaks,* for Documenta 7, in 1982. On June 19, the opening day of the exhibition, Beuys planted the first of seven thousand oak trees on Friedrichsplatz, outside the Museum Fridericianum, and there, on the first day of Documenta 8, five years later, he intended to plant the seven thousandth tree. He did not live to do so, but the idea caught on. "Urban Afforestation Not Urban Administration" was Beuys's slogan in 1982. His plan was that in a major ecological campaign, seven thousand oak trees were to be planted in the urban area of Kassel, and next to each tree was to stand a basalt column, four feet high. The cost to each purchaser, including transportation, planting, and ancillary work, would be $210. The total cost has been estimated at about $1.68 million. Each donation was acknowledged by a certificate and a "tree diploma," signed by Beuys and with the stamp of the Free International University.

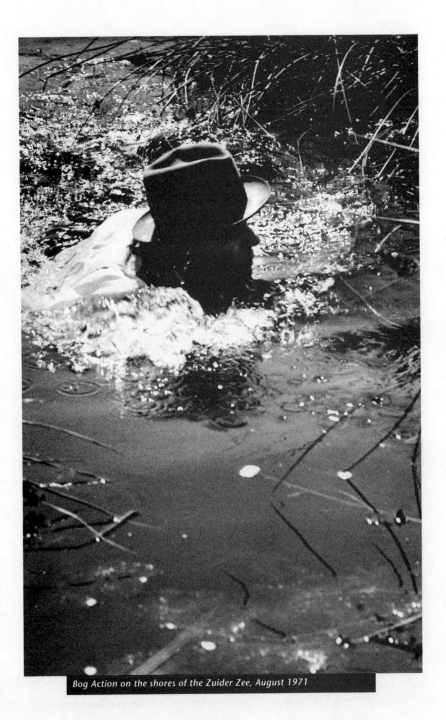

Bog Action on the shores of the Zuider Zee, August 1971

In 1982, when Beuys's seven thousand basalt blocks were piled up, forming a range of wedge-shaped mountain peaks on Friedrichsplatz, there was a storm of protest from the citizens of Kassel. It was said that downtown Kassel's historic center, the city's "best parlor," had been desecrated. Beuys's proposal to set up an "ecological sign" was not well received. Drivers feared the loss of their parking places; others worried that someday urban afforestation would get out of hand and that the trees would grow so tall that they would interfere with gas and electricity lines.

Even so, the "7,000 Oaks Coordinating Bureau" in Kassel had some success to report. Local community councils, associations, and citizens' initiatives came up with siting proposals; many patches of land outside schools and kindergartens, and many playgrounds, could be greened with Beuys's trees; and there were enough unbiased citizens—or citizens able to get over their biases—to allow trees to grow in their streets. However, only a small proportion of the oaks have been donated by Kassel citizens and institutions; most of the sponsors are outsiders, and the Japanese are easily in the lead with well over a thousand.

By the time Beuys died, 5,500 of his oaks had been planted. Had he lived until his sixty-fifth birthday, on May 12, 1986, he would have been gratified to know that by then a total of 6,100 trees, complete with basalt blocks, had been planted. At the opening of Documenta 8, on June 12, 1987, in the presence of Eva Beuys, his son, Wenzel, planted the seven thousandth oak. Kassel now has a sculpture that grows over the years, probably the biggest ecological sculpture in the world, and it is indebted to its "own" artist, Joseph Beuys, who from the time of his first appearance at the 1964 Documenta consistently attracted worldwide attention with his dramatic contributions to the exhibition.

Characteristically, Beuys had attached some fundamental conceptions to this tree Action. He took the view that trees today are far more intelligent than people. In the wind that caresses their leaves, there blows the essence of suffering human beings, and the trees perceive it, for they themselves are sufferers, disinherited like the animals. Beuys wanted to give these trees and animals back their rights. The whole *7,000 Oaks* project is a basic contribution on Beuys's part toward the realization of his idea of Social Sculpture. He aimed to improve the quality of urban life and

to give concrete expression to what he called "super time": time measured in terms of the life span of an oak, which he figured as eight hundred years. Ultimately, he was concerned with fostering awareness of the need to conserve the environment everywhere in the world. "We're going to Russia and China, too," he announced in Kassel.

The Installations

"I call everything drawing," Beuys once said. He regarded his studio as a laboratory, in which he worked on "research reports." He regarded drawing as the basis of all his work as an artist, as defined by the expanded concept of art. Drawing, he constantly reiterated, helped him clarify his thoughts about his work in society. He never ceased to draw, even at the time of his most intensive political commitment.

Beuys loved the simple, plain, "poor" materials for which he found such varied uses, as is clearly evident in the enormous corpus of his works on paper. He often used scrap paper, and when he chose to use handmade paper he liked to alternate it with scrap. He also used cardboard and cloth, and he was always drawing on stamped, creased, torn, written-on, ruled, squared, patched-together, discolored sheets of paper. Beuys also expanded the concept of watercolor: he drew with blood, beef tea, whey, fruit juices, vegetable juices, herb juices, coffee, tea, stagnant water enriched with rust and dust, iodine, and wood stain.

Similarly significant are the works that Beuys published as multiples. This was a medium of communication for which he had a strong instinct. Accordingly, many of his works were issued in editions—from massive print runs of postcard sets to limited editions of objects. Beuys constantly stressed his concern with spreading ideas, with giving them a wide public circulation. He succeeded in doing so as no other postwar German artist has done.

There are some telling examples of how strong the influence of one medium on another could be. For instance, the foot-washing sequence from the Action *Celtic + rrm*, in Basel in 1971, found a continuation in the multiple *For Foot-Washing*, in 1977. This consisted of a number of enamel bowls, of East German manufacture, to which Beuys added the inscription *Für Fusswaschung* and his signature. *Honey Pump at the Workplace*, Beuys's contribution to Documenta 6, in 1977, lives on in the multiple *Give Me Honey*, of 1979, a metal pail of honey. The silkscreen *Earth Telephone*, of 1973, refers back to the object of the same title made in 1967.

One early forerunner of his multiples was the simple little wooden box that Beuys first brought out in 1968 for two dollars and subsequently sold by the thousands. Inside it he drew a line with a pencil, above which he wrote the word *Intuition*—that was all. Simple though it may seem, this work is a piece of Beuysian philosophy: a representation of the insight that intuition is a higher form of reason. The box is empty only for those to whom intuition has no value, for those who like to be supplied with a recipe. Beuys issues no recipes. Here, as elsewhere, he inimitably supplies an energetic impulse.

That impulse was experienced in 1973, in a rather different way, by certain ladies of the Altenrath section of Leverkusen. Requested by their husbands to find some chairs for a summer gathering of the Social Democratic party (SPD) at the city's museum, Schloss Morsbroich, they found in a storeroom an old baby bathtub swathed in gauze bandages and equipped with Band-Aids, a lump of fat, and Vaseline ointment. They at once decided that this was just the right receptacle for rinsing beer glasses. So they set to work and cleaned all the "garbage" out of the tub. In their energetic efforts for the SPD party they had unwittingly destroyed a work of art by none other than the celebrated Düsseldorf professor of sculpture, Joseph Beuys.

In the early 1960s Beuys had determined that this tub was the one in which he had been bathed as a baby by his mother. And so he decided to present a section of autobiography, which he did in his radical way, by using gauze and bandages to refer to the cutting of the umbilical cord, and Vaseline to refer to the constant care required by the infant Joseph. *The Bathtub* came into the possession of the Munich art collector and publisher Lutz

151

Schirmer, who lent it with other Beuys objects to the Von der Heydt Museum in Wuppertal for a touring exhibition in 1972. The last venue on that tour was Schloss Morsbroich, where after it closed, the show's valuable contents were stowed away in a secure place—at least until those festive ladies came along.

When Schirmer got his *Bathtub* back and saw what had happened, it reminded him of nothing so much as a shaved cactus. He lodged a complaint with the state court in Wuppertal, which resulted—after some shilly-shallying and the calling of expert witnesses, including Beuys's Düsseldorf dealer, Alfred Schmela—in the payment of $30,400 in damages to Schirmer.

Beuys's exhibitions nearly always had the character of installations or environments. This is true even of the early exhibitions organized by the van der Grinten brothers on their parents' farm at Kranenburg, such as *Giocondologie,* Beuys's tribute to his revered master Leonardo da Vinci; the drawings, woodcuts, and sculptures shown there in 1953; and, in particular, the Fluxus exhibition in the stable in 1963. One contemporary account of that exhibition, in the *Rheinische Post,* rose to some fine flights of rhetoric:

> The Fluxus works of Joseph Beuys are marked by a perfect synthesis between an extreme of ascetic refinement and its total antithesis, "nature" at its rawest. Invocatory alienation of the known, revelatory selection of the inconsequential, and associative juxtaposition of the remote have here created objects that for the first time convey—instead of beautiful appearances—the fascinating aura of a new Being, a new Reality.

Between 1961 and 1967 Beuys made a large shelf piece, *Barraque Dull Odde,* a work with alchemical overtones. The shelves are crammed with things that Beuys the researcher has collected: flashlights, batteries, preserving jars, scraps of felt, screws, tools, wires, vessels of all kinds, bottles, stones, old clothespins—a typical Beuysian arsenal. *Barraque* means "frame," *Dull* means "absurd," and *Odde* means "wilderness." Next to the shelves stands a table, strewn with Beuys's notes; in front of it is a chair. The piece also incorporates two video recorders, each with a monitor, and nine tapes of Beuys's 1971 Action *Celtic + nm. Barraque*

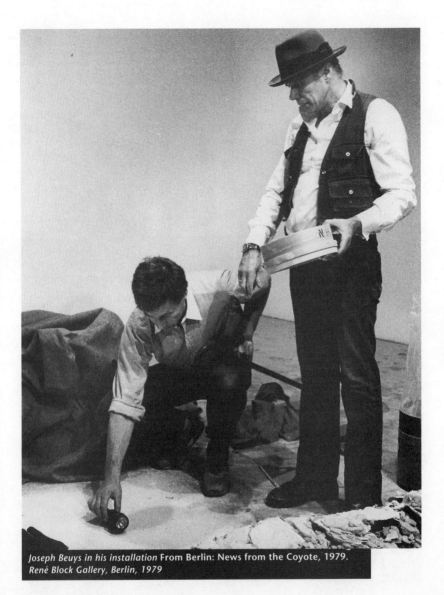

Joseph Beuys in his installation From Berlin: News from the Coyote, *1979.*
René Block Gallery, Berlin, 1979

153

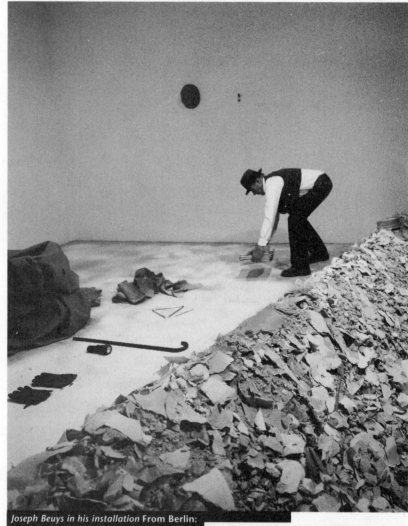

154

Joseph Beuys in his installation From Berlin: News from the Coyote, 1979. *René Block Gallery, Berlin, 1979*

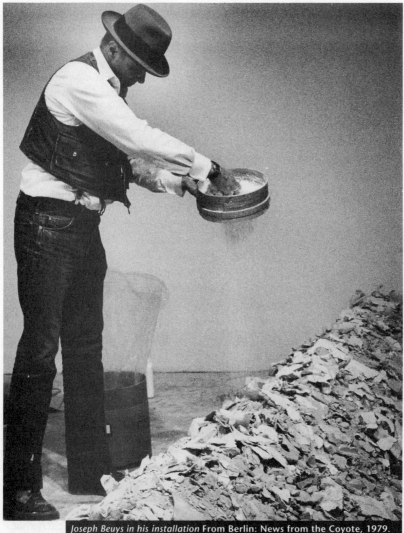

155

Joseph Beuys in his installation From Berlin: News from the Coyote, 1979. *René Block Gallery, Berlin, 1979*

Dull Odde is now in the Kaiser Wilhelm Museum in Krefeld, which acquired it from the Lauffs collection.

Another spectacular work, which has remained in a private collection, is *The Pack,* of 1969. It consists of a Volkswagen minibus with thirty-two little sleds streaming out of its open rear doors. Each sled is equipped with a roll of felt, a lump of fat, and a flashlight.

In a succession of exhibition projects Beuys drew attention to the special qualities of his work, with its constant shifts and its constant interchanges between the realms of drawing, multiple, object, sculpture, installation, and Action. The aspiration to totality was implicit from a very early stage. *Parallel Process,* begun in 1967 at the Städtisches Museum, Mönchengladbach, was just such a project. It presented relics of Beuys's Actions in conjunction with other, "independent" objects in glass cases, the documents of his artistic activity. *Parallel Process* itself was shown seven times more, all in 1968—in Antwerp, in Eindhoven, at Documenta 4, and in Düsseldorf as an exhibition; in Karlsruhe, Stuttgart, and again in Düsseldorf—as a "Statement" for or against specific events. Its showing at the Düsseldorf Academy, for example, was prompted by the vote of no confidence in Beuys by his colleagues.

Another series important to Beuys is *Fond,* consisting of six items made between 1966 and 1980. *Fond 0* (1953) is a massive iron block. *Fond I* is a glass jar of preserved pears, given to him by his mother, which in 1957, after he had conquered his depression, he elevated to the rank of an energy-giving object. *Fond II* (1968) consists of two tables covered with copper sheet metal, with batteries, glass tubes, and wires beside them.

Fond III was first shown at Galerie Alfred Schmela, Düsseldorf, in 1969. Georg Jappe wrote in the February 11 *Frankfurter Allgemeine Zeitung:*

> Nine massive stacks of felt, each made up of a hundred thick gray sheets of felt capped with a brand-new, gleaming sheet of copper, convey beneath dim lighting the oppressive atmosphere of a warehouse in which the stored material, as if unredeemed, waits for activity. . . .
>
> For Beuys, the effect of an intimidating stockroom of muffling material is only "the residual product of the idea, namely the mood. At the outset of

my work, feelings may have been my starting point, but since then ideas have crystallized out. The primary thing here was the idea of the battery. These felt piles . . . are aggregates, and the copper sheet is the conductor. And so, to me, the capacity of the felt to store energy and warmth creates a kind of power plant, a static action."

There were further *Fond* installations, again at the Schmela in 1976, then at the Fifteenth Bienal in São Paulo, where Beuys presented *Brazilian Fond,* an environment of four piles of felt, some sixty-three inches high, each trimmed on one side to a semicircular shape and each standing on a copper plate. Four massive horseshoes: the association is hard to avoid. In June 1984 the Seibu Museum of Art in Tokyo, which also played a major part in the *7,000 Oaks* Action in Kassel, staged an exhibition of works from the large Ulbricht collection of Beuys works in Düsseldorf. At the center of this exhibition was a *Fond* environment built up, once more, from piles of felt and copper plates.

In the exhibition, *from here out* in Düsseldorf in September of the same year, Beuys was represented by this same *Fond* piece and by the installation *Economic Values.* This is a group of iron shelving units sparsely laid out with basic groceries from East Germany: flour, margarine, bottled beer, sugar, instant coffee, Tempo brand peas, oatmeal, all bought from the state HO supermarkets. A dismal sight, and particularly so in the Federal Republic, land of the economic miracle. A typical Beuysian provocation, once again: a "counterimage." On the walls were original paintings by Otto Dix, Gert Heinrich Wollheim, Jankel Adler, Karl Schwesig, Theo Champion, and Peter Ludwigs, the circle of friends who congregated around the legendary Düsseldorf café owner and encourager of artists, Johanna "Mutter" Ey.

It was in his installations, above all, that Beuys demonstrated—aside from the mostly obscure and mysterious contents—his growing mastery of presentation and "stagecraft." During the group show *Art into Society—Society into Art,* at the Institute of Contemporary Arts, London, in October 1974, Beuys spent most of his time debating with visitors to the exhibition. He wanted to make clear the "directional forces of a new society." And so, as on many other occasions, he wrote words and diagrams on blackboards, which he tossed onto the floor once he had finished

with them. This produced the environment *Directional Forces 1974,* which was installed in the René Block Gallery, New York, in 1975 and was bought by the Nationalgalerie in West Berlin a year later. Altogether there were 100 blackboards with diagrams and words, three easels, a projection of a photograph, and a walking stick.

Beuys constantly took elements from his multifarious and—considering his intentions—nevertheless unified work and presented them in different contexts. The results of such metamorphoses belong predominantly to the realm of the mysterious, the enigmatic, the existential; the realm of suffering and of death. Beuys was a moralist. He urged his spectators or listeners, as the case might be, to concentrate on their own strengths, abilities, and hopes. His "anthropological" interpretation of the world always took as its point of departure the human individual as a creative being who must be placed in a position to shape his own future. This is why Beuys evoked counterimages of humankind; this is why he spoke of the ultimate necessity of expanding the concept of art to achieve Social Sculpture.

Joseph Beuys's concrete images often possess an uncanny density and an overpowering magical quality. This applies particularly to his last installations. It is as if this increasingly gaunt and ascetic man had long sensed the approach of death.

In 1977 the Kunstmuseum in Basel bought *Hearth I,* which had been shown in 1974 by the Ronald Feldman Gallery, New York, first at the Basel Art Fair and a few months later at the Feldman Gallery itself. It consists of a wooden wagon loaded with two copper rods, its handle lowered to the floor; another copper rod, shaped like a walking stick and wrapped in felt; and groups of copper rods leaning against the walls. Among other items are three blackboards suspended from the ceiling, with characteristic Beuys diagrams and statements on them. In addition to the original installation, there has been since 1978 a pile of other metal components and imitations of the felt suits, modeled after Beuys's own, that had been issued as a multiple in an edition of a hundred by Galerie René Block, Berlin. The felt suit is an extension of Beuys's concern with the idea of warmth sculpture.

These felt suits are those of sixty citizens of Basel, who took the opportunity that the 1978 Mardi Gras parade provided to dress in Beuysian felt, don animal masks, and "protest," not entirely seriously, the purchase by their local art museum of

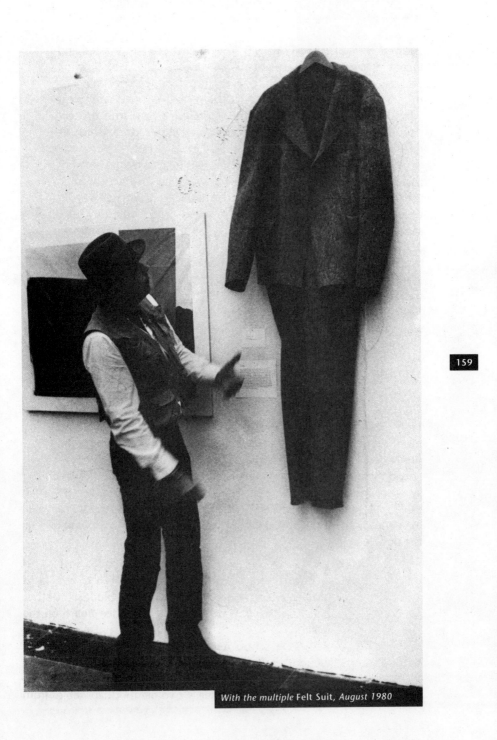

159

With the multiple Felt Suit, *August 1980*

Hearth I for the sum of $159,000. They claimed to feel cheated and incensed, and they handed out a flier on the subject of *Hearth I*. Beuys joined the parade in a felt hat and a long felt coat, was surrounded by ostensibly protesting citizens, and beamed with pleasure. Later he arranged a number of relics from the protest demonstration—suits and metal rods—to create *Hearth II*, which he gave to the museum.

A major public ruckus was ignited by the environment *Show Your Wound*, which Beuys installed in the Städtische Galerie im Lenbachhaus, Munich, on January 22 and 23, 1980. Galerie Schellmann and Klüser, also in Munich, had shown the same work in the art space of the Maximilianstrasse-Altstadtring pedestrian underpass early in 1976, without eliciting any marked reaction. It was not until the environment was acquired by the Städtische Galerie in 1979—and the purchase price of $154,000 became known—that all hell broke loose, regardless of the fact that half the sum came out of the gallery's annual budget and the rest was provided by private donors. The media jumped all over it. There was a storm of protest from citizens. Words like "degenerate" were bandied about. Politicians fought to get a piece of the action. Epic battles were waged in the letters columns of the newspapers. There were, fortunately, a number of rational voices and positive attitudes; Beuys did not stand alone. He himself was in dazzling form, debating with wit and aplomb at numerous seminars and meetings, and handling interviewers with panache. Every time, he succeeded in making the majority of his hearers think again and abandon some of their prejudices. Beuys always had an answer, and usually he had the last laugh.

The piece *Show Your Wound* is a death piece, a memento mori. It both repels and attracts. In it, Beuys combined five double objects:

> 1 Two implements, with wooden shafts and wrought-iron blades, bearing "Brown Cross" and "Mainstream" stamps, leaning with blades together against a two-part, white-painted wooden board on the wall.
> 2 Two school blackboards, on which "show your wound" has been chalked in a childish hand.
> 3 Two beds, perhaps the most memorable of all the groups, which are actually two old mortuary tables from

a pathology lab, together with two "lamps"—galvanized iron boxes, each fronted with a glass pane smeared inside with fat; two galvanized iron chests filled with fat and each fitted with a clinical thermometer and a test tube containing the skull of a thrush; and two preserving jars covered by gauze filters.

4 Two "standards," wooden-handled iron forks, each with a colored neckerchief tied around it and each standing on a slate tablet onto which a semicircle has been scratched.

5 Two newspapers in postal wrappers—copies of the Italian left-wing paper *La Lotta continua* (The Ongoing Struggle)—addressed to Joseph Beuys. The papers are mounted in glazed, white-painted wooden boxes.

In an interpretative essay Armin Zweite, director of the Städtische Galerie im Lenbachhaus, pointed to the "connection with the evocation of death." The injunction "show your wound" addresses a sensitive aspect of humanity:

> Repression seems to be the stock response here. To the question of why this is so, the most varied answers have been given. Most of all the insight carried on here is the realization that feelings and sensations—positive or negative—do not constitute a direct effect of nature. The development of feelings of shame and embarrassment, in particular—and this is certainly what we are dealing with here—must in fact be both natural and historical.

161

In the context of the whole environment, with its varied allusions to the individual and society, the injunction "show your wound" indirectly signifies ". . . the simultaneous existence of social prohibitions and restrictions and of their psychic substrate: specific fears and feelings of aversion and embarrassment."

This, Zweite says, to some degree explains the vehemently hostile reactions to this particular work by Beuys: "The mortuary tables bring into consciousness what is supposed to be taboo. The encounter with death, even in this objectivized, indirect form, is equivalent to confessing one's own impotence in the face of terror and also one's inability to give an adequate response." According to Zweite, when Beuys was asked what he really meant

by this environment, he answered that his primary concern was "to make visible the death zone toward which today's society is rushing with great speed."

Death as a mythic event, a magical rite; the wound that can account for death: these are ideas that played a major part in Beuys's thinking from very early on. He had come face to face with death early in life; he had been severely wounded more than once in the war. Beuys knew all about wounds. In this sense, *Show Your Wound* is a piece of autobiography, an experience of pain. But Beuys never complained; on the contrary, he saw art as the only therapy that could lastingly heal the wounds of the individual and of society. When you put your finger on the sore point—on the wound—you clarify a problem; you get to the heart of the matter. *Show Your Wound* touches the core of human existence, the question of life and death. The shock it provokes was intended; once more Beuys revealed himself as a rigorous moralist.

Another piece of autobiography—a childhood experience—is *Tram Stop,* a striking monument that Beuys created in the German pavilion at the 1976 Venice Biennale. The story is familiar: in Kleve, where Beuys grew up, Count Johann Moritz von Nassau, who governed the city on behalf of the great elector of Prussia, had monuments erected at all the avenue intersections. At the corner of Nassauer Allee and Gocher Landstrasse, the so-called Iron Man monument was placed in 1653. As a schoolboy Beuys was fascinated by this monument: a cast-iron gun barrel surmounted by an armored cupid and surrounded by four mortars. It became part of his inner life: the Iron Man stands right by the streetcar stop where Beuys waited every day on his way to school.

Now, in 1976, Beuys was able to transplant his memory of the monument in Kleve. Like many things he did, it turned out to be a simple and yet highly complicated work. The upright cannon barrel and the four mortars around it were cast directly from the Kleve monument but changed in proportion and in surface treatment. In place of the armored cupid, there was the bust of a man, his mouth open, his face distorted with pain, and the eyes sunk deep in their sockets. According to Franz Joseph van der Grinten, this was the work of a former student of Beuys who had modeled the head in his class. Beuys later modified her work and had it cast in iron. In Venice it achieved monumental status. The length of streetcar track needed for the installation—just over

twenty-six feet—was supplied by the Düsseldorf transportation department. It was set horizontally in the floor, and one had the impression that it came from the earth and returned to the earth. Its curvature, if extended, would have described a circle far out across the Venetian lagoon.

Two other interventions by Beuys evoked references to geological time. He had a special drill brought in to sink a borehole sixty-nine feet deep, at a specified distance from the monument. The water of the lagoon became visible thirty feet down. The British writer on Beuys, Caroline Tisdall, notes in the 1976 Biennale catalog that this borehole "makes a topographical link between the geological relationship of land above and water below in Beuys's native Cleves, on the Dutch border, and the lagoons of Venice. Running down the length of the borehole is an iron bar, bent horizontally at the surface, then vertically upwards: a schematic echo of the three main directions in *Tram Stop*": depth, breadth, and height.

A second aspect of the earth is provided by the heap of spoil extracted in setting up the Iron Man. The West German commissioner for the Biennale, Klaus Gallwitz, noted in his catalog journal:

163

> The excavated material from the monument is conserved. It lies in a heap next to the iron castings concreted into the ground. It is part of the Campanile of San Marco, which collapsed in 1902. The rubble was used to build up the ground level in the Giardini. The German pavilion stands on these remains, and the bones and shards that now come to light again give an unexpected extra dimension to Beuys's intentions: the historic ground on which he has erected his "monument for the future."

Gallwitz's journal also gives an impression of the intensity with which Beuys worked:

> Every day, between seven and eight in the morning, Beuys showed up at the pavilion. The guards had only just opened it up. Installation of *Tram Stop* could begin. . . . For ten days on end, Beuys worked in Venice from morning to night, hard manual labor with all the attendant progress and setbacks. To

the conceptual dimension of *Tram Stop* was added the experience of the building trade: fast-setting concrete, lonely chiseling on weekends with the unsuitable tools of the janitor, Boscolo. Beuys felt the resistance of stone and iron, earth and water. The elements not only stirred his senses but his physical powers. The difficult process of laying the foundation of the monument into the earth brought a crisis in the first days of the work. Operations were temporarily suspended, but this proved to be a productive pause. He and the Italian workers understood each other better every day.

On the opening day of the 1976 Biennale, Beuys treated the builders who had worked so hard with him on *Tram Stop* to bread and wine in the German pavilion. One year later, at Documenta 6, visitors were treated to honey for one hundred days. In the stairwell of the Museum Fridericianum, Beuys had installed his *Honey Pump at the Workplace*. One of two electric motors drove a pump that constantly propelled several hundred

164

gallons of honey through a gigantic system of Plexiglas tubes that ran from the basement to the roof. The other motor rotated a crankshaft coated in thick layers of fat. On its way through the Fridericianum the honey pipeline led into the back room that Beuys had chosen as the location for his Free International University (FIU), and in which, at the information office of the Organization for Direct Democracy through Referendum, he spent one hundred days talking, preaching, debating, and teaching.

Beuys said at the time that *Honey Pump* was intended to be a workplace like any other: the workplace of a collective of the FIU. Honey, as we have seen, had always interested Beuys as a primal example of sculptural form in nature. He had, he told Volker Harlan in conversation, "let the thing go on for a long time without putting it into practice." Now he was able to get his circulatory system running. To Harlan he gave explanations that seem almost simpleminded: the honey pump was the circulation of the blood, the FIU room was the ventricle of the heart, and the head organ was the long tube up in the roof space, where there was a kink and the honey flow was blocked: "So I had the feeling there must be something like a brain, like a head, where something builds up and takes on the function of the head, up there in the roof of Documenta." Beuys developed his *Honey Pump at the*

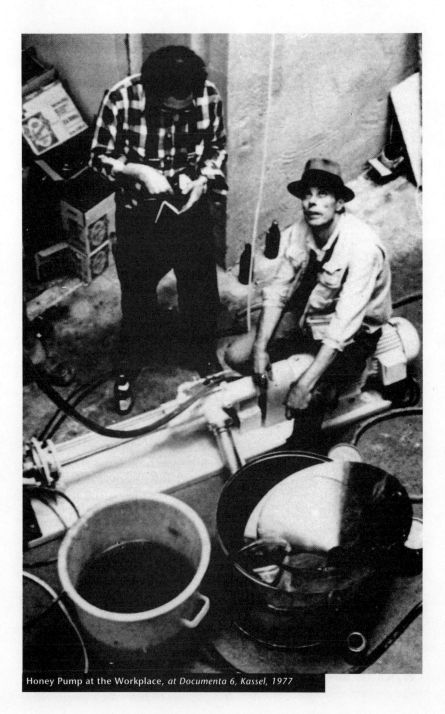

165

Honey Pump at the Workplace, *at Documenta 6, Kassel, 1977*

Workplace into a symbol of creative forces, as manifested in motion (heart), thought (head), and will (machine).

The dimensions of Beuys's art are vast in every sense. *Honey Pump* is one example, another is the installation *The End of the Twentieth Century,* a collection of big, heavy rocks from which a cone has been carved out and then bedded in felt and clay. Yet another is the environment *Lightning with Stag in Its Glare,* which the city of Frankfurt acquired in 1987 for $1.4 million.

Lightning is the only one of Beuys's environments to be cast in bronze. Four casts of it exist, one of which was shown at Documenta 8 in 1987. His idea was to build a kind of workshop in which primeval entities would unite as prototypes of the mystery of life and of the origin of life. The earliest plans date from 1958, but it was not until 1982, when at the *Zeitgeist* exhibition in Berlin the big patio of the Martin-Gropius-Bau was placed at his disposal for an installation, that he was able to bring together all the elements for his workshop and establish the shape of the work as it was to be cast in bronze.

The environment is in thirty-nine parts, of which thirty-five are "primeval creatures," shaped by Beuys from clay and tools. A *Goat* was made from tools and an old iron mining truck. From the wooden components of an old ironing board he made a *Stag.* In an "earth box" are the withered roots of a plant that Beuys dug up on his 1964 visit to Manresa, in Spain, the place where Loyola began his *Spiritual Exercises.* This box he called *Boothia Felix.* The *Lightning* is a segment of the huge mound of clay Beuys had erected at the Martin-Gropius-Bau. He intended it to tower above all the sculptures in the workshop like a petrified shadow.

In December 1983 Beuys transformed the tiny Galerie Konrad Fischer, on Mutter-Ey-Strasse in Düsseldorf, into a lead-lined chamber. To this environment he gave the title *Pain Room.* The visitor walked through a glass door into a cube totally lined with sheet lead. From the center of the ceiling hung a naked electric light bulb that gave off very little light. Nearby, two silver rings were attached to the ceiling, one with the circumference of a child's head, the other with that of an adult. The associations are evident: bunker, mausoleum, radiation shelter. Beuys said: "There is no question, as far as I am concerned; the time bomb is ticking. Everything is so ossified that hardly any movement is possible now. Only what is after the bone still counts."

Lead, a relatively soft and malleable heavy base metal, which combines chemically with many other elements, is the insulator par excellence. Beuys endowed this physical function with an existential meaning: in his lead chamber, pain is insulated and takes on a quality of its own. Beuys said, "Nothing happens without pain—without pain there is no consciousness." One might think of the *piombi*, the chambers in the lead roofs of the Doges' Palace in Venice, where the notorious interrogation chambers of the Inquisition were located, but the true image of this *Pain Room* becomes apparent only when one understands the significance of the silver rings at the ceiling: silver is the counter metal to lead. It is a conductor of heat—warmth—and it resonates. Beuys had expressed all the pain of the age in a single metaphor. He was calling for political, social, and personal lead chambers to be broken open, and for us to emerge from our growing isolation. "What is needed," said Beuys, "is warmth."

It is clear that in the last years of his life, with death constantly facing him, Beuys thought long and hard about living and dying. His installations and objects bear eloquent testimony to this. There were quite simple but subtly evocative objects such as *Free Ladder* (also known as *Harvest Ladder*), a little wooden ladder with heavy stones attached to it; and *Capri Battery,* a yellow electric light bulb with a socket and its plug stuck into a real lemon. The ladder he had found in a garden on Capri in the fall of 1985. When he hung stones on it he might have been thinking about the burden of life, for the two stones, one in front of the ladder and one behind it, are there to hold it in equilibrium. On a visit to Amalfi at Christmas 1985, he bought a second, taller ladder from a landlord and called it *Neopolitan Ladder.* Like *Free Ladder,* it is held in balance—this time by two heavy metal balls.

Capri Battery, too, can be regarded as a metaphor. It was made in 1985 on the island of Capri, where Beuys was recovering from a lung condition; however, the damp climate, in combination with the cortisone that was being prescribed for him, did him no good. *Capri Battery* is an allusion to this situation. Beuys knew that the ancient Greeks are said to have been able to generate very weak electric currents by putting copper in contact with the citric acid from lemons. His own vital current was now a weak one, and he supplied his *Capri Battery* with the recommendation: "Change battery after 1,000 hours"—i.e., get a new lemon.

167

Ephemerality is also the theme of the object *I Believe,* made during this same phase. On an iron table stands an iron box painted gray; in it is a carton containing flowers of sulfur and nineteen oranges. But the preservative substance cannot arrest the growth of mold on the fruits: they must constantly be replaced.

Beuys's last installation was *Palazzo Regale,* in the Museo di Capodimonte in Naples. The opening took place on December 23, 1985. He died just one month later. In this former palace of the Bourbon kings, Beuys was given a beautiful elongated room with a magnificent floor of fine-veined red marble, inlaid with dark purple insets arranged in a strictly regular grid of five squares by twelve. Beuys installed two brass-mounted glass cases, one in the first third of the room, slightly off the central axis, and the other close to the far wall. This spatial disposition was completed by seven rectangular brass plates—two on the left-hand wall, four opposite, one on the end wall—that had been chemically treated by Beuys so that they looked like obscured mirrors. The near show-case contained the cast of the head from *Tram Stop* in Venice; the lynx coat, lined with blue silk, that Beuys wore for his performances of *Iphigenia/Titus Andronicus,* at Experimenta 2 in Frankfurt in 1969; two concert cymbals, not identical with those used in that Action; and the shell of a giant snail, which Lucio Amelio—at whose instigation *Palazzo Regale* was made—says Beuys bought on Capri in 1971 and used as a wind instrument in the Academy occupation on October 10, 1972. In the far case Beuys placed a backpack with a felt wedge in the side pocket; three electric calipers with cords attached; and two large crossed pins, all directed toward the gray-green backpack; two copper walking sticks; three dried, rolled smoked hams laid out in a wedge; a large piece of fat bacon. That was all.

Many observers have interpreted *Palazzo Regale* as an artistic testament. *Regale* means belonging to a king. The word *regalia* has been used since the eleventh century to denote royal powers or privileges.

In his last interview, given to Michele Bonuomo in December 1985, Beuys said:

> **I am not concerned with power in the institutional sense, or—even worse—with a monarchical concept, by which I mean anything to do with *Palazzo Regale* as the idea of state power. The palace that we have first to conquer, and then to inhabit worthily, is the**

> human head, our own heads. The idea of *Palazzo Regale* was contained in very many of my earlier works. Twenty-five years ago I stated in one of my Actions in Cologne that every human being is a Sun King; that actually every human being is sovereign. All of this is kept from us by politics: our sovereignty is exercised for us by other individuals and at once betrayed. . . .

Beuys always maintained that he worked not with symbols but with materials; but in the case of *Palazzo Regale* he admitted to using a form of symbolism. In the same interview he said:

> In this work the symbolic component is very strong, because in it I have tried to bring out two elements, present in all my work, that I think ought to be contained in every human action: the dignity of the self-determination of one's own life and one's own gestures, and the modesty of our actions and our work in every moment. All this is expressed without any great fuss, in a very quiet way.

The solemn and the unassuming, the celebratory and the ascetic, the sublime and the simple, the precious and the austere: these polarities underlie the weird fascination, the magic of this man. Beuys had the gift of being able to ride the tensions between New York and Manresa, between showmanship and contemplation. In *Palazzo Regale* he produced one last perfect expression of this gift.

In Italy, in America, at Home

Italy was the great love of Joseph Beuys's life. In no other European country did he exhibit so often: around thirty-five times from 1971 onward, to count only the solo shows, Actions, installations, and lectures. He appeared in Rome, Venice, Pescara, Milan, Genoa, Salerno, Bologna, Verona, Turin, Brescia, Perugia, and Bolognano, the last of which made him an honorary citizen in 1984. His greatest allegiance was to Naples, the city where he first exhibited in November 1971, and whose Museo di Capodimonte was the scene of his swan song, in December 1985, with *Palazzo Regale*. In Naples, Beuys presented numerous aspects of his work between 1971 and 1985: Naples was the starting point of his *tracce in Italia,* his "tracks in Italy"—to quote the title of a touring exhibition that ran for several years with a varying complement of works.

Beuys's way to success in Italy was paved by Lucio Amelio, avant-garde dealer, patron, and lover of art. The feelings of the Neapolitan Amelio for his friend from the Rhineland are apparent in his obituary for Beuys:

> He had summoned up the last of his strength and returned to his beloved Naples for the last time. . . . I think now of the last Christmas that we spent together, while Joseph was carefully, meditatively arranging his objects in the showcases of *Palazzo Regale.* Perhaps he already knew that he was writing his own Te

Deum. He stayed there all day long, untroubled by the death that lay in wait for him. I remember his rapt face during midnight mass in the church in Amalfi. He had taken off his hat, and suddenly he seemed immensely old. He, the unbeliever, almost had tears in his eyes. Then I understood that he was moved by the suffering and the hope in the faces of the worshippers there—and I have this image in my mind as I mourn him now. . . .

Lucio Amelio made Beuys's first Naples exhibition possible in 1971, and from then on he organized many exhibitions, Actions, and debates with and by Beuys, in Naples and elsewhere. In his obituary—which was published in the volume *Beuys zu Ehren* (In Honor of Beuys), in conjunction with the exhibition of the same title held at the Städtische Galerie im Lenbachhaus, Munich, in 1986—Amelio quoted from Beuys's speech at the opening of *Palazzo Regale* on December 23, 1985:

> **It makes me angry that so many people from the south, who could do important work at home, end up as cabdrivers in Düsseldorf. I believe that in Naples, and all over the Mezzogiorno, the word "people" still has meaning—in contrast to other European countries, where this idea has been destroyed by capitalist selfishness, by Americanization, and by industrialization. That is why I love these people so much. The first time I came to Naples, my first thought was: at last I am at home, this is my home. All the work I have done here is connected with the catastrophe that is the constant state of the south. If every one of us could succeed in inventing something, then the Mezzogiorno could become a happy land once more, a fruitful soil for creativity. That is why it was in Naples that I wanted to establish the statement: The Revolution is Us.**

The reference to a catastrophe is also an allusion to the devastating southern Italian earthquake of 1980, to which Beuys responded with such works as *Earthquake* and *Earthquake in the Palazzo*. These were the result of his journey to the places worst affected by the quake. His relationship with Italy, and with Naples in particular, was free from any traces of discord. Was it the opposite pole of life and thought, the cheerful, playful, Mediterranean element that captivated this intense, Gothic, Rhineland mystic? Did it present him with his own counterimage?

Of course, Italy was not the only country that con-

tributed to his worldwide fame. Beuys exhibited in England twenty-two times, sixteen of them in London—the place that saw the highest number of individual Actions. And if the seven Scottish exhibitions are counted, then Britain takes second place to Italy and is ahead of Switzerland, Austria, Holland, France, Belgium, Ireland, and Denmark.

Beuys exhibited in the United States about two dozen times, fifteen of them in New York. A note of reservation about America was often sounded in his expanded concept of art. But Beuys was hungry for knowledge, and he was quite capable of revising his opinions. Even so, America, and in particular New York, where he first exhibited in 1974, was always tough for Beuys.

In January 1974 he spent ten days lecturing, sometimes more than once a day, in galleries and art institutions in New York, Minneapolis, and Chicago. He said that he had traveled to America with nothing but the idea of Social Sculpture. And everywhere he went he tried to impress on his listeners that art was the only truly revolutionary force in the world. The conclusion to all his lecture and discussion sessions turned out to be complimentary to his audience, especially the young. He found them less aggressive and less radicalized than their contemporaries in West Germany. Although the Americans were much more bourgeois, they were also more relaxed and open to new ideas. He praised the cheerful atmosphere during his lectures, and often said that he had seldom laughed so much and that seldom had there been so much laughter at any of his events as on this tour.

Beuys's trip to Chicago set the stage for a curious and macabre spectacle. Its title: *Dillinger: He Was the Gangster's Gangster.* In Chicago, on the actual location, Beuys died the death of John Dillinger, who was shot down by the police after rising to the height of notoriety in the late 1920s as Public Enemy Number One. Dillinger, a farmer's son from Indianapolis, initially worked as a bank clerk until he was sent to prison for a minor fraud. After his release he was a man transformed. In Chicago he worked for the gang boss Al Capone and became known as Capone's torpedo. He always carried a revolver in his pocket, with the safety released, and he was quick as lightning on the draw. Specializing in bank heists, he later succeeded in building up his own gang of marksmen and radio experts.

The brutality of the Dillinger gang appalled the

American public, which breathed a sigh of relief when he was eventually caught and put in jail. But with the help of his gang he escaped. The bank raids resumed. The FBI now took over the hunt for Dillinger, who nevertheless managed to go underground after having plastic surgery done to alter his appearance. The horrific end to his career was precipitated by Dillinger himself, through a domestic drama. For years he had been living with a woman, who had borne his child. All of a sudden, without the slightest show of emotion, he left her. It was more than she could swallow, and she turned him in, collected $25,000 in reward, and tipped the police off about where to find Dillinger: at a movie house, the Biograph Theater on Lincoln Avenue, where he went every night. On June 22, 1934, she stood beside the theater exit in a red dress and dropped her glove as a signal to identify him. Dillinger was struck by nineteen bullets. He had managed to pull his gun but not to fire it. Public Enemy Number One was dead. His funeral was a spectacular event; the police could not control the hordes of curious sightseers. It is said that not long afterward souvenir vendors were peddling dirt from Dillinger's grave.

Beuys clearly knew this story in detail. In Chicago he commemorated Dillinger, the "gangster's gangster," in his own way. On January 14, 1974, he rode in a cab along Lincoln Avenue. He was wearing a felt hat and a long gray coat with a fur collar. He stopped the cab outside the Biograph Theater, jumped out, ran as if fleeing from a hail of bullets, slumped into a snowdrift in front of the theater, and lay motionless. After a while he stood up. The movie was in the can, or on the videotape, as the case happened to be: Staeck/Steidl Productions presents *Dillinger: He Was the Gangster's Gangster,* starring Joseph Beuys.

"The artist and the criminal," Beuys reflected in his own interpretation of this Action, "are fellow travelers; both have a wild creativity, and both are amoral, driven only by the force of liberty." In his Dillinger piece he had crossed—as he did so often—to the other side, beyond "normality."

It was in America, four months later, that Beuys once more broke through the bounds of normality, this time in an even more radical fashion. The drama that he enacted from May 21 through May 25, 1974, in the René Block Gallery, New York, bore the title *I Like America and America Likes Me;* in it he was joined by another star performer: Little John, a live coyote. Since

173

childhood Beuys had lived with animals and studied their behavior in nature; he had formed the "Party of Animals"; he had explained pictures to a dead hare. Sheep, stag, elk, bee, and swan appear in many contexts in his work.

The coyote, the prairie wolf, *Canis latrans,* is a nocturnal predator native to the forests and prairies of North and Central America. It lives mainly on small creatures and carrion, and it presents no threat to man. But of course the coyote is more than that. To the Indians, the coyote was a sacred animal; they revered it as one of the mightiest of their gods. But, as Caroline Tisdall tells us in her interpretation of Beuys's piece:

> Then came the White Man, and the transition in the coyote's status. He was reduced from being an admirably subversive power on a cosmic scale to what C. G. Jung in his preface to Pueblo Indian legends called "the Archetype of the Trickster." His ingenuity and adaptability were now interpreted as low and common cunning: he became the mean coyote. And, having classed him as an antisocial menace, white society could take its legalized revenge on him, and hound him like a Dillinger.

For Beuys, Tisdall says, the persecution of the coyote was an example of man's tendency to project his own sense of inferiority onto an object of hate or a minority. This hatred and this sense of inferiority will always drive man to destroy the object of his hatred, the scapegoat and the eternal victim in every society—as the Europe of pogroms and concentration camps well knows, or prefers to forget. America is rich in minorities, but the Indians, as the aboriginal inhabitants, are a special case in the history of persecution. "'The manner of the meeting was important,'" said Beuys, as quoted by Tisdall. "I wanted to concentrate only on the coyote. I wanted to isolate myself, insulate myself, see nothing of America other than the coyote."

And that was exactly how it was. At Kennedy Airport in New York, Beuys was wrapped in felt, laid on a stretcher, and driven by ambulance to the gallery. There, one room was divided in two by a wire grille, behind which his coyote awaited him. Beuys arranged strips of felt in the space, and every day he stacked the latest issue of the *Wall Street Journal* in two piles of

twenty-five copies each. He wore brown gloves, had a flashlight with him, and leaned on a walking stick. And so he set out, gradually, to get close to the coyote.

Beuys wrapped himself in felt, with only the stick protruding, and lay down on the floor. A sculpture. He stacked other pieces of felt into a pile from which the flashlight shone. He talked to the coyote and encouraged him to tug at the felt strips and tear them. Then the situation was reversed; the coyote curled up on the felt, and Beuys lay down on the coyote's straw. From time to time, Beuys made "music" with a triangle, which he wore suspended around his neck. Then the taped sounds of turbines broke the silence. Three days and nights later, the two were used to each other. Beuys said goodbye to Little John, hugging him gently. He scattered the straw in the room in which he had lived with the animal. Once more Beuys was wrapped in felt, laid on a stretcher, and taken to JFK airport in an ambulance. And so he left New York, having seen nothing of the city beyond the room with the coyote.

Beuys did not deny that in this Action he had taken on the role of the shaman, although he did not see the shaman as someone who uses the elements of the past to say something about the future. He said of the coyote that this animal, so detested by the whites, might also be seen as an angel.

Dillinger and the coyote thus showed the Americans just how radical was Beuys's pursuit of the expansion of art. Did he make them feel uneasy? Five and a half years after *I Like America and America Likes Me*—an interval during which Beuys had made a number of installations in New York, in Minneapolis, and in California—he was honored with a retrospective exhibition at the Solomon R. Guggenheim Museum in New York. This was quite an event. Beuys was the first postwar German artist to be invited to fill all the turns of the mighty spiral of that hallowed sanctuary of the New York museum scene. In twenty-four "stations" he showed important samples from the arsenal of his works, all masterfully displayed by the artist himself. He did not conceal that this exhibition gave him great personal satisfaction. From an international point of view, he had arrived.

The American reaction was mixed. Some of the words used by the media must not have pleased Beuys or his followers. Shaman, guru, art medicine man, also crusader, alchemist,

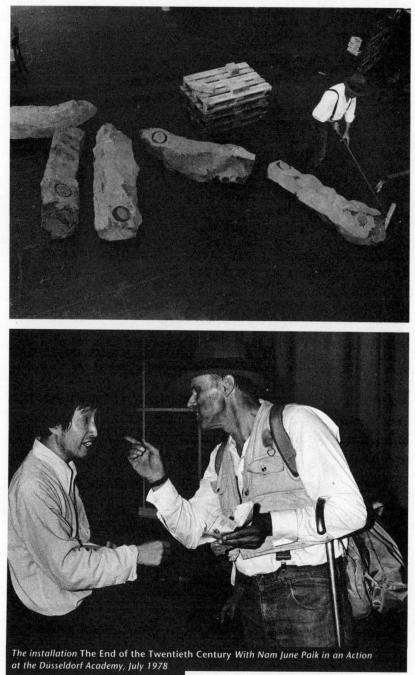

The installation The End of the Twentieth Century *With Nam June Paik in an Action at the Düsseldorf Academy, July 1978*

Parzifal's partner: these at least almost pass for friendly, but such terms as "Teutonic Romanticism," "exorcism," and the remark that Beuys's art had something to do with earth and race, must have given him pause. "Götterdämmerung at the Guggenheim," pronounced one headline.

But at the Guggenheim, Beuys had not met his Waterloo by any means. He had presented a puzzle for America to solve. But the Americans had no very pronounced feeling for the uncanny, the obscure, the irrational, for the austerity of the Romanesque or the mysticism of the Gothic. Beuys inevitably struck them as profoundly alien, because his counterimages disturbed their sense of security. He himself struck them as a counterimage. For this reason, if for no other, the show was essential.

It does honor to Thomas Messer, then the director of the Guggenheim Museum, that in the memorial volume *Beuys zu Ehren* he recognized and articulated the contradictions: "In Kassel in 1972, when I first saw Beuys surrounded by his students and watched him for a while, I decided not to speak to him. His speech, his mission, aroused in me all too strong a feeling of disquiet: I was inadequately prepared for their deeper meaning and obviously not yet ready for them. . . ." Four years later, at the Venice Biennale, the two men had a conversation, which led in turn to the 1979 exhibition. Thomas Messer recalls the preparatory phase:

177

> The building was emptied in no time, so that the huge fat sculptures could be set up. To this end, the windows on the Fifth Avenue side had to be taken out. A faint but penetrating smell proclaimed the presence of a new art form. With it there returned something of the old, slightly threatening aura that I had initially thought I perceived in connection with Beuys, as this rapid, uncompromising Action, with its unusual results and far-reaching consequences, went on to disrupt our long-established practices.

And Messer does not shrink from a cautiously phrased, but unmistakable, criticism of Beuys:

> The fundamental contradiction between a free, Messianic spirit and an institution that was trying to receive such a man into its fixed framework

became more acute, sometimes to my own discomfiture, when Beuys—who had traveled to New York with his entourage at our expense—started to live it up with a chauffeured Cadillac, caviar, and all the trimmings, much to the amazement even of his friends, who were at a loss to account for such atypical behavior. For my own part, I thought I understood it all too well, and started to fear that Joseph Beuys had gotten the idea that the destruction of the Guggenheim might be—in his sense of the word—an impressive artwork. Fortunately, he suddenly stopped, as if he had decided that was enough of that gesture.

What Messer described is a slice of Beuysian life, the kind that runs through his entire biography: Beuys himself spoke of the wide span between dignity and modesty. Cadillac, chauffeur, caviar: Beuys could never resist going against the grain. An ascetic with a hankering for luxury? Dillinger? Living with Little John? Clearly, the love affair between Joseph Beuys and America went very deep.

Beuys, says Eva Beuys, died his whole life long. She has always called her husband "Beuys," and even his children, Wenzel and Jessyka, never called him Father or Papa but always "Beuys." He died his whole life long, says Eva Beuys, but he was always so alive. He loved life; it was the path he had to conquer. She says that Beuys walked the path of life and the path of death with total sureness—right through to *Palazzo Regale*.

The couple first met in 1958, at a Mardi Gras party at the Düsseldorf Academy. It was the first time since his depression that Beuys had sought out the company of other people. Eva remembers that he always carried a rabbit's foot in the breast pocket of his shirt—just like her father, a noted professor of zoology in Bonn. But this eccentricity did not prevent Beuys from developing a predilection for good clothes. He was the best-dressed man at the Academy. His shirts, shoes, and hats: nothing but the best. In the early days Beuys wore a flannel suit and black necktie, with a hare's mandible as a tiepin.

The switch to jeans was Eva Beuys's doing. She

had the impression that he felt constricted in his suits, so she bought him durable jeans. When she saw a fishing vest in a Düsseldorf tackle shop one day, she decided that this original and practical garment would suit her, and she proudly wore it home. And that is how Beuys found the piece of clothing that became his trademark. As soon as he saw the vest, he knew it was just right for him. Eva Beuys made his vests herself from then on, and always made sure to slip a bright silk handkerchief in one of the pockets.

And how did Beuys come to wear the hat that became his trademark? It was quite simple: because of his war wounds, especially from the crash in the Crimea, his head was very sensitive, and he also had very thin hair. At first he used to wear a woolen cap, and then he discovered that he was a born hat man. The number of hats he bought for himself from the early 1960s on is considerable; especially since, as his fame increased, they started to go astray. Beuys bought his hats in London: Stetson brand. He would take off his hat only on very specific occasions, such as at the funeral of his dealer, Alfred Schmela. That day he wore a gray felt suit instead of jeans and a fishing vest. To Eva Beuys, the felt hat was genuinely so much a part of Beuys that she no longer noticed it. A few times he sacrificed his hat to art by turning one of these costly articles into an object. In provocative or self-mocking moods, he used to answer inquiries about his hat by saying that he had had one plane crash too many and had a screw loose.

179

Beuys appreciated luxury. At various times, he drove a Cadillac, a Lincoln Continental, and a Bentley. He said he liked his luxury limos for their sculptural qualities. He bought them used; his last Bentley cost him $7,000. His Cadillac went up in flames outside the Düsseldorf Academy. Beuys was no good with money. Eva Beuys remembers that in the early, difficult days, she would give an account of their finances every New Year and that Beuys then always took his gross income to be entirely at his disposal, dismissing the idea that there might be taxes to pay.

Luxury and economy: the expensive automobiles and the modest apartment on Drakeplatz, in Düsseldorf-Oberkassel, into which the Beuyses moved in March 1961 from Kleve. Beuys had had a serious accident in the Kleve studio. He lost his balance while trying to unblock a stovepipe and fell back against the sharp edge of the iron stove. One of his kidneys was so badly crushed that it had to be removed, hours later, in a Düsseldorf hos-

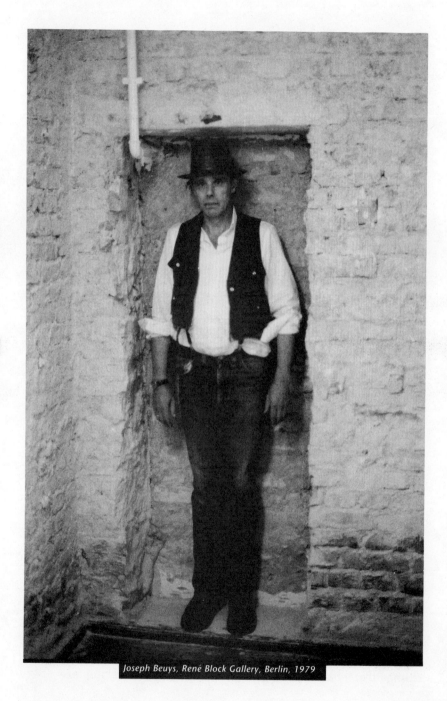

Joseph Beuys, René Block Gallery, Berlin, 1979

pital. In their big living and dining room at Drakeplatz, Beuys put up a red light bulb in the entryway as a reminder: "Always be alert."

The living room was a communication room: it was furnished with a table, chairs, a couch, a television, a huge refrigerator, a stove, and an enormous polished mahogany dresser from the workshop of the Art Nouveau architect Joseph Olbrich. The many drawers and compartments of this magnificent dresser initially housed baby bottles, laundry, and dishes. Later, Beuys used his valuable cabinet to store drawings and various papers. The carpet in this room was made of cowhides sewn together. In this room Beuys not only worked, talked, debated, and telephoned, but also ate with his family and often with guests. He loved to cook. His favorite dishes were lentils and beans, and he was also very fond of Parma ham. With his refined knowledge of mushrooms and spices, he could conjure up the most marvelous dishes. In the enclosed yard behind the living room Beuys raised many Mediterranean plants: little pomegranate trees, lemon trees, myrtle, bay. This little yard was his tribute to Italy and especially to his beloved city of Naples.

To Eva Beuys, as to others, Beuys was an equable, self-contained person, constantly cheerful, "alarmingly so at times." He was never moody, she says; he never complained about the weather. "All weather is good," he would say. Hans van der Grinten has spoken of Beuys's positive attitude to life. He was quick to see the funny side of a situation and often found other people amusing, without ever being malicious. He could recite wonderfully: one favorite piece was Kurt Schwitters's poem "Anna Blume." Hans van der Grinten says that it was a pleasure to listen to him.

Beuys had learned to play cello and piano as a boy. He knew a lot of folk songs and liked to sing them with abandon, especially on long road trips. In the 1970s he owned an old upright piano, which he frequently played. As an art student in Düsseldorf he occasionally visited the Bach Society and turned pages for the cellists. Beuys always did the unexpected. According to Eva, Beuys always kept his options open: there was always an escape route. He was like a cunning old peasant, who knew how to go on even when worse came to worst. Fatherhood, says Eva Beuys, was paradise to him. He had always wanted a family, and it made him happy to have one. He did what he did, and he always tried to include his family in that certainty of action. He was uneasy

when his family failed to understand his activities and put him on the spot, even attacked him. With him there were no vacations, but he often took his family along on trips, sometimes abroad. In 1975 he went to Kenya with his wife and the Düsseldorf advertising photographer Charles Wilp. This was supposed to be a real ten-day vacation, but it was no such thing. It was awful: Beuys, with his head shaved, posed for Wilp in swimming trunks on the beach and traced ritual signs in the sand. It was "Action" all the way.

That was in January 1975. Early the following summer Beuys suffered a serious coronary infarction. He had to stop work for several months. But after that he never spared himself. His body was already weakened by his war wounds, and he had lost his pancreas and one kidney. Fragments of shrapnel were lodged in his body. His poor circulation gave him trouble with his legs. He mortified the flesh by standing still for hours on end during his Actions. Sometimes an absent look would come into his eyes; after his crash he had believed for weeks that he was blind. One lung was affected, and he later contracted an inflammation of the pulmonary interstitial tissue. "The King sits in the wound," he said. After his coronary he had very little resistance left. How long could he go on feeding himself by dissipating his strength?

Beuys looked for a place where he could regenerate himself. He found it, curiously enough, not in his beloved Italy but near the Dutch city of Weert. On the six acres of land that Beuys and his wife bought in 1975 there was nothing but a rather dilapidated house. Restored and enlarged over the years, this became a sanctuary where Beuys could work undisturbed, both with and in nature. He raised various salad vegetables, and a year before his death he planted ginkgo trees and a variety of exotic plants. He intended to start a botanical garden.

One day, Eva Beuys says, an unfledged baby sparrow fell from the farmhouse roof. Beuys told her what to do to keep it alive. She nursed it to health; it was put in a cage and finally grew big enough to fly. What happened? The sparrow flew to Beuys, who was working in the field, and perched on his knee. The same thing happened for three days on end. Then the sparrow went. Of course, too much importance should not be laid on such anecdotes—they encourage the creation of myth. But Beuys did have an intimate understanding of animals. It was out of his contact with them and his knowledge of their behavior that he evolved

his own counterimages. Ultimately, it all fits together. Beuys was always on the way before the others arrived. He was a wayfarer, an expander, a source of energy, with his eye constantly on the utopian goal of Social Sculpture.

Eva Beuys, quiet, concentrated, protective, says: "It was all ethereal in this house. Everything was very light. His footsteps, his voice. Nothing here was ever totally real."

Requiem

Joseph Beuys had come to the end. He had shown his wounds, and in *Palazzo Regale* he had held his last great celebration. His memory stretched far back, to Kleve, where as a child he had felt himself to be like a shepherd. By the age of five he had experienced it all—he knew that. He had truly believed, then, that he was ready to die.

Death he saw as the beginning of rebirth; life itself was fulfilled in death. He was convinced that human beings are helped by suffering. He regarded his own period of depression as a form of therapy. According to Beuys, the world is enriched not by those who act but by those who suffer. He resisted a purely biological image of humankind: birth, death, nothing more. He loathed preachiness; he hated promises of heaven. Rubbish, mere chatter, he said. No, what mattered to him was the constant dialogue, the logic of Christianity. Only through suffering could the world be filled with Christian substance. There was a connection between suffering and creation. Through suffering, something spiritually higher came into being.

Beuys wanted to bring Christianity into conjunction with planetary motions and cosmic dimensions. But because the old powers of faith were no longer operable, man would have to attain the spiritual through his own resources. Christ, to Beuys, represented the healing principle; the Sermon on the Mount fascinated him as a summit conference in the truest sense of the phrase. The cross that Christ took up signified rising above materialism. The

message was: "I will set you free." And so the cross was one of the essential elements of Beuys's work.

The wounds of Joseph Beuys: the King sat in them. He suffered much, but he loathed being ill. God, the Great Generator, would keep everything going with his energy. Without death there is no consciousness: "Death," said Beuys, "keeps me awake." As the end approached, there were times when the pain of breathing would not allow him to lie down to sleep. So he stood up, propped himself in a corner of the bedroom, and slept on his feet. "Like a horse," he said, with a heartrending smile.

Death kept Joseph Beuys awake. During Documenta 6, in 1977, three little bronze vessels stood in a corner down in the basement, where the motors for *Honey Pump at the Workplace* were running. It all looked like an archeological dig. The bronze vessels were empty. Then an archeologist came in and told Beuys that beneath a temple, somewhere in Greece, his team had recently found three ancient bronze vessels full of honey, and the honey still tasted good!

Beuys's three bronze vessels were on board when the little West German motorboat *Sueño*, home based in Meldorf, sailed out into the Helgoland Bight on April 14, 1986. The name *Sueño* is Spanish and means "sleep" or "dream." At latitude 54°07.5' north, longitude 8°22.0' east, Captain Nagel hove to. The three bronze vessels containing the ashes of Joseph Beuys were committed to the North Sea. Wild swans flew overhead.

Chronology

1921	May 12—Joseph Beuys is born in a hospital in Krefeld, Germany, to Joseph Jacob and Johanna Beuys, who live in Kleve, Germany.
1940	Finishes studies at Hindenburg secondary school in Kleve; decides to study medicine and become a pediatrician but is drafted into the Luftwaffe.
1941–45	Serves as a pilot and radio operator; is wounded five times.
1943	Winter—plane is hit by Russian gunfire; Beuys lands behind German lines and for eight days is cared for by Tartars, who wrap him in fat and felt; he is found by a German search party and taken to a military hospital.
1945	Incarcerated in a British prisoner-of-war camp in Cuxhaven, Germany.
1946	Returns to his parents' home in Kleve. Meets the van der Grinten brothers.

1947–51 Studies at the State Academy of Art, Düsseldorf, with the sculptors Joseph Enseling and Ewald Mataré.

1950 Reads James Joyce's *Finnegans Wake* and gives a reading from it at Haus Wylerberg, near Kranenburg, Germany.

1951 Begins work for private patrons. His first commission is a monument for Dr. Fritz Niehaus in the cemetery in Büderich, Germany.

Spring—the van der Grinten brothers begin their extensive collection of Beuys's work, buying a drawing and a woodcut for five dollars apiece.

1953 February—Beuys's first solo exhibition is held at the van der Grintens' farmhouse, Kranenburg.

1954 Early in the year—rents studio in the Heerdt district of Düsseldorf (remains until 1957).

Christmas—his fiancée ends their engagement; Beuys is thrown into a severe depression that lasts two years.

1957 April–August—works on the van der Grinten farm in Kranenburg.

1958 Moves studio into the spa at Kleve (remains until 1961). Meets Eva Wurmbach.

1958–61 Adds two chapters to Joyce's *Ulysses*.

1959 September 19—marries Eva Wurmbach.

1961 Becomes Professor of Monumental Sculpture at the Düsseldorf Academy.

187

March—moves to 4, Drakeplatz, in Oberkassel district of Düsseldorf.

October–November—exhibition of drawings, watercolors, oil paintings, and sculpture by Beuys from the van der Grinten collection, at the Städtisches Museum, Haus Koekkoek, Kleve; the catalog includes a text by Beuys.

1962–64 Involved with the Fluxus movement.

1963 Presents his first major Action, *Siberian Symphony.*

February 2–3—participates in the Festum Fluxorum Fluxus, a Fluxus concert for the students at the Düsseldorf Academy.

July 18—exhibits *Fat Chest,* his first work to use fat, in conjunction with a lecture by Allan Kaprow at the Galerie Zwirner, Cologne.

1964 June 27—participates in Documenta 3, Kassel, Germany.

July 20—performs Action at the Festival of New Art at the Institute of Technology, Aachen, Germany. Disturbances in the audience interrupt one performance; a student storms the stage and punches Beuys in the nose.

November 11—the Action *The Silence of Marcel Duchamp Is Overrated,* with Beuys, Bazon Broch, Tomas Schmit, and Wolf Vostell, is broadcast live on German television.

December 1—Beuys performs *The Chief, Fluxus Song* at the Galerie René Block, West Berlin; Robert Morris performs the piece simultaneously in New York.

1965 June 5—Beuys performs in *24-Hour Happening* at the Galerie Parnas, Wuppertal, Germany.

November 26—performs the Action *How to Explain Pictures to a Dead Hare* at the Galerie Alfred Schmela, Düsseldorf.

1966 Summer—Beuys and his wife visit Manresa, Spain, with the Danish artist and scientist Per Kirkeby and his wife.

October 14–15—Beuys performs the Actions *Eurasia* and *34th Movement of the Siberian Symphony* at the Galerie 101 in Copenhagen.

1967 June 22—founds the German Student party (DSP) in Düsseldorf.

September—installs *Parallel Process I* at the Städtisches Museum, Mönchengladbach.

1968 Declares that art is life.

June—participates in Documenta 4, Kassel.

November 12—ten fellow professors issue a declaration that Beuys's activities threaten the survival of the Düsseldorf Academy.

1969 February—takes blame for the snowfall of February 15–20.

May 7—the Ministry of Science and Research of North Rhine–Westphalia, responding to the Lidl demonstration at the Düsseldorf Academy, orders the police to close the Academy; it reopens on May 12.

189

1970 March 2—Beuys founds the Organization of Nonvoters, Free Referendum Information Point, in Düsseldorf.

May 1—at an exhibition opening in Dortmund, Germany, meets Willi Brandt and explains some of his political ideas to the chancellor.

1971 February 10—Beuys, Erwin Heerich, and Klaus Staeck issue proclamation against the exclusivity of the Cologne Art Fair of September 1970.

June 1—Beuys founds the Organization for Direct Democracy through Referendum (People's Free Initiative), in Düsseldorf.

October 15—Beuys and his supporters occupy the administration offices at the Academy to protest the denial of admission to seventeen students; three days later the Ministry of Science and Research decides to admit the students.

November 1—Beuys founds the Committee for a Free College.

December—with fifty students, sweeps out the Grafenberger Wald, a wooded area near Düsseldorf, in the Action *Overcome Party Dictatorship Now.*

1972 June–October—at Documenta 5, Kassel, debates with the public for one hundred days straight on democracy, art, and related issues.

October 11—after Beuys and his followers occupy the administrative offices for the second time, Minister Johannes Rau instantly dismisses Beuys from the Academy.

1973 Becomes a member of the Anthroposophical
Society.

April 27—founds a Free International College for
Creativity and Interdisciplinary Research.

1974 February—establishes, with Heinrich Böll, the Free
International University for Creativity and
Interdisciplinary Research (FIU), in Düsseldorf.

May 21–25—performs with a live coyote in *I Like
America and America Likes Me* at the René Block
Gallery, New York.

1976 July—installs *Tram Stop* at the Venice Biennale.

1977 June—installs *Honey Pump at the Workplace* at
Documenta 6, Kassel.

1978 January 14—receives the Thorn-Prikker Medal of
Honor in Krefeld.

1979 Runs for election to the European Parliament as
the candidate of the Green party; loses.

October—represents West Germany at the São
Paulo Bienal; the Solomon R. Guggenheim
Museum, New York, presents a major retrospec-
tive of Beuys's work.

1981 Major exhibition of works from Munich private
collections at the Städtische Galerie im
Lenbachhaus, Munich.

1982 June 19—begins the Action *7,000 Oaks* at
Documenta 7, Kassel.

1983 December—installs *Pain Room* in the Galerie
Konrad Fischer, Düsseldorf.

1984 June—exhibition of works at the Seibu Museum of Art, Tokyo.

1985 On Capri, recovering from a lung ailment, creates *Capri Battery,* his last multiple.

 December 23—*Palazzo Regale,* Beuys's last installation, opens at the Museo di Capodimonte, Naples.

1986 January 12—receives the Wilhelm Lehmbruck Prize, Duisburg.

 January 23—dies of heart failure.

1987 June 12—at the opening of Documenta 8, Kassel, Beuys's son, Wenzel, plants the last oak of the *7,000 Oaks* Action.

Selected Bibliography

Interviews and Statements

Allemandi, Umberto. *Joseph Beuys, Superstar*. New York: Ronald Feldman Fine Arts, 1974. Interview conducted June 1974 for *Bolaffi Arte*, translated by Donna Morawetz.

Bakchahyan, V., and Ur, A. "Joseph Beuys: Art and Politics." *L'Art russe contemporaine non officiel* 2 (1980): 54–58. Interview.

Beuys, Joseph. "Krawall in Aachen: Interview mit Joseph Beuys" and "Plastik und Zeichnung: Interview mit Joseph Beuys." Interviews in *Joseph Beuys: Werke aus der Sammlung Karl Ströher*. Basel, Switzerland: Kunstmuseum, 1969.

———. "From a Telephone Conversation." In Caroline Tisdall, *Joseph Beuys: The Secret Block for a Secret Person in Ireland*. Oxford, England: Museum of Modern Art, 1974.

———. "Rede von Joseph Beuys zur Eröffnung seiner Ausstellung 'Zeichnungen 1946–1971' im Museum Haus

Lange, Krefeld am 19. Mai 1974." In *Joseph Beuys: Zeichnungen, 1947–1971.* Krefeld, Germany: Museum Haus Lange, 1974. Translated in *Art into Society, Society into Art.* London: Institute of Contemporary Arts, 1974.

———. "Public Dialogue." *Avalanche Newspaper,* May–June 1974, pp. 5–7. Transcript of the first hour of Beuys's first American performance at the New School, New York.

———. "Kunst und Staat." *Kunstmagazin* 84 (November 1978): 57–60. Translated into French in *Musée des sacrifices/Musée de l'argent.* Paris: Centre Georges Pompidou, Musée National d'Art Moderne, 1979.

———. "Manifesto." In *Documenta 7.* Vol. 2, pp. 44–47. Kassel, Germany: Dierichs, 1982.

Bodenmann-Ritter, Clara. *Jeder Mensch ein Künstler.* Frankfurt am Main: Ullstein, 1975. Records Beuys's talks and discussions during the one hundred days he was at Documenta 5.

Bongard, Willi. "Letter from London." Excerpts from a conversation between Beuys and Bongard. In *Joseph Beuys: Multiplizierte Kunst, 1965–1980, Sammlung Ulbricht.* Düsseldorf: Kunstmuseum, 1980.

Bonito Oliva, Achille. *A Score by Joseph Beuys: We Are the Revolution.* New York: Ronald Feldman Fine Arts, 1971. Originally published in *Domus* 505 (December 1971).

Demarco, Richard. "Conversations with Artists: Richard Demarco Interviews Joseph Beuys, London (March 1982)." *Studio International* 195 (September 1982): 46–47.

Feldman, Ronald. "Interview with Joseph Beuys in English and German." In Robert Filiou, *Lehren und Lernen als Aufführungskunste.* Cologne: König, 1970.

————. "Joseph Beuys: From Berlin: News from the Coyote." *Impressions* 24–25 (1980): 20–21. A taped telephone interview.

Foote, Lona. "Interview." In Irene Von Zahn, et al., *Some Artists, for Example, Joseph Beuys.* Riverside: University of California, 1975.

Gowing, Lawrence. "In Search of Beuys." *London Magazine* 20 (February–March 1981): 39–49. Interview.

Grinten, Hans van der. "Interview, February 17, 1973." In Franz Joseph van der Grinten and Hans van der Grinten, *Joseph Beuys: Bleistiftzeichnungen aus den Jahren 1946–1964.* Berlin: Propyläen, 1973.

Harlan, Volker. *Was ist Kunst? Werkstattgespräch mit Beuys.* Stuttgart: Urachhaus, 1987.

Horsfield, Kate. "Joseph Beuys." *Profile,* January 1981, pp. 1–15.

Jappe, Georg. "Not Just a Few Are Called, but Everyone: Joseph Beuys in Discussion with Georg Jappe." *Studio International* 184 (December 1972): 226–29.

Koepplin, Dieter. "Interview mit Beuys am 1. Dezember 1976." In Caroline Tisdall and Dieter Koepplin, *Joseph Beuys: The Secret Block for a Secret Person in Ireland.* Basel, Switzerland: Kunstmuseum, 1977.

Krüger, Werner. "Joseph Beuys Interview." *New York Arts Journal* 15 (September 1979): 9–10.

Lebeer, Irmeline. "Joseph Beuys." *Cahiers du Musée National d'Art Moderne* (Paris) 4 (April–June 1980): 170–93. Interview in French.

Lieberknecht, Hagen. "Conversation with Joseph Beuys." In *Joseph Beuys, Zeichnungen, 1947–59.* Cologne: Schirmer, 1972.

Price, Jonathan. "A Parable of Dialogue." *Artnews* 73 (Summer 1974): 50–52. Interview.

Robertson, Clive, and Lisa Steele. "Sprechen Sie Beuys?" *Centerfold,* August–September 1979, pp. 306–14. Includes a translation of Joseph Beuys, "Appeal for the Alternative," first published in the *Frankfurter Rundschau,* December 23, 1978.

Rywelski, Helmut. *Heute ist jeder Mensch Sonnenkönig.* Cologne: Art Intermedia, 1970. Interview, May 18, 1970.

Sarenco. *Intervista-azione: 10 Domande di Sarenco, Düsseldorf, 10.5.1978.* Calaone-Baone, Italy: Edizioni Factotumbook, 1978. Interview with Beuys and reproductions of his work of the same title.

Schwebel, Horst. *Glaubwürdig: 5 Gespräche über heutige Kunst und Religion mit Joseph Beuys, Heinrich Böll, Herbert Falken, Kurt Marti, Dieter Wellershoff.* Munich: Kaiser, 1979.

Sharp, Willoughby. "An Interview with Joseph Beuys." *Artforum* 8 (December 1969): 40–47. Includes a translation of Beuys's "Life Course/Work Course."

Spoerri, Daniel. "Interview with Joseph Beuys." In Joseph Beuys, *La Gebratene Fischgräte.* Berlin: Edition Hundertmark, 1972.

Struycken, Peter. *Beuys in Rotterdam: Diskussie Joseph Beuys–Peter Struycken, 19 April 1980.* Rotterdam, the Netherlands: Museum Boymans-van Beuningen, 1981.

Monographs and Solo-Exhibition Catalogs

Adriani, Götz, Winfried Konnertz, and Karin Thomas. *Joseph Beuys: Life and Works.* Woodbury, N.Y.: Barron's, 1979. Originally published in German as *Joseph Beuys,* Cologne: M. DuMont Schauberg, 1973.

Balkt, Herman Hendrik ter. *Joseph Beuys.* Arnhem, the Netherlands: Stichting Ravenberg Pers, 1978. Poetry with illustrations by Beuys.

Bastian, Heiner. *Joseph Beuys, Skulpturen und Objekte.* Munich: Schirmer/Mosel, 1988.

——— and Jeannot Simmen. *Joseph Beuys: Zeichnungen, Tekeningen, Drawings.* West Berlin: Nationalgalerie, 1979; Munich: Prestel-Verlag.

Beuys, Joseph. *Zeichnungen, 1947–59.* Cologne: Schirmer, 1972.

———. *Zeichnungen zu den beiden 1965 wiederentdeckten Skizzenbücher "Codices Madrid" von Leonardo da Vinci.* Stuttgart: Manus-Presse, 1975.

———. *Painting Version 1–90.* Munich: Schellmann and Klüser, 1976. Limited edition of 500 copies.

———. *Aus Berlin: Neues vom Kojoten.* 1st ed., New York: Ronald Feldman Gallery, 1979; 2d ed. Berlin: Block, Fröhlich and Kaufmann, 1981.

———. *Suite "Schwurhand": Mischtechniken, Radierung und Aquatinta mit Lithographie und Prägung.* Cologne: Galerie Dreiseitel, 1980. In English and German.

———. *Suite "Schwurhand": Radierungen-Etchings, Lithographien-Lithographs.* Vaduz, Liechtenstein: Grafos-Verlag, 1980.

197

————. *Words Which Can Hear.* London: Anthony d'Offay, 1981.

Beuys-Wurmbach, Eva. *Die Landschaften in den Hintergründen der Gemälde Leonardos.* 1st ed., 1974; 2d ed., Munich: Schellmann and Klüser, 1977. Schematic diagrams by Beuys analyzing the construction of Leonardo's paintings.

Beuys in Boymans. Rotterdam, the Netherlands: Museum Boymans-van Beuningen, 1980.

Bonita Oliva, Achille. *Joseph Beuys: Il Ciclo del suo lavoro.* Milan: Studio Marconi, 1973.

Bott, Gerhard, and Hans Martin Schmidt. *Joseph Beuys: Zeichnungen und andere Blätter aus der Sammlung Karl Ströher.* Darmstadt, Germany: Hessisches Landesmuseum, 1972.

Burgbacher-Krupka, Ingrid. *Prophete rechts, Prophete links: Joseph Beuys.* Nuremberg, Germany: Institut für Moderne Kunst, 1977. Includes an extensive list of German articles and reviews, 1963–77.

Celant, Germano. *Beuys: Tracce in Italia.* Naples: Amelio, 1978.

Damme, Claire van. *Joseph Beuys: Tekeningen, Aquarellen, Gouaches, Collages, Olieverven.* Ghent, Belgium: Museum van Hedendaagse Kunst, 1977. In Dutch, English, French, and German.

De Crescenzo, Giuliana. *Partituren, 1957–1978: Joseph Beuys.* Rome: Studio Tipografico, 1979.

Eigenheer, Marianne, and Martin Kunz. *Joseph Beuys: Spuren in Italien.* Lucerne, Switzerland: Kunstmuseum, 1979.

Glozer, Laszlo. *Joseph Beuys: Zeige deine Wunde.* Munich: Schellmann and Klüser, 1976.

Grinten, Franz Joseph van der. "Uber Joseph Beuys." In *Joseph Beuys: Werke aus der Sammlung Karl Ströher.* Basel, Switzerland: Kunstmuseum, 1969.

———— and Hans van der Grinten. *Joseph Beuys: Zeichnungen/ Aquarelle/Ölbilder/plastische Bilder aus der Sammlung van der Grinten.* Kleve, Germany: Städtisches Museum, Haus Koekkoek, 1961.

————. *Joseph Beuys: Fluxus aus der Sammlung van der Grinten.* Kranenburg, Germany: Haus van der Grinten, 1963.

————. *Joseph Beuys: Bleistiftzeichnungen aus den Jahren 1946–1964.* Berlin: Propyläen, 1973.

————. *Joseph Beuys: Wasserfarben, 1936–1963.* Frankfurt am Main: Propyläen, 1975.

————. *Joseph Beuys: Ölfarben, Oilcolors, 1936–1965.* Munich: Prestel, 1981.

Grinten, Hans van der. *Joseph Beuys: Sammlung Hans und Franz van der Grinten, Kranenburg.* Vienna: Galerie Nächst St. Stephan, 1970.

Harlan, Volker, Rainer Rappmann, and Peter Schata. *Soziale Plastik: Materialen zu Joseph Beuys.* Achberg, Germany: Achberger Verlaganstalt, 1976.

Herzfeld, Anatol. *Art Information of Anatol Herzfeld,* vol. 1. Düsseldorf: Mediacontact, 1971. Documentation of a film by Herzfeld and Beuys titled *Der Tisch;* in English and German.

Holtmann, Heinz. *Joseph Beuys: Zeichnungen und Objekte.* Goslar, Germany: Mönchehaus Museum für Moderne Kunst, 1979.

Joachimides, Christos M. *Joseph Beuys: Richtkräfte*. Berlin: Nationalgalerie, 1977.

Joseph Beuys: Sammlung Lutz Schirmer. St. Gallen, Switzerland: Kunstverein, 1971.

Joseph Beuys: Zeichnungen 1949–1969, vol. 1. *Joseph Beuys: Zeichnungen von 1946–1971*, vol. 2. Düsseldorf: Galerie Schmela, 1973. Reproductions without text.

Joseph Beuys. Brescia, Italy: Studio Brescia, 1974.

Joseph Beuys: Zeichnungen 1946–1971, Krefeld, Germany: Museum Haus Lange, 1974.

Joseph Beuys: Multiples, Bücher und Kataloge aus der Sammlung Dr. med. Speck. Kassel, Germany: Kasseler Kunstverein, 1975.

Joseph Beuys: Zeichnungen, Bilder, Plastiken Objekte, Aktionsphotographien. Freiburg, Germany: Kunstverein, 1975.

Joseph Beuys: Zeichnungen. Munich: Schellmann and Klüser, 1977.

Joseph Beuys: Multiplizierte Kunst, 1965–1980, Sammlung Ulbricht. Düsseldorf: Kunstmuseum, 1980.

Joseph Beuys: Objekte. Munich: Galerie Schellmann and Klüser, 1980.

Joseph Beuys: Zeichnungen, Bildobjekte, Holzschnitte. Basel, Switzerland: Kunstmuseum, 1980. Catalog for an exhibition held at the Badischer Kunstverein, Karlsruhe, Germany.

Joseph Beuys. Atlanta: Heath Gallery, 1981.

Joseph Beuys. Duisburg, Germany: Wilhelm Lehmbruck Museum, 1986.

Joseph Beuys: Ideas and Actions. New York: Hirschl and Adler Modern, 1988.

Joseph Beuys im Kaiser Wilhelm Museum. Krefeld, Germany: Kaiser Wilhelm Museum, 1976. Catalog of works in the museum's collection.

Koepplin, Dieter. *Joseph Beuys: Werke aus der Sammlung Karl Ströher.* Basel, Switzerland: Kunstmuseum, 1969.

Lindegren, Karin Bergqvist. *Joseph Beuys: Aktioner, Aktionen— Teckningar och Objekt 1937–1970 ur Samling van der Grinten.* Stockholm: Moderna Museet, 1971. In German and Swedish.

Mauer, Otto. *Beuys.* Eindhoven, the Netherlands: Stedelijk van Abbemuseum, 1968.

Murken, Axel Hinrich. *Joseph Beuys und die Medizin.* Münster, Germany: Coppenrath, 1979. In English and German.

Schellmann, Jörg, and Bernd Klüser, eds. *Joseph Beuys, Multiples: Catalogue Raisonné of Multiples and Prints 1965–1985.* 1971; 6th ed. Munich: Editions Schellmann, 1985.

Speck, Reiner, "Beuys und Literatur." In *Joseph Beuys: Multiples, Bücher und Kataloge.* Bonn: Galerie Klein, 1973.

Tisdall, Caroline. *Joseph Beuys: The Secret Block for a Secret Person in Ireland.* Oxford, England: Museum of Modern Art, 1974.

———. *Joseph Beuys, Coyote.* 1976; 2d ed. Munich: Schirmer/ Mosel, 1980.

———. *Joseph Beuys*. New York: Solomon R. Guggenheim Museum; London: Thames and Hudson, 1979. Includes chronology.

———. *Joseph Beuys: Dernier Espace avec introspecteur, 1964–1982*. London: Anthony d'Offay, 1982.

———. *Bits and Pieces: A Collection of Work by Beuys from 1957–1985*. Edinburgh: Richard Demarco Gallery, 1987.

——— and Dieter Koepplin. *Joseph Beuys: The Secret Block for a Secret Person in Ireland*. Basel, Switzerland: Kunstmuseum, 1977. Revised and translated version of the Oxford catalog.

Wember, Paul. Introduction to *Joseph Beuys: Zeichnungen 1946–1971*. Krefeld, Germany: Museum Haus Lange, 1974.

———. Introduction to *Joseph Beuys*. Hanover, Germany: Kestner-Gesellschaft, 1975.

Wright, Charles B., and Gary Garrels. *Joseph Beuys*. New York: Dia Art Foundation, 1987.

Von Zahn, Irene, et al. *Some Artists, for Example, Joseph Beuys*. Riverside: University of California, 1975.

Zweite, Armin. *Joseph Beuys: Zeichnungen, Tekeningen, Drawings*. Munich: Prestel, 1979. In Dutch, English, and German.

———. *Joseph Beuys: Arbeiten aus Münchener Sammlungen*. Munich: Schirmer/Mosel, 1981. Exhibition held at the Städtische Galerie im Lenbachhaus, Munich.

———, ed. *Beuys zu Ehren*. Munich: Städtische Galerie im Lenbachhaus, 1986.

Periodicals, Books, and Group-Exhibition Catalogs

Adams, Brooks. "Landscape Drawings of Joseph Beuys." *Print Collector's Newsletter* 10 (November–December 1979): 148–53.

Amann, Jean Christophe. *Joseph Beuys, Michael Buthe, Franz Eggenschwiler und die Berner Werkgemeinschaft (Konrad Vetter, Robert Waelti), Markus Raetz, Diter Rot.* Lucerne, Switzerland: Kunstmuseum, 1970.

Art into Society, Society into Art. London: Institute of Contemporary Arts, 1974.

Baatsch, Henri Alexis. "Objets sans objet." *XXe siècle* 44 (June 1975): 143–49.

Bamberg, Regus. *Pop Art?* Basel, Switzerland: Galerie Studio B, 1967.

Barthes, Roland. *Wilhelm von Gloeden: Interventi di Joseph Beuys, Michelangelo Pistoletto, Andy Warhol.* Naples: Amelio, 1978. Includes Beuys's drawings over photographs by von Gloeden.

Beuys, Gerz, Ruthenbeck. Venice: Biennale di Venezia, 1976. In English and German.

"Beuys: Ich hab' Genug vom Kunstbetrieb." *Art, das Kunstmagazin* 2 (February 1983): 66–77.

Buchloh, Benjamin H. D. "Beuys: The Twilight of the Idol." *Artforum* 18 (January 1980): 35–43.

Burgbacher-Krupka, Ingrid. *Strukturen zeitgenössischer Kunst: Eine Untersuchung zur Rezeption der Werke von Beuys, Darboven, Flavin, Long, Walther.* Stuttgart: Enke, 1979.

Burckhardt, Jacqueline, ed. *Ein Gespräch=Una Discussione/Joseph Beuys, Jannis Kounellis, Anselm Kiefer, Enzo Cucchi.* Zurich: Parkett-Verlag, 1985.

Da Vinci, Mona. "A Beuys World." *Soho Weekly News,* April 17, 1975, p. 8. Review of exhibitions at Ronald Feldman Fine Arts and René Block Gallery.

Davis, Douglas. "Pied Piper." *Newsweek,* May 1, 1972, p. 87.

———. "The Man from Düsseldorf." *Newsweek,* January 21, 1974, p. 100.

Duffy, Helen. "Joseph Beuys, le Miroir de l'age technicien." *Vie des arts* 25 (Autumn 1980): 50–53, 88–90. In English and French.

Flood, Richard. "Wagner's Head." *Artforum* 21 (September 1982): 68–70. Review of Beuys's participation in Documenta 7.

Francblin, Catherine. "Joseph Beuys et les idées reçues." *Art Press* 42 (November 1980): 6–8.

Gale, Peggy. "Explaining Pictures to a Dead Hare: The Robertson/Beuys Admixture." *Parachute* 14 (Spring 1979): 4–8. Transcript of a teleperformance for live cablecast, September 8, 1978.

Grinten, Franz Joseph van der, and Hans van der Grinten. *Mataré und seine Schüler.* Berlin: Akademie der Künste, 1979.

Hahne, Heinrich. "Zum neuen Beuys-Prozess: Versuch einer Kategorialanalyse." *Kunstwerk* 29 (March 1976): 36–37.

Hughes, Robert. "The Noise of Beuys." *Time,* November 12, 1979, pp. 89–90. Review of exhibition at the Guggenheim Museum.

Jappe, Georg. "A Joseph Beuys Primer." *Studio International* 182 (September 1971): 65–69.

Jochimsen, Margarethe. "Eine Holzkiste von Joseph Beuys konfrontiert mit Erwin Panofskys Grundsätzen zur Beschreibung und Inhaltsdeutung von Werken der Bildenden Kunst." *Zeitschrift für Ästhetik und allgemeine Kunstwissenschaft* 22 (1977): 148–55.

Kreuz und Zeichen: Religiöse Grundlagen im Werk von Joseph Beuys. Aachen, Germany: Suermondt Museum, 1985.

Kuspit, Donald B. "Beuys: Fat, Felt and Alchemy." *Art in America* 68 (May 1980): 79–88.

Lamarche-Vadel, Bernard. *Joseph Beuys: Is It about a Bicycle?* Paris: Marval, 1985.

Mackintosh, Alastair. "Beuys in Edinburgh." *Art and Artists* 5 (November 1970): 10.

———. "Proteus in Düsseldorf." *Art and Artists* 6 (November 1971): 24–27.

———. "Beuys, Joseph." In Colin Naylor and Genesis P-Orridge, *Contemporary Artists.* New York: St. Martin's Press, 1977.

Marzorati, Gerald. "Beuys Will Be Beuys." *Soho Weekly News,* November 1, 1979, pp. 8–9.

Meyer, Ursula. "How to Explain Pictures to a Dead Hare." *Artnews* 68 (January 1970): 54–57, 71.

Miles, Ray. "Beuys." *Arts Review* 26 (July 26, 1974): 463. Review of exhibition at the Institute of Contemporary Arts, London.

Morgan, Stuart. "Joseph Beuys, 'Dernier Espace avec introspecteur,' Anthony d'Offay." *Artforum* 20 (Summer 1982): 95. Review of the exhibition.

Morris, Linda. "The Beuys Affair: Calendar of Events." *Studio International* 184 (December 1972): 226. Outline of events in 1972 leading up to Beuys's dismissal and reinstatement as a professor at the Düsseldorf Academy.

Neville, Timothy, trans. *Joseph Beuys: In Memoriam.* Bonn: Inter Nationes, 1986. Obituaries, essays, speeches.

"Numero Monografico su Joseph Beuys." *Lotta Poetica* (Brescia, Italy) 46 (March 1975). Entire issue devoted to Beuys.

Perreault, John. "Felt Forum." *Soho Weekly News,* November 1, 1979, pp. 44–45. Review of exhibition at the Guggenheim museum.

Phillips, Deborah C. "Joseph Beuys." *Artnews* 81 (April 1982): 230. Review of exhibition at Ronald Feldman Fine Arts.

Phillips, Tony. "Joseph Beuys at the Art Institute." *SAIC: A Quarterly Magazine of the School of the Art Institute of Chicago* 4 (Spring 1974): 22–25.

Plouffe, Paul-Albert. "Joseph Beuys: Avers et Revers." *Parachute* 21 (Winter 1980): 32–41.

Poinsot, Jean-Marc. "Beuys à propos de quelques objets." *Opus International* 24–25 (May 1971): 90–91.

Rickey, Carrie. "Where the Beuys Are." *Village Voice,* November 26, 1979, p. 99. Review of exhibitions at the Guggenheim Museum and Ronald Feldman Fine Arts.

Robinson, Walter. "Beuys: Art encagé." *Art in America* 62 (November–December 1974): 76–79. Description of the performance at the René Block Gallery called *I Like America and America Likes Me.*

Rohan, Matthew. "New Thoughts on Joseph Beuys' Early Development." *Dumb Ox* 8 (Winter 1979).

Romain, Lothar, and Rolf Wedewer. *Über Beuys.* Düsseldorf, 1972.

Rose, Bernice. *Drawing Now.* New York: International Council of The Museum of Modern Art, 1976.

Russell, John. "Polemic and Poetic Art by Beuys." *New York Times,* February 16, 1975.

———. "The Shaman as Artist." *New York Times Magazine,* October 28, 1979, pp. 38–40, ff.

7 Vorträge zu Joseph Beuys. Mönchengladbach, Germany: Museumsverein, 1986.

Stachelhaus, Heiner. "Phänomen Beuys." *Magazin Kunst* 50 (1973): 29–46.

Stephens, Charles. "I See the Land of Macbeth: Joseph Beuys and Scotland (1970–1986). *Variant* (England) 6 (1989): 8–11.

Stevens, Mark. "Art's Medicine Man." *Newsweek,* November 12, 1979, pp. 76–77. Review of the exhibition at the Guggenheim Museum.

Storr, Robert. "Beuys's Boys." *Art in America* 76 (March 1988): 96–103, 167.

Stüttgen, Johannes. *The Warhol-Beuys Event: Three Chapters from the Forthcoming Book "The Whole Room."* Dublin: Free International University, 1979. Also published in *Impressions* (Toronto) 26 (1980): 38–47.

———. "Die Grünen." *Impressions* (Toronto) 27 (Spring 1981): 32–39. Discusses Beuys's involvement with the Green party.

———. *Zeitstau: Im Kraftfeld des Erweiterten Kunstbegriffs von Joseph Beuys.* Stuttgart: Urachhaus, 1988.

———, ed. *Similia similibus, Joseph Beuys zum 60. Geburtstag.* Cologne, 1981.

"Talking about Beuys, Toronto, March/80." *Impressions* (Toronto) 24–25 (1980): 22–29.

Thönges-Stringaris, Rhea. *Letzter Raum.* Stuttgart, 1986.

Thwaites, John Anthony. "The Ambiguity of Joseph Beuys." *Art and Artists* 6 (November 1971): 22–23.

Tisdall, Caroline. *Joseph Beuys.* London: Thames and Hudson, 1988.

Vischer, Theodora. *Beuys und die Romantik: Individuelle Ikonographie, individuelle Mythologie?* Cologne: König, 1983.

Wedewer, Rolf. "Hirsch und Elch im zeichnerischen Werk von Joseph Beuys." *Pantheon* 35 (January–March 1977): 51–58. Summaries in English and French.

Films of Beuys's Actions

Ausfegen. Produced by Galerie René Block, Berlin. Photography by Horst Behrensdorf. 1972. 16 mm, color, 33 minutes.

Celtic + ~~~. Produced by Editions Jörg Schellmann, Munich. Photography by Bernd Klüser. 1971. Super 8, b/w, 25 minutes.

Eurasienstab. Produced by Wide White Space Gallery, Antwerp. Music by Henning Christiansen; photography by Paul de Fru. 1968. 16 mm, b/w, 20 minutes.

Ich versuche Dich freizumachen/lassen. Produced by Galerie René Block, Berlin. Photography by K. P. Brehmer and K. H. Hödike. 1969. 16 mm.

I Like America and America Likes Me. Produced by René Block Gallery, New York. 1974.

Transiberische Bahn, 1961. Produced by Heiner Friedrich Gallery, Munich. Photography by Ole John. 1970. 16 mm, b/w, 22 minutes.

209

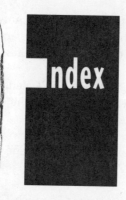

Index

211

C

215

W

Y

Z

Photography Credits

223